PHOTOGRAPHY
THEORY AND PRACTICE

2 The Camera
and its Functions

Revised by LA Mannheim MA (Oxon)

FOCAL PRESS London & New York

Completely revised and enlarged edition.

Originally published by Sir Isaac Pitman & Sons Ltd.

First Edition 1930
Second Edition 1937
Reprinted 1940
Reprinted 1942
Reprinted 1944
Reprinted 1946
Reprinted 1947
Third Edition 1954
Completely revised Edition 1970

© 1970 FOCAL PRESS LIMITED

ISBN 0 240 50685 5

Printed and bound in Great Britain at
the Pitman Press, Bath

Preface

There have been few really classical text books in photography. One of these, Louis Philippe Clerc's *La Technique Photographique*, was first published in 1926, and went through six French editions. The last of these was published just after the author's death in 1959. It was as unique a work as L. P. Clerc's personality was as a man. For *La Technique Photographique* was the first comprehensive treatise on photographic theory and practice, covering the whole field concisely yet precisely, scientifically yet in clearly understandable form.

The key to these qualities is that L. P. Clerc was probably the last photographic scientist to be able to keep an overall view over a discipline which – since his death in 1959 – has expanded far beyond the scope of any single man or mind.

L. P. Clerc himself devoted a long life to photographic research and writing. He accumulated the leading honours awarded in photographic activities – from membership of the Council of the *Société Française de Photographie et de Cinématographie* and honorary professorship at the *Institut d'Optique* to the progress medal of the *Royal Photographic Society* and the honorary Fellowships of the *R.P.S.* and the *Photographic Society of America*. At the same time he gained some of the highest distinctions in public service – including the *Croix de Guerre* and *Chevalier de la Legion d'Honneur*.

His qualification for the unique coverage of *La Technique Photographique* was his encyclopaedic and versatile knowledge of photographic science and technology which ensured his leading position in the French photographic industry as scientific consultant, research leader, teacher, lecturer and author. In this connection he read for over fifty years almost everything published on photography in the majority of international technical journals. The worthwhile and significant parts of this information appeared in the journal *Le procédé* which he started in 1898, and later in *Science et Industries Photographique*, which he founded in 1921 and which is still being continued by one of his close collaborators.

Three English editions of *La Technique Photographique* – with a number of intermediate reprints – appeared as *Photography: Theory and Practice* between 1930 and 1954. The last of these had to face the problem that one man could no longer span the whole photographic field, and it became the joint work of a number of expert photographic scientists and writers who brought their specialized knowledge to the sections they covered. The present edition necessarily continues this principle. It also has two specific purposes.

The first is to make *Photography: Theory and Practice* once more the exhaustive current textbook which *La Technique Photographique* was in its day. It has therefore been very extensively rewritten. But even with this radical revision the express aim remained to follow Clerc's original style and presentation as far as possible. Inevitably the work has grown to just over double the size of the third English edition, even though certain very marginal sections have been dropped.

The second purpose is to make *Photography: Theory and Practice* easily accessible to students of scientific as well as professional photography at photographic schools and courses – for whom such a comprehensive text and reference book should prove particularly valuable. To this end the book is being published in separate sections which the student can buy at an economic price and handle more easily. Eventually, the complete work will be issued in a hardbound version.

The present volume is the second in this series, and concerns itself with the equipment side of photography—specifically with camera design and operation.

Two points of detail remain to be made:

(1) The sections, though part of a whole, are self-contained. Their sequence is logical, but not a compulsory order of study, especially for students with a certain basic knowledge of the subject. Even the paragraphs – though following a rational progression within each section – present essentially distinct aspects, steps of exposition or items of information. They are of course cross-referenced where necessary. For this reason the paragraphs are numbered; this numbering is also the form of reference in the index at the end.

(2) As in previous editions, no bibliographical references are included. The reason is that such references would have added enormously to the bulk of the book – with comparatively little advantage to most readers, in view of the limited accessibility of original literature sources in other than specialized libraries. The references have therefore been confined to a mention of the names of authors (and dates) of various discoveries, improvements, etc. This will serve to narrow down the scope of any bibliographic search which some readers may wish to carry out.

PUBLISHER'S NOTE

Please note that the pagination of this volume is arranged as follows:
Section III pages 177–300.

Volume I contained: Section I pages 1–60
Section II pages 61–176

Contents

Chapter XVIII

Viewfinders, film loading and transport, accessories for hand cameras 272

SECTION III
THE CAMERA AND ITS FUNCTIONS

CHAPTER XIV

CAMERA TYPES AND SYSTEMS

194. Main Components of a Camera. Essentially a camera consists of a light-tight box—identical in principle with the camera obscura (§ 60) but with a lens in place of the pinhole and provision for holding sensitized material at the end opposite to the lens, so that the latter can project its image on the sensitized surface. For operation, the camera may have various control functions, the nature and complexity of which depend on the camera type and its purpose.

One of the main functions is the admission of a specific light intensity for a specific time—the *exposure*. The light intensity is controlled by the lens aperture (§ 102 ff), and the time for which the light is allowed to act on the film by the shutter (§ 252 ff). The two factors of light, intensity and time, control the quantity of light reaching the film and hence the effective exposure. As on most cameras intensity (aperture) and time (shutter speed) can be adjusted separately, similar effective exposures may be obtained by a variety of aperture and time combinations. The basis on which these are selected will be discussed in a later section. On some cameras the shutter and aperture are interlinked to yield a programme of exposures whose selection is controlled by an exposure meter. Inexpensive cameras may work with a fixed shutter speed and rely on as few as two aperture settings to control exposure over a

very limited range. This naturally limits the versatility of the camera.

One other basic adjustment is the distance between the lens and the sensitive surface to permit focusing of the camera for objects at different distances. This may involve either movement of the lens or adjustment of the latter's focal length (front cell focusing—§ 159); very simple cameras may not have a focusing movement and rely on the depth of field of the optical system to cover an adequate range of object distances (§ 124).

The third main item is provision for holding the sensitive material in the exact plane of the image projected by the lens, and for changing the film from one exposure to the next. With single sheet materials (sheet films and plates) a separate film holder is attached to the camera back. Accurate location of the film plane depends here on sufficiently precise construction of the camera. With this system the films are however not only exposed individually but can also be processed one by one if required. Roll and miniature film cameras take long strips of film which may hold anything up to six dozen or more individual exposures; the camera therefore has built-in film holding and transport arrangements, the exposed films being processed as a complete strip—although it is sometimes possible to cut off exposed lengths and develop these separately. In amateur

photography all the available exposures on the film are usually made before the latter is unloaded from the camera.

Other camera features are to some extent optional. Most important among these is some kind of viewfinder system (§ 285 ff) to help in aiming the camera precisely at the subject and to judge the limits of the field of view taken in by the lens. On professional studio and technical cameras the focusing screen in the camera back serves for this purpose; the film or plate holder then replaces the screen for taking the picture. Most other cameras either have a reflex system—also employing a focusing or viewing screen—or else some form of external finder or sighting device. Cameras of this type may combine the viewfinder with a rangefinder (§ 294) which serves as a focusing aid.

195. Sensitized Materials: Plates and Sheet Films. Here we are concerned only with the forms in which sensitive materials are available for various cameras; their photographic characteristics are covered in a later section.

Plates, the oldest form of sensitive material still in use, carry the sensitized emulsion on a glass support. This was the easiest material to handle at a time when photographers sensitized their own plates (wet collodion process) and was naturally adopted even when dry plates came into use about 100 years ago. The main advantages of glass are its rigidity, flatness and dimensional stability; but the weight and fragility of glass have induced most photographers to abandon plates in favour of sheet film. Plates are now used mainly in such special applications as certain photogrammetric, scientific, colour separation, etc., work, where their flatness and extreme dimensional stability are essential features.

In the camera, plates are held in light-tight plate holders (§ 230) which are attached to the camera back in place of the focusing screen, the holder keeping the plate in the exact image plane. Plates for general photographic cameras come in inch sizes from $2\frac{1}{2} \times 3\frac{1}{2}$ up to about 12×15 inches, and in metric sizes from $4\cdot5 \times 6$ up to 30×40 cm. (Only reprographic and other specialist cameras take bigger formats.) Some of the standard formats are shown in the lower half of the table in § 134.

With plates the exact dimensions are important for fitting in appropriate plate holders. Thus while a camera may be specified as taking for instance 5×7 inch or 13×18 cm plates, and plate holders for these formats may be interchangeable on the camera, the plates themselves are not interchangeable in the plate holders. For 5×7 inches is slightly smaller than 13×18 cm ($5\frac{1}{8} \times 7\frac{1}{8}$ inches) and each format would need its own plate holder. Even with the current conversion (in Britain) to metric sizes, the established inch formats are unlikely to disappear overnight since a large number of plate holders taking them are still in use. But manufacturers are now quoting both metric and inch sizes on their packings.

Photographic plates are usually sold in boxes of a dozen (half a dozen in larger sizes from $6\frac{1}{2} \times 8\frac{1}{2}$ inches and from 18×24 cm upwards). In the boxes the plates are packed face to face in groups of two, four or six, usually with edge spacers between the plates to keep the emulsions apart, and wrapped in black paper or plastic.

Sheet films cut in similar standard sizes as plates are used in much the same way and in similar holders. The latter must however have provision for keeping the film flat as well as for keeping it in the correct image plane (§ 230). Sheet films (also known as cut film or flat film) are packed in boxes of 25, 50 or 100 sheets. A special sheet film packing, now largely obsolete, is the film pack which is in effect a changing box for 12 films and only needs placing in a film pack adapter, interchangeable with normal plate of film holders (§ 233). Nowadays film packs are used mainly for instant picture material (§ 234).

196. Roll Films. First introduced by George Eastman in 1889, roll film is now the standard film packing for a number of amateur and medium-sized professional cameras. In its present form roll film consists of a long strip of film wound up on a spool together with a strip of opaque paper of fractionally greater width. In conjunction with the flanges of the spool on which the film and paper are wound, this provides full protection against light so that the film can be loaded into, and unloaded from, the camera in daylight. The backing paper also carries numerals printed on the back at regular intervals; these are used in some snapshot cameras as a guide when winding on the film between one exposure and the next (§ 299).

Roll films have been produced in a variety of widths and spool sizes and for picture formats from 28×28 mm to 9×14 cm ($3\frac{1}{2} \times 5\frac{1}{2}$ inches —postcard size). The table opposite indicates the standard roll film sizes still produced by film manufacturers, as well as perforated film

ROLL FILMS

Usual designation	Other designations	Film width mm	Exposures per roll	Nominal picture format	
				cm	ins.
Current roll film sizes					
120	20 B2, BS No. 2	61	8	5·7 × 8·2 ("6 × 9")	$2\frac{1}{4} \times 3\frac{1}{4}$
			10	5·7 × 7·2	$2\frac{1}{4} \times 2\frac{7}{8}$
			10	5·5 × 6·9	$2\frac{1}{8} \times 2\frac{3}{4}$
			12	5·7 × 5·7 ("6 × 6")	$2\frac{1}{4} \times 2\frac{1}{4}$
			16	4·5 × 5·7	$1\frac{3}{4} \times 2\frac{1}{4}$
220		61	As 120, but twice the number of exposures		
127	27, A8, BS No. 1	46	8	4·2 × 6·4	$1\frac{5}{8} \times 2\frac{1}{2}$
			12	4·2 × 4·2 ("4 × 4")	$1\frac{5}{8} \times 1\frac{5}{8}$
			16	3 × 4·2	$(1\frac{1}{8} \times 1\frac{5}{8})$
126		35	12 or 20	2·8 × 2·8	$(1\frac{1}{8} \times 1\frac{1}{8})$
Obsolete roll film sizes still manufactured					
620	62, Z20, BS No. 3		As 120, but different design of spool		
116	16, BS No. 4	70	8	6·4 × 11	$2\frac{1}{2} \times 4\frac{1}{4}$
			16	5·4 × 6·4	$2\frac{1}{8} \times 2\frac{1}{2}$
616	Z16, BS No. 5		As 116, but different design of spool		
828	88, BS No. 0	35	8 or 12	2·8 × 4	$(1\frac{1}{8} \times 1\frac{5}{8})$
Perforated films					
35 mm miniature		35	*36	2·4 × 3·6	$(1 \times 1\frac{1}{2})$
			*55	2·4 × 2·4	(1×1)
			*72	1·8 × 2·4	$(\frac{3}{4} \times 1)$
70 mm		70	*50–90	As 120 roll film	

* Maximum in standard cartridge; any shorter length can also be loaded, or longer lengths used in special magazines.

sizes (§ 197). Apart from the Nos. 126, 127 and 120 types, the roll films are sold mainly for obsolete camera formats at one time sponsored by the film manufacturers.

A special form of the No. 120 roll film is the No. 220 roll which has a film strip of twice the normal No. 120 length attached to short pieces of backing paper at the beginning and end. This offers the same light protection as roll film with a backing paper along the whole film length; by reducing the amount of paper wound up with the film it is thus possible to accommodate twice as much film on the same spool diameter.

Special roll film widths are made for aerial and other specialist cameras; these films may be between 80 and 240 mm wide and up to 60 metres or 200 feet long.

A special roll film type, the Polaroid film for instant pictures, is described in § 215.

197. Perforated Films. A widely used material is perforated 35 mm film similar in form to standard motion picture stock. It became popular with the introduction of the first commercially successful miniature camera (Leica, in 1924) and consists of a strip of 35 mm wide film carrying about 210 perforations per metre (64 per foot) along both edges.

The usual nominal image format for cameras using this type of film is 24 × 36 mm; the

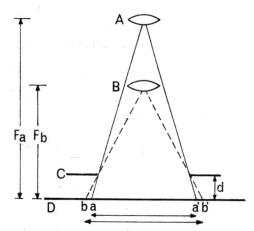

FIG. 14.1. FOCAL LENGTH AND IMAGE FORMAT
ON FILM

actual image size depends both on the exact
dimensions of the film aperture in the camera
and on the focal length of the lens used. Thus
in Fig. 14.1 a lens of back focus F_a projects
its light cone through the film aperture C
on to the film D, to yield an image format of
length aa'. A lens B of back focus F_b projects
a wider cone which produces a format dimension
bb'. The difference between the two depends
on the distance d between the film aperture
C and the film plane D. This is shown
exaggerated in the diagram, in practice images
produced by a short focus or extreme short
focus lens on a 35 mm camera are fractionally
larger on the film than images produced by a
normal or long focus lens. It is incidentally
the back focus (F_a, F_b) which is significant
here.

The 24 × 36 mm format was obtained by
doubling the standard 35 mm (silent) motion
picture image area, and arrived at from theore-
tical as well as practical considerations of in-
formation content and the number of image
elements that were required to equal the
information perceived in an actual scene
(Barnack). Alternative picture formats were
however also used down to 18 × 24 mm.

As 35 mm perforated film is used without
a backing paper, it is loaded into the camera in
the form of light-tight cartridges.

35 mm material is used—apart from motion
picture photography—also in bulk lengths in a
variety of specialized recording, microfilming
and other cameras.

Perforated 70 mm wide film, originally em-
ployed also in special recording, aerial, etc.,

equipment, is finding increasing use in pro-
fessional roll film type cameras. The film has
the same type and spacing of perforations as
35 mm stock, and is used without a backing
paper, in light-tight cartridges similar to those of
35 mm film.

Still wider perforated films are used in aerial
and similar cameras.

Perforated and also unperforated 16 mm wide
film is used in ultra-miniature cameras (§ 210)
for image sizes between 10 × 14 and 12 × 17 mm.
The smaller format is obtained on single per-
forated 16 mm stock, similar to 16 mm sound
motion picture film, and the larger format on
unperforated material. Still narrower ultra-
miniature film, for instance 9·5 mm wide, is
also used for some cameras.

198. Standardization. Once photography had
progressed to the stage that amateur and pro-
fessional workers expected to be able to use
sensitized materials of all brands in their
cameras, it became necessary to assure some
standardization in sizes of both materials and
camera fittings concerned with plate or film
holding and transport. Such standardization
evolved over the years first on national levels
and then on an international one, leading either
to the issue of international (ISO) standards
or to the voluntary alignment of national
standards of different countries to common
specifications.

In film and plate sizes and packings, standards
cover the actual dimensions of glass plates and
sheet films, glass thicknesses, widths and lengths
of roll films, widths and perforations of 35 mm
and other perforated films—and of course the
permissible tolerances from the dimensions
laid down.

199. Evolution of Camera Types. While
the first cameras were little more than a camera
obscura with a lens and some means for holding
the sensitized plate, successive improvements in
photographic processes greatly increased their
uses and led to the evolution of different types
of camera. In the first place two broad levels
of distinction evolved:

(a) between stand and hand cameras (includ-
ing intermediate types), and

(b) between professional and amateur camera
types.

Cameras intended for photographing station-
ary subjects or posed sitters in a studio have
to fulfil different conditions from those used
for taking action shots and most of the subjects

of the amateur photographer. Cameras for commercial or studio work are generally large and comparatively bulky as they are used on a rigid stand rather than carried from place to place. Such so-called stand cameras tend to be more specialized professional instruments, and in their modern forms include technical and view cameras, systems for studio portraiture as well as various industrial camera units.

The main requirement for amateur cameras is easy portability, rapid—and at times unobtrusive—operation and easy handling, and advances in camera design have been accompanied by a reduction in the size of the original negative without noticeable loss of quality in the print, even with greater degrees of enlargement. Photographers' preferences changed first from plates and sheet films to roll films and then to miniature camera types. In reducing the size and weight of the equipment the precision with which it is made had to be increased to provide the necessary image sharpness. So while at the beginning of this century the smallest usual image formats were 9 × 12 cm and $3\frac{1}{4} \times 4\frac{1}{4}$ inches, the majority of current amateur cameras use a 24 × 36 mm or 28 × 28 mm image.

As large cameras for their own sake became less necessary even in professional photography, various formerly 'amateur' camera types diversified further and even more rapidly than the more traditional stand cameras. Here the development followed two main directions:

1. *The foolproof amateur camera.* To exploit the amateur market in photography, it became necessary to simplify camera manipulation. The first step was of course George Eastman's "You press the button—we do the rest" policy in 1888. This led directly to the simple box camera which offered little more in controls and features than the first photographic "boxes" of the mid-19th century—but was considerably smaller. With practically everything fixed— lens setting, exposure time and often also lens aperture—and only a simple viewfinder, this camera type was simple in operation, though it took only outdoor snapshots in good sunshine. In its styling, shape and also picture size the box camera has changed appreciably during the past 80 years or so; but its basic design and principle remained the same.

With black-and-white materials of reasonable exposure latitude the success ratio of box camera exposures was remarkably high. With the growing popularity of colour films this formula no longer proved adequate. To preserve the same manipulative simplicity for mass use, amateur cameras developed with a number of automatic features (programmed exposure control, automatic flash exposures, etc.) which took care of the greater adjustability needed to cope with colour film characteristics and often with an expanding field of amateur photographic applications. The automation features however remained outside the control of the user: he now had a more complex camera which however remained as easy to use (sometimes even easier with such features as automatic film loading) and as foolproof as the traditional box.

2. *The advanced amateur camera.* To extend the versatility of the hand camera it was fitted first with adjustable lenses and shutters to permit a wider control of exposure conditions, later with more sophisticated view-finding and focusing aids including rangefinders or reflex systems, and eventually with other refinements. While aimed partly at the advanced amateur, this camera type became equally popular with professional photographers since features like interchangeable lenses and film magazines made the camera exceptionally versatile and led to the system camera (§ 211).

The following are the main camera types. Their detailed features are discussed in later chapters.

200. The Technical and View Camera. This development of the stand or studio camera is the versatile tool of professional and industrial photography. The technical camera, also known in Britain as the field camera and in the U.S.A. as the view camera, is, although transportable, intended exclusively for use on a camera stand or tripod. It provides complete image control in geometry as well as definition, at all distances, but under conditions where the photographer has sufficient time to arrange every detail of the scene to his satisfaction and examine the image at every stage on a ground glass screen in the back of the camera. The technical camera is thus primarily used for static or posed views, ranging from commercial and advertising photography of studio set-ups to outdoor architectural and industrial views. Definitely excluded from its scope are all pictures where the photographer has to follow or accommodate himself to the subject rather than the other way round.

The main feature of the technical camera is its adjustability. The rear part, carrying a ground glass screen in the image plane—

interchangeable against the film or plate holder —is connected to the front component or standard by bellows. This permits a wide variation in the distance between the two to allow the use of lenses of different focal length (mounted on interchangeable panels on the front standard) and to cover a focusing adjustment from distant to extremely close objects. In addition the image plane and the lens plane can be tilted about horizontal and vertical axes (swings and tilts) while the lens panel and the rear standard (image plane) can also be displaced in planes parallel to each other (rising and cross front movements). On older technical cameras the front and rear panels were mounted on a baseboard consisting usually of sliding sections to provide the necessary camera extension, yielding double extension and triple extension cameras. This refers to the maximum separation between the lens and image planes in terms of the normal focal length (§ 134) relative to the image format. Such cameras were made in wood, usually mahogany, reinforced by brass fittings. The bellows were square in section and could be straight or tapered (Figs. 14.2 and 14.3). Modern view cameras are of light alloy metal construction, with the earlier baseboard replaced by a single round or square section rail or a pair of rails which can often be extended by adding further sections. The front and rear standards then move to and fro along this support on runners which in turn carry the mechanical features for swings and tilts.

Traditional view cameras used to be available in various sizes to take plates or sheet films from $6 \cdot 5 \times 9$ to 30×40 cm or $2\frac{1}{2} \times 3\frac{1}{2}$ to 12×15 inches. Often the larger cameras take smaller formats by means of reducing adapters.

FIG. 14.3. TAPER BELLOWS CAMERA

The most common formats with modern technical cameras are 9×12 cm and 4×5 inches (the same camera takes alternative film holders for the two sizes), 13×18 cm or 5×7 inches, and 18×24 cm or 8×10 inches. Bigger sizes still persist in reprographic cameras (§ 212).

The technical camera is discussed in detail in Chapter XV (§ 216) onwards.

201. The Press and Hand-Stand Camera. The earliest press photographers worked with half-plate or quarter-plate field cameras, modified to permit fast shooting. This camera type developed into the traditional press cameras which sacrificed some of the movements (especially swings and tilts which were rarely needed in press work) but were fitted with viewfinders and often rangefinders to overcome the time delay between viewing on a screen and fitting a film holder. They were fitted with fast (and often interchangeable) lenses, high-speed shutters and—later—flash synchronizing features. Press cameras eventually developed, as a type, to rigid designs using modular systems of interchangeable components, such as quick-change film magazines, etc. When advanced miniature camera and reflex (including roll film reflex) systems appeared, many press photographers adopted this type of instrument as an alternative to the traditional large-format press camera. On the other hand the folding press type camera with bellows and provision for easy closing and portability also evolved to the medium-size technical camera (known as the hand-stand camera) as an intermediate between the commercial stand camera and amateur hand cameras. This retained much of the versatility of the technical view camera, together with its camera adjustments and movements, and combined this with action speed

FIG. 14.2. SQUARE BELLOWS CAMERA

features of the press type model. See also § 237.

202. Studio Portrait Cameras. As these cameras are never used outside the studio, considerations of weight and bulk are secondary to those of stability and rigidity, and of precision in manipulation. Studio portrait cameras used to be simply large versions of a field or technical camera, with a long baseboard extension (to permit the use of long focus lenses when required) and some camera movements (especially a large rise and fall of the front or lens frame and a vertical swing (about a horizontal axis) of the camera back. The rise and fall of the front permits the camera to remain at more or less one height and truly level when covering sitters of different heights (see also § 222) while the vertical swing about the horizontal axis permits the use of large lens apertures while obtaining uniform sharpness of for instance a seated figure whose knees and face are at different distances from the camera (see also § 96). Most portrait studios now use larger versions of modern technical or view cameras (§ 200 and 216) which offer even greater versatility.

Studio cameras are used on large stands which not only ensure maximum stability but—in the more elaborate versions—allow the camera to be raised and lowered from around 3 metres or 10 feet down to almost floor level, as well as inclined and tilted in any direction (§ 314). This is essential not so much for portraiture as for the photography of many commercial subjects in the studio, ranging from small still life subjects to groups of figures posed on staged sets for fashion and advertising photography.

Not all studio photography is necessarily done with a large camera; advanced roll film reflex cameras (usually of the 6 × 6 cm or $2\frac{1}{4}$ × $2\frac{1}{4}$ inch size) are used both in portraiture and in the studio set-ups involving some action. The reflex viewing facility permits the photographer to observe the expressions and movements of sitters or models while making sequences of exposures.

203. Twin-lens Studio Cameras. Twin-lens cameras consisting essentially of two matched cameras one on top of the other are also used in studio portraiture. This arrangement permits the photographer to observe the sitter's expression on the focusing screen, and to expose at exactly the chosen moment without the delay involved in replacing the screen by the film holder. The lens B of the lower camera in Fig. 14.4 projects its image on the film in the film holder D; the lens A of the upper camera shows virtually the same view on the focusing screen C. The latter may be set in the top of the camera or at an angle, with the image forming rays reflected by a mirror M; this then shows an upright (but laterally reversed) image at a more convenient level for the photographer. This design resembles that of the twin-lens reflex (§ 207), and studio twin-lens cameras may use roll film in special holders which attach to the back in place of the sheet film holder D. Usually cameras of this kind are intended for 9 × 12 to 13 × 18 cm or 4 × 5 to 5 × 7 inch sheet film. The lenses A and B must be matched in focal length, to ensure that the image in the film plane of B is as sharp as on the screen C or C'. To fill the image format with a large-scale head and shoulder or half-length view from a reasonable camera distance (to avoid exaggerated perspectives) the lenses A and B are usually of comparatively long focal length. They may be interchangeable against shorter-focus sets, for instance for full-length figures and groups.

204. Multiple Portrait Cameras. With the increasing need for portrait photographs in personal identity documents (passports, security passes etc.) cameras evolved for taking a number of such portraits economically, and often simultaneously, on one sheet of film. For immediate availability of the print, the sensitive material may also be an instant picture material (§ 225).

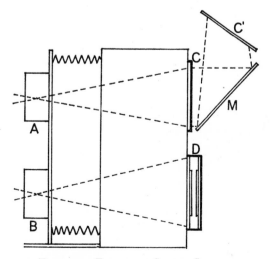

FIG. 14.4. TWIN-LENS STUDIO CAMERA

Multiple portrait cameras of this kind consist usually of four lenses mounted side by side on a lens panel (Fig. 14.5), each with its own shutter or (less frequently) with a common shutter behind the whole lens assembly. With a single common shutter the four exposures can only be made simultaneously; with individual shutters the camera can take four identical exposures at the same time or four different poses in succession. A septum or dividing partition inside the camera prevents overlapping of the images and protects each quarter of the film area from stray light from the other three lenses. Some multiple cameras of this kind have two, or six, or more lenses. Adapters made for normal view cameras can convert them to multi-lens operation; in this case a dividing septum is mounted in front of the film plane inside the bellows, and a four-lens panel fitted in place of the normal single lens (Fig. 14.6).

Another development of the multiple studio camera is the step and repeat system. Here the camera produces small images of around 3 × 3 cm on a large sheet of film in a holder which moves by one image interval between exposures. The latter are made more or less automatically, producing up to four dozen pictures (e.g. in six rows of eight) on the single film. This is a service operated by certain chains of commercial studios, the aim being to yield live portraits, with the sitter selecting successful frames from a proof print for enlargement. Such multi-shot portraits are also made on

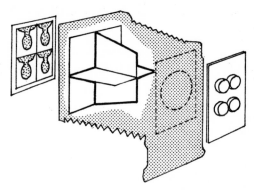

FIG. 14.6. FOUR-LENS ADAPTER SYSTEM

multi-lens cameras of the type described above, yielding half a dozen or more exposures per film.

205. Identity Cameras. These are used for the rapid production of works and security passes etc., and consist of two optical systems (Fig. 14.7): one lens A photographs the sitter in front of the camera—usually with flash illumination and under standard lighting and exposure conditions, to yield a portrait image A' on one half of the film format. A second lens B at the same time projects the image of a card D carrying personal particulars of the sitter on to the second half of the film B'. The light path through the lens B is usually directed via mirrors (M_1 and M_2) so that the card D is inserted in a special compartment of the camera itself (two mirrors are usually needed to ensure that the image B' is right-reading).

The finished picture contains both the portrait and the documentary data. A print from

FIG. 14.5. FOUR-LENS MULTIPLE
PORTRAIT CAMERA

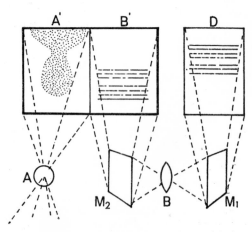

FIG. 14.7. IDENTITY CAMERA

the negative forms a complete identity card and may be laminated between plastic sheets for protection against soiling and forgery. With the use of instant-picture materials (§ 215) identity card or pass production becomes a high-speed and automated operation.

206. Reflex Cameras. The reflex camera, first suggested by Sutton in 1861 and made in a practical form by C. R. Smith in 1884, became popular about 1900 and for a long time was constructed in box camera form. Its main purpose was to provide an image on a ground glass screen for viewing and focusing, without the loss of time involved in changing the screen holder for a film holder. The reflex camera thus permits far more rapid operation than a studio or technical camera with rear focusing screen.

Fig. 14.8 shows the principle and form of an early reflex camera. A mirror M projects the image forming rays from the lens O upwards on to the ground glass screen D. In its rest position the mirror is arranged at an angle of 45° in the plane bisecting the angle between the sensitive surface and the ground glass screen. If under these conditions the lens is in a position to form a sharp image on the sensitive surface ab, the reflected image $a'b'$ is also sharp on the ground glass. This image can thus be used for precise focusing and—provided the screen area is correctly positioned and masked—for establishing the exact field of view. The image on the screen is the right way up, although laterally reversed.

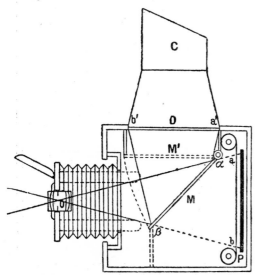

FIG. 14.8. EARLY REFLEX CAMERA

On pressing the release, the mirror M swings up to the position M' against stops, thus sealing the upper portion of the camera light-tight. A focal plane shutter P is then immediately released and uncovers the film surface for the time fixed by the speed setting. To reset the camera for another exposure, the mirror is allowed to drop and the shutter set again— either automatically or by hand. Some of these early reflex cameras were fitted with a lens shutter, the mirror protecting the sensitive surface sufficiently during viewing of the image. With modern reflex cameras (and modern high-speed films) this protection is not adequate and models with the shutter built into the lens usually incorporate an auxiliary shutter or flap in front of the film plane, to swing out of the way after the mirror has risen and before the lens shutter opens for the exposure.

As with this arrangement the photographer has to look downwards on to the top of the camera, pictures taken with a reflex camera tend to give a waist-level rather than an eye-level view of things. This has certain implications in portraiture, especially when using a hand-held waist-level reflex camera.

Moreover, such a camera can be used conveniently only in its normal upright position. (When the camera is turned sideways, the screen is on the side, and shows an inverted image.) Reflexes for single-sheet films or plates were therefore usually fitted with a square reversing or revolving back which carries the film holder in one or other position. The rotation of the back may operate a mask below the ground glass screen to change over from upright to a horizontal format. Alternatively the screen may be marked with the outlines of both picture formats.

Designers of waist-level roll film reflexes (§ 242) where rotating the film in the back of the camera is not practical, adopted a square picture format. The camera is held the same way for all shots, and the final negative cropped during enlarging. The difficulty of format orientation disappears with eye-level reflexes where the pentaprism finder arrangement shows an upright and laterally correct image even when the camera is turned about the lens axis.

The older type of reflex camera was popular despite its considerable bulk. (Usual image sizes ranged from 6 × 9 to 13 × 18 cm and from $2\frac{1}{2} \times 3\frac{1}{2}$ to $4\frac{3}{4} \times 6\frac{1}{2}$ inches.) It was eventually displaced by more advanced and elaborate roll film and miniature reflex types

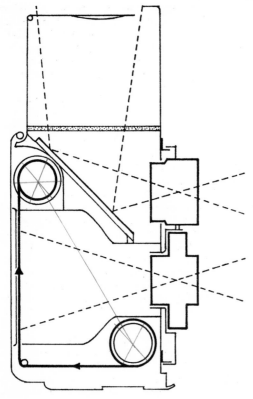

FIG. 14.9 TWIN-LENS ROLLFILM REFLEX

are however separated in space, there is a framing difference or parallax between them which becomes progressively more intrusive at nearer focusing distances. This difference may be compensated by decentering or swinging the upper or viewing lens (Fig. 14.10) or by moving a mask underneath the focusing screen (Fig. 14.11). These adjustments are linked to the focusing movement to ensure the coincidence of the fields included in the plane of space-object conjugate to the plane of the sensitive emulsion.

In Fig. 14.11a the object space A recorded on the film coincides closely enough with the object frame B seen on the finder screen when the camera is focused on infinity. With a near subject, however, the object frame B of the finder has its upper limit displaced upwards compared with the object frame A recorded on the film, as shown in Fig. 14.11b. To compensate this, the mask C moves downwards to bring down the top boundary of the view seen

(described in more detail in Chapter XVI), but reappeared again as a studio reflex camera with a limited range of camera movements (parallel displacement of the lens panel—found sometimes on early reflexes—and certain tilting movements of the lens axis). One application of the reflex principle in technical or view cameras is the use of a reflex housing or back in place of the rear standard of such a camera.

207. The Twin-lens Reflex. The method of focusing a rigid or folding camera by means of an auxiliary lens of the same focal length as the main lens, but less fully corrected, was not only used in studio portrait cameras (§ 203) but also appeared in the form of the roll film twin-lens reflex camera at the end of the 1920s. The camera offers the same viewing and focusing facilities of a reflex, though not with the same versatility. The auxiliary camera is then of the reflex type, but with a fixed mirror (Fig. 14.9).

In the twin-lens reflex camera the viewing image is thus visible all the time and the whole construction is thus simpler. As the two lenses

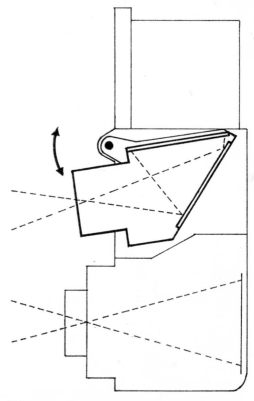

FIG. 14.10 VIEWING CORRECTION IN TWIN-LENS REFLEX BY INCLINATION OF THE VIEWING SYSTEM

on the screen. Parallax compensation is discussed in detail in § 287.

The twin-lens roll film reflex became popular some time before the single-lens roll film and 35 mm reflex, but has remained basically unchanged in design. It has benefited from improvements in focusing screens and viewing attachments as these evolved for single-lens reflexes; and some modern twin-lens reflexes offer similar facilities of interchangeable eye-level and waist-level viewing (§ 250) and interchangeable screens with Fresnel field lenses (§ 248) and other focusing aids (§ 249).

With one or two exceptions, twin-lens reflex roll film cameras have always used a lens shutter. Because of this, and the need for having two lenses of matched focal length, twin-lens reflexes are comparatively rarely made with interchangeable lenses. Lens changing would involve not only changing both lenses on a common panel but also elaborate auxiliary shutter systems to prevent light reaching the film during the lens change, and a long focusing movement for the structure carrying the lens panel to accommodate a reasonable focusing travel for the longest focal length to be used. The few roll film twin-lens reflexes that have appeared with interchangeable lens systems are therefore bulky and heavy.

The twin-lens reflex is mostly used with its fixed lens of 75–80 mm focal length for the nominal 6×6 cm ($2\frac{1}{4} \times 2\frac{1}{4}$ inch) picture format. Alternative focal lengths may be provided by afocal attachments (§ 184); special models have also appeared with a pair of wide-angle lenses or a pair of long focus lenses (e.g. 135 to 150 mm) permanently built in, in place of the normal focal length. Long focus twin-lens reflexes are used in studio portraiture (see also § 203).

As an alternative to the 6×6 cm format some cameras of this type take mask inserts to cut down the picture size to 4.5×6 cm (actually 4.5×5.7 cm), the film transport and the focusing screen being modified at the same time to cover the smaller picture. Special conversion kits enable some models to use perforated 35 mm film, sheet film in single film holders or Polaroid instant picture material (§ 215). Scaled-down versions of the twin-lens roll film reflex for 4×4 cm pictures on No. 127 roll film and 35 mm film have been produced. One attempt to increase the versatility among the latter involved the use of interchangeable main lenses (with a focal plane shutter in the camera) and a fixed reflex viewing lens. The latter of course no longer showed the image on the same scale as recorded on the film, and the focusing adjustment involved elaborate construction measures to couple the different focusing travels of the various lenses to the focusing movement of the reflex system.

To reduce the depth of field of the auxiliary (reflex system) lens and so permit more accurate focusing, this lens has sometimes a greater relative aperture than the main lens.

In some of the cheaper twin-lens reflexes the auxiliary lens carries no focusing movement while the focusing screen is replaced by a field lens; the viewing assembly therefore becomes merely a full-size reflecting viewfinder (§ 293).

208. The Folding Roll Film Camera. This type evolved from the hand-stand bellows camera (§ 210) with film chambers and film winding provision added. The folding facility made smaller-format versions compact enough to be carried in a pocket and made it—for nearly half a century—a highly popular amateur camera.

To speed up the opening and closing procedure, later folding cameras had a self erecting front where jointed levers with spring catches automatically place the lens board in position on opening the baseboard—and return the lens into the camera body on closing. Fig. 14.12 shows a simple lever arrangement; sometimes the system was more complex to ensure maximum rigidity of the lens panel (and parallel

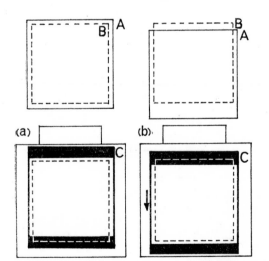

FIG. 14.11. VIEWING CORRECTION IN TWIN-LENS
REFLEX BY MASKS

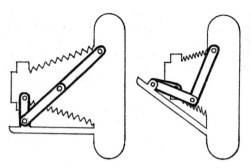

FIG. 14.12. SELF-ERECTING FOLDING CAMERA

positioning to the film plane) when open. Since the lens panel is no longer movable for focusing, such cameras used front cell focusing (§ 159).

Some folding movements dispense with the hinged baseboard and instead bring the lens panel forward with the aid of scissor-like struts which lock in the extreme positions (Fig. 14.13). The anchoring point of these struts can be made movable to vary the lens extension for focusing. The lens is unprotected, but the lens panel is large enough to protect the bellows and opening movement when the camera is closed. This design was used in amateur snapshot and a number of press cameras.

In their technical specifications folding roll film (and also 35 mm) cameras covered a wide range of types, from the simplest models with fixed focus lens and simple viewfinder to advanced types with rangefinders, a measure of automatic control and other features. By the end of the 1950s folding camera designs, however, disappeared from the amateur market—partly because they became uneconomical to manufacture by highly automated mass production methods, and partly because the various intercoupling systems between the lens and shutter assembly on the one hand and items in

the camera body on the other (film transport, exposure metering, etc.) were easier to design into a rigid camera.

209. The Miniature Camera. The appearance of cameras taking 24×36 mm pictures on perforated 35 mm film (§ 197) had notable effects on photographic technique:

(a) It popularized the concept of using small negatives to obtain big prints. (At the time—the 1920s—the smallest popular amateur format was 6×9 cm of $2\frac{1}{4} \times 3\frac{1}{4}$ inches and was used for contact album prints rather than enlargements.) The miniature thus also made enlarging a widespread amateur technique.

(b) It stimulated improvements in film materials and processing to lead to better image definition and lower graininess (which had not been a problem with larger negative formats).

(c) It started an era of high precision camera and lens design to meet the higher mechanical and optical standards demanded. These developments eventually caused the miniature camera to become the predominant amateur camera type, displacing the medium-size roll film format in virtually every field other than the professional reflex camera.

The miniature camera consists of a body holding the perforated 35 mm film and a lens mounted on a tube-like projection on the front of the body. On early 35 mm cameras this lens tube was collapsible to make the cameras as compact as possible; 35 mm folding cameras also appeared, but the majority of current types have a rigid lens mounting and barrel. The body also incorporates the film transport and exposure counting systems (§ 304). The camera has either a focal plane shutter built into the body or a lens shutter in or behind the lens. In Fig. 14.14, a classical miniature camera, the film B runs from a cartridge A over a transport sprocket C (which engages the film perforations) on to a take-up spool D. The camera here has a focal plane shutter E; the lens F

FIG. 14.13. SCISSOR FOLDING CAMERA
SYSTEM

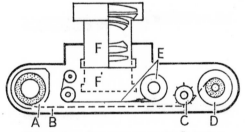

FIG. 14.14. CROSS-SECTION OF CLASSICAL
MINIATURE CAMERA (LEICA)

is mounted in a collapsible barrel which brings the latter back to the position F' when not in use.

Current simple miniature cameras differ little from this scheme in fundamentals; more advanced models may have built-in rangefinders, interchangeable lenses and other auxiliary features (Chapter XVII). The 35 mm reflex camera (§ 242) is the main separate direction of miniature camera evolution. The 35 mm camera also established itself as a camera system of accessories (§ 211).

210. The Ultra-miniature. Cameras producing pictures as small as 8×11 mm are as old as photography itself (Steinheil, 1839) and appeared in numerous forms of spy camera for small plates or films in the latter half of the 19th and the early 20th century. In modern usage "ultra-miniature" or "sub-miniature" implies a camera taking pictures on film narrower than 35 mm—i.e. 16 mm or 9·5 mm. Like the earlier spy cameras, present-day ultra-miniatures are (in view of their small size) inconspicuous in use. With the current resolution and definition performance of fine grain films, negatives made with such cameras are of a quality which yield reasonable enlargements.

The technical specifications of ultra-miniature cameras range from simple—often with plastic bodies, single speed shutter, etc.—to a precision level comparable with a high-quality 35 mm camera. In view of the short focal length of lens used and the resulting depth of field, ultra-miniatures rarely need or have rangefinders or other distance measuring aids, though one or two single-lens and even twin-lens models have been built. Lenses are usually not interchangeable and even zoom lenses are rare with this camera type, mainly because the size of such lens systems (even when scaled down to the focal length range of an ultra-miniature format) would seriously increase the bulk of such a tiny camera.

Where, however, ultra-small instrument size is not of primary importance, 16 mm still camera types have been suggested not only with zoom optics but also with a wide range of automatic features which would have made a larger camera altogether too bulky for carrying or handling. A futuristic concept of the fully automatic 16 mm still camera is thus one of a normal-sized (comparable with a standard amateur 35 mm model) body, in which greatly increased versatility is achieved by scaling down the image format and the dimensions of the mechanical and optical elements, rather than increasing the volume of the camera.

Early versions of modern ultra-miniature cameras appeared complete with processing outfits, scaled-down enlargers and even projectors, since at the time no standard processing and printing equipment was suitable for such small picture sizes.

211. System Cameras. The 35 mm miniature also introduced the concept of a universal camera outfit: a camera adaptable to a variety of jobs by means of accessories and adapters. These are added to what is basically a simple camera unit, holding the film, shutter and lens. Such accessory units cover:

(*a*) Optical accessories such as alternative interchangeable lenses (§ 134), supplementary lenses (§ 180, etc.), various other close focusing adapters (bellows, supplementary rangefinders) and micro adapters.

(*b*) Viewfinding and focusing accessories such as supplementary rangefinders, reflex housing and attachments (if the camera is not already a reflex camera) and alternative viewfinders.

(*c*) Mechanical and electro-mechanical items: remote control, motor drive and so on.

Such systems for universal application developed around a number of precision 35 mm cameras, including reflexes.

A second approach to camera systems is building up the camera itself from modular components, none of which is a camera as such. There are two possibilities:

(*a*) Alternative modules or component units assembled to a camera for different picture formats, with different lenses, etc. This is widely used in modern technical or view cameras (§ 219). This is the true "building block" approach evolved for this camera type in the late 1940s.

(*b*) Derived from (*a*) is the modular hand-stand camera, a medium format instrument primarily designed for roll film use. It consists of one or more basic camera bodies (*E* in Fig. 14.15) and takes different lenses (*A″*), micro adapters (*A′*), lens adapter units (*B*) and bellows units (*B′*, *B″*) for optical versatility, as well as different finder attachments, such as a reflex viewing device with focusing screen (*C* in Fig. 14.15) and a range of alternative film holders for roll, perforated or sheet films (*D*). Such modular systems have appeared in numerous forms, either as self-contained camera outfits or developed from single-lens or twin-lens roll film reflex designs.

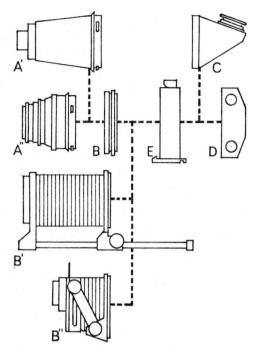

FIG. 14.15. UNIVERSAL MODULAR CAMERA
SYSTEM

212. Reprographic Cameras. Reprography is
the copying and reproducing of flat images such
as illustrations, printed or written texts, docu-
ments, etc., by photography. In cartographic
and photo-mechanical work, i.e. the reproduc-
tion of illustrations as printing plates, the
cameras employed are usually large size units
with the various parts hanging from wheels
running on a rigid frame suspended by springs
from the ceiling. The lens may be mounted on
a plate fixed to a partition separating the dark-
room from the studio. Rails parallel with the
optical axis carry in the studio a travelling easel

and in the darkroom a travelling support for the
sensitive material, while carriages and a mech-
anism are provided for moving the easel and
film holder arrangement slowly and holding
them fixed. One advantage of this layout is
that dark slides for the film or plate become
unnecessary; such slides would be exceedingly
bulky and heavy when the negative material
is 100 × 150 cm (40 × 60 inches) or larger.
Alternatively, only the rear frame of the
camera may be inside the darkroom and the
lens panel with bellows as well as the copying
easel in the studio. The overhead rail construc-
tion is used for the very largest cameras;
many process cameras with a horizontal set-up
have the various parts running on rails mounted
in the floor or on a specially rigid bed (Fig. 14.16).

A primary requirement for a graphic arts or
process camera is rigidity and freedom from
vibration. Modern cameras are of all metal
construction; where older wooden cameras
are still in use, the wooden parts are heavily
built and strongly reinforced with metal.

The overhead or floor mounted rails permit
free movement of the lens panel and easel
(copy holder) while preserving strict parallelism
between these units and the sensitive surface.
Graphic arts cameras are usually set up in
rooms least affected by external vibration
(traffic etc.). Where this is not possible, the
bed or rail may be mounted on springs so that
any oscillation swings the whole apparatus
without displacement of the camera relative
to the original.

The arrangements in the camera back are
usually more complex than with a technical
or view camera, since in the process camera
absolute coincidence of the focusing plane and
the sensitive surface is vital. Additional items
such as half-tone screens, masking components
etc., often have to be mounted just in front of
or in contact with the sensitive surface. Until

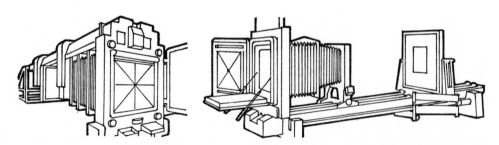

FIG. 14.16. OVERHEAD (LEFT) AND BED-MOUNTED (RIGHT) PROCESS CAMERAS

recent years process cameras used only plates as the sensitive material, and these are held between horizontal bars which move up and down between the vertical sides of the plate holder. With the appearance of film bases of improved dimensional stability sheet film is gradually replacing glass plates. Sheet film is held in a vacuum back, being sucked against a backing plate with grooves from which air is exhausted by a pump.

The original being reproduced is mounted on the easel by various means such as clamps or a vacuum holder. The copy board of the easel may be interchangeable with a light box to illuminate transparency originals. Both the easel and the film holder usually incorporate register pins or similar devices to permit location of the image in exactly the same position on successive films—an important requirement when a film has to be exposed in contact with, e.g. a filtered image of the same original produced on a different film—as in masking procedures.

The easel in the studio is illuminated by powerful arc or xenon lamps. The camera arrangement must, however, ensure that no light other than that from the original being copied reaches the lens. The lens panel is therefore often black, and special screens may be used to reduce the incidence of stray light.

Process cameras usually have a focusing travel which accommodates only a limited range of reproduction scales—e.g. from 1:4 to 4:1. Process lenses are generally corrected to yield their optimum performance within such a reproduction range. Alternative lenses must be used for scales of reproduction outside the normal limits. The focusing adjustment may be automatic; more usually the lens and easel position are set according to scales for the required reduction or magnification. On large size process cameras the movement of the lens carrier and of the easel is often motor driven, since the units are very heavy to move by hand.

Smaller process cameras for image sizes up to about 30 × 40 cm (12 × 16 inches) may use a vertical layout similar to that of an enlarger. Big-format precision enlargers sometimes have provision for use as a process camera in this way (lighting systems for the easel, vacuum easels, registering devices, etc.). The main advantage of the vertical arrangement is the considerable saving in space.

213. Industrial and Commercial Copying Cameras. For copying documents in offices, drawing offices, etc., special copying cameras photograph the original directly on paper supplied in spools. To obtain an unreversed copy on the paper, the lens is fitted with a reversing prism (§ 191). The originals to be reproduced are placed flat on a horizontal table or against a vertical plate, where they are held by suction or by electric attraction. This type of machine, usually handled by non-technical staff, is almost automatic in operation. It is however being gradually displaced by more compact contact copying equipment with built-in rapid processing machinery, or by electro-photographic copiers which require no liquid chemicals at all and deliver a finished positive copy within seconds of feeding in the original.

Smaller-scale copying cameras are used industrially for two purposes: close-up work and microfilming. A close-up camera is a camera unit fixed to a column mounted on a base-board so that the camera is adjustable in height and points vertically down. Such set-ups, which may be built up from miniature or medium format reflex cameras with appropriate close-up accessories, are used for occasional copying as well as for the photography of small objects, engineering components and similar items for commercial illustration. The subject is placed on the baseboard or supported above it and illuminated by suitable lighting units. More elaborate industrial cameras for this type of work may include sliding backs for changing over from ground glass focusing to exposure, calibrated scales for various scales of reproduction, supplementary lighting units and other accessories.

Microfilming cameras are a development of this scheme, with appropriate lighting units for even illumination of the original on the baseboard and special cameras for copying documents, engineering drawings, etc., on unperforated or perforated film in widths from 16 to 70 mm or wider, depending on the size of the originals to be handled. Microfilming cameras usually work at fixed reduction scales—e.g. 1:20 to 1:40 with 16 mm film, 1:15 with 35 mm film and so on. The larger film sizes are employed for cartographic work and engineering plans and drawings, the smaller film formats for routine document copying for subsequent filing in microfilm systems.

For mass production, the camera operation is extensively automated, with motorized film transport, fixed exposures (determined by the

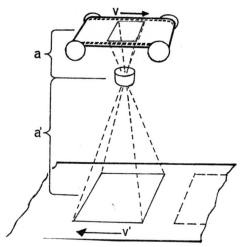

FIG. 14.17. IMAGE MOTION COMPENSATION IN MICROFILM CAMERA

intensity of illumination on the baseboard) and take film in bulk lengths of 30 metres (100 feet) or more. In some microfilming cameras both the film and the documents move continuously in opposite directions at carefully regulated speeds so that the image remains stationary on the film by precise image motion compensation. To achieve this, the ratio of the film movement speed v to the document speed v' must be the same as that of the lens-to-film distance a to the lens-to-subject distance a' (Fig. 14.17); in other words $a/a' = v/v'$.

Other automatic microfilming cameras run the documents around a continuously moving drum from where they are photographed on a continuously running film. In step-and-repeat systems the camera exposes up to 6 dozen small images side by side on a 4×6 inch sheet of film; the step-by-step movement is again automatically controlled from exposure to exposure.

214. Cameras for "While-you-wait" Photography. Various cameras and processes have been proposed for obtaining a finished photograph by processing in the camera within minutes of the exposure. Early forms, employed for street and fairground photography, used ferrotype plates or postcards and incorporated a box for immediate development and fixing in which the operator introduced his arms in sleeves of opaque material fixed to the camera. In other systems a negative paper material was cut off after the exposure in the camera and dropped

into a developing compartment underneath; after partial development, exposure to daylight produced a positive image by reversal.

For modern while-you-wait photography these systems have been superseded by one-step cameras of the type originated by Polaroid (§ 215) for simple commercial photography as well as for a variety of industrial recording purposes where a picture is required as soon as possible after an exposure.

215. One-step Instant Picture Cameras. The Polaroid camera system (E. H. Land, 1943) enables a semi-dry print, in contact with a negative, to be withdrawn by hand from the back of the camera within $\frac{1}{4}$ to 1 minute of making the exposure. In its original form the camera used was a large folding roll film camera with two roll chambers. One chamber takes a spool of negative paper or film (A in Fig. 14.18), while in the position normally occupied by the take-up spool is another roll of paper B. This has a specially prepared non-light sensitive layer and attached to it, at intervals corresponding to the distance between one exposure and the next, a number of pods containing a viscous processing solution. After each exposure the film and paper are drawn off so that the film moves from the exposure position A' through a pair of pressure rollers C in the back of the camera in contact with the paper into position A''. The pressure rollers break the pod of solution and squeeze the two layers together with a layer of processing chemicals between them. The latter here develop the negative image and at the same time, by a process of transfer diffusion, produce a positive image in the

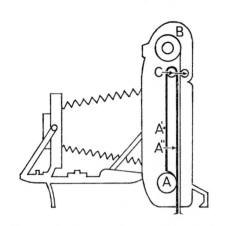

FIG. 14.18. INSTANT-PICTURE ROLL FILM CAMERA

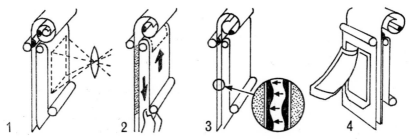

FIG. 14.19. THE POLAROID PROCESS OF SIMULTANEOUS NEGATIVE AND POSITIVE PRODUCTION

positive paper layer (step No. 3 in Fig. 14.19). The sandwich is cut off by a knife in the camera back and peeled apart after $\frac{1}{4}$ to $1\frac{1}{2}$ minutes—depending on the type of material used. The chemically produced positive print needs no fixing or washing. Polaroid cameras now use film packs (§ 234) containing interleaved assemblies of negative and positive material. These simplify loading in the camera which still contains the processing rollers. Transparencies and colour prints can be made by analogous procedures.

In addition to instant-picture amateur photography, this system has found growing use in studio photography to give an advance view in a picture of specific lighting and subject effects, for exposure tests, in identity cameras (§ 205) and various industrial and scientific applications. In many of these a Polaroid film back—essentially the rear part of the camera with the chamber for the film pack or roll holders and processing rollers—is used on appropriate camera systems. Similar backs can also be fitted to technical or view cameras in place of the normal film holder.

CHAPTER XV

TECHNICAL, VIEW AND PRESS CAMERAS

216. Camera Parts and Functions. Derived from the stand camera of generations of professional photographers, the view or technical camera is designed to give the photographer the widest possible control over the scale, sharpness, coverage and perspective of the image. To provide this scope, the technical camera must incorporate all of the following features:

(*a*) ground glass screen focusing;
(*b*) interchangeable lenses;
(*c*) a wide adjustment of the lens-to-image plane distance (almost invariably involving the use of bellows as the light-tight connection between the lens and the film plane);
(*d*) provision for lateral displacement and inclination of the optical axis relative to the image plane.

The modern view camera usually has the layout of an optical bench with the parts arranged on a single (or double) rail which takes the place of the earlier baseboard (e.g. as in Fig. 14.2, § 200). The rail supports two or more frames or standards which move along the axis

of the rail. In the basic form (Fig. 15.1) the front standard *A* takes the lenses on lens panels *B* while the rear standard *C* takes interchangeable holders *D* for the ground glass screen and for the various types of film material or plates. The bellows—similar to the bellows of an accordion—is made of cloth, plastic or leather and allows the distance between the

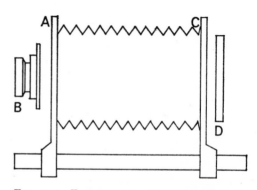

FIG. 15.1. TWO-STANDARD TECHNICAL CAMERA

196

FIG. 15.2. FLAT AND RECESSED LENS BOARDS

two standards to be varied over a considerable range while still shutting out all light.

The lens panel is a square or rectangular plate of the appropriate size to fit into the frame of the front standard. The lens itself, usually with a diaphragm shutter (§ 260) is mounted in a hole in this panel. A camera may have available for it a number of panels of different apertures for various lens mountings; the use of a panel (which is easy to make in the right size) provides the greatest versatility of lens interchanging. In addition to flat lens panels or boards, recessed panels may also be used to reduce the minimum lens-to-image plane distance (B in Fig. 15.2). The panel is held in place by a groove C and a sliding ledge or catch D.

The ground glass screen frame is attached to the main frame of the rear standard in a similar way. As however the frame has to be replaced by the film holder for every exposure, various quick release devices are used to speed up this operation.

A common method is to have the ground glass screen frame pressed against the main frame of the rear standard by spring loaded arms. The film or plate holder then slides in between the camera frame and the ground glass screen frame, the latter moving back while the sprung arms press the frame and the film holder against the camera.

Sophisticated forms include rapid action sliding or repeating backs (§ 235).

The image plane of the ground glass screen must precisely match the position of the film plane in the film holder to ensure that maximum image sharpness obtained on the focusing screen is also preserved on the film. This is usually the case with precision film holders made by the camera manufacturer. A number of camera backs of better known technical camera makes are now standardized in their form of film holder attachment and in the precise distance between the film plane and the back flange. Many camera accessory makers produce film holders and adapters to such standard specifications.

Since it is inconvenient to turn a technical camera on a tripod or stand sideways to change from an upright to a horizontal picture format (or vice versa), film or plate holders or cassettes can often be attached to the back in either orientation. The ground glass screen is then usually square, with markings to show the image limits with the different format orientations.

Another way of providing the changeover from horizontal to upright views is the rotating back. Here an intermediate frame with circular rails rotates in matching grooves set in the frame of the rear camera standard. The intermediate frame in turn carries the ground glass screen frame—for instance with the spring loaded arms described above—and takes the film or plate holders. Usually the frame is intended to be used only in its two end positions (upright or horizontally); if the rear standard of the camera is appreciably larger than the film format to be used, any intermediate position of the rotating back can also be utilized—as in Fig. 15.3b. (In a more compact camera the corners of the picture C are cut off in intermediate positions of the back, as in Fig. 15.3a.)

217. Bellows Types. The bellows of the technical camera may be detachable from the frames to which they are fitted to permit the use of alternative bellows types. Usually the bellows are square and provide a maximum extension of about 3 times the normal focal length (§ 134) of the lens to be used with the film or plate format. On cameras with interchangeable rear frames for different formats (§ 219) taper bellows may be used to connect the front frame to the larger versions of the rear frame.

To obtain still longer bellows extensions two bellows are linked together via an intermediate standard or frame C (Fig. 15.4) which rides on the same base rail. The intermediate frame prevents sagging which would occur with a single bellows of too great a length. Sometimes a further bellows unit A, also supported by its

FIG. 15.3. ROTATING BACK ON A SMALL (a) AND A LARGE (b) REAR FRAME

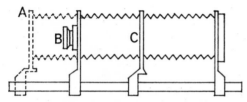

FIG. 15.4. TRIPLE-STANDARD TECHNICAL CAMERA
WITH INTERMEDIATE BELLOWS SUPPORT

own frame, may be fitted in front of the lens *B* as a lens hood (see § 192).

The minimum bellows extension may also be significant; it is determined by the finite thickness of the fully folded pleats which may be too great to allow the front and rear standards to be brought sufficiently close together when using lenses of very short focal length. Such lenses may either be accommodated with a recessed lens board (§ 216) or the pleated bellows replaced by a bag bellows which also permits greater adjustability when using the camera movements (Fig. 15.5).

218. The Rail and Axial Camera Adjustments.
The single supporting rail of the modern view camera (twin rails are comparatively rare) may be round, square, triangular, rectangular or even hexagonal in section. Sliding sleeves or runners on the rail carry the front, rear and possibly intermediate standards of the camera. Square, triangular, etc., rails automatically prevent twisting of the sleeves or runners so as to keep the frames strictly in line; while round rails have a protruding track or similar device to ensure alignment. The track or one of the flat faces of the rail usually carries a rack to engage a pinion on the sleeve or runner to permit forward and backward movement by a knob

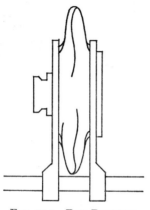

FIG. 15.5. BAG BELLOWS

drive. On some cameras this may be a friction drive; it can be locked to clamp all camera parts rigidly in position once adjustments are made.

A further sleeve or runner on the same rail carries a mounting platform for fitting the whole camera assembly on a tripod or stand. The whole arrangement then offers three longitudinal movements in the direction of the camera axis:

(*a*) Adjustment of the front standard to change the lens-to-object and lens-to-image distance at the same time;

(*b*) Adjustment of the rear standard to change only the lens-to-image distance, and

(*c*) Movement of the whole camera (front and rear standards) to adjust the lens-to-object distance. The implications of these alternatives

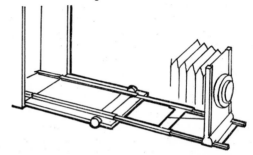

FIG. 15.6. TRIPLE EXTENSION FLAT BED CAMERA

will be discussed in a later section when dealing with focusing technique.

The length of the basic rail can be extended by screwing or attaching supplementary lengths. The limit of such extension, with intermediate frames and multiple bellows, is set by the loss of rigidity as the set-up grows in length—and by the weight of long focus lenses or the reduced image brightness with small apertures of longer focal length.

Twin rails need twin runners, which increase the rigidity (provided the rails are firmly connected to eliminate the risk of twisting) but make extension of the rail less convenient. The twin rail set-up can be regarded as an intermediate between the monorail camera and the older flat bed or baseboard type. The latter provides a double or triple extension by supplementary beds sliding over each other (Fig. 15.6). At least one of the movements—usually that of the innermost bed—may be knob driven via a friction drive or rack and pinion movement.

In baseboard cameras the rear standard is mostly hinged to the baseboard (which permits the camera to fold up comparatively compactly),

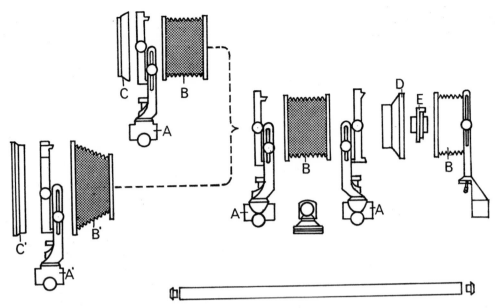

FIG. 15.7. MODULAR MONORAIL CAMERA SYSTEM

so that the rear frame does not move along the baseboard at all. As the latter is often also mounted directly on the tripod, the range of camera movements in the direction of the optical axis is rather more restricted than with a monorail system.

219. Modular View Camera Systems. The monorail design with similar front and rear standards, detachable bellows and accessory units lends itself to modular construction giving such technical cameras high versatility. In this system a number of similar frames or standards (*A*, *A'* in Fig. 15.7) can take either various lens panels *D* with lenses *E* or different ground glass screens, film backs, etc. (*C*, *C'*). There is further a choice of bellows, possibly behind-the-lens shutters (to go between the bellows and the front standard), viewing units and other items. The required camera for a given job is then assembled from these components. Thus short bellows without centre standard yield a normal or wide-angle camera, long bellows with centre standard a telephoto or close-up camera, different rear standards and ground glass screens different picture formats and so on. The various components are not only fully interchangeable but have identical controls and movements to simplify handling. Some modular systems include a reflex housing to take the place of the rear

standard, providing the camera with the convenience of reflex viewing and focusing with most of the versatility of camera movements.

The modular system also has the advantage that the photographer can start by acquiring a comparatively simple outfit and extend its scope with the addition of further units as required.

220. Technical Camera Movements. In terms of their optical effect, the adjustments—known as the *movements*—of a technical or view camera comprise:

(*a*) Parallel displacement of the lens axis away from the centre of the film area while the axis remains at right angles to the film plane;

(*b*) Inclination of the optical axis with respect to the film plane, the optical axis remaining centred in the image area;

(*c*) Inclination of the optical axis with respect to the film plane, with the axis displaced from the centre of the image area.

Mechanically these adjustments are achieved by:

1. Rising (or drop) and cross front and back movements, which yield the parallel displacement as under (*a*) above;

2. A swinging or tilting movement of the lens panel or standard about a vertical or horizontal axis. This leads to decentred inclination as in (*c*) above;

3. Swinging or tilting movements of the ground glass screen and image plane about a vertical and/or horizontal axis, leading to centred inclination as in (b) above.

The various movements can be used in combination, so that for instance a rising front and a tilted lens panel can provide centred inclination, a swing in the same direction at the same degree of both the front and the back frames can give increased parallel displacement etc. (§ 236, 238).

221. Rising Front and other Lateral Movements. The rising front in its simplest form—found even on amateur cameras half a century ago—has the lens panel sliding vertically between runners or in grooves. The whole lens carrier or front standard can also slide sideways

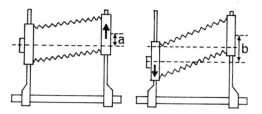

FIG. 15.9. MAXIMUM FRONT RISE (LEFT) INCREASED BY DROPPING THE REAR FRAME (RIGHT)

front and dropping the rear (or vice versa) the available degree of parallel displacement is doubled (b as against a in Fig. 15.9). The same applies to the lateral movements of the front and rear frames.

The total parallel displacement of either standard may typically be between 5 and 10 cm vertically and horizontally, i.e. half these amounts from the centre position of the standards. Not all cameras offer this degree of movement in all directions, partly because greater parallel displacement is usually possible by utilizing parallel tilts of the front and rear standards (§ 228). The limit of the usable parallel displacement is set by the coverage of the lens (§ 222) rather than the mechanics of the camera construction.

222. Effects of Parallel Displacement. Parallel displacement permits the selective utilization of portions of the wide-angle field of a larger camera format. In Fig. 15.10 movement of the

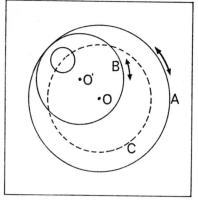

FIG. 15.8. PLANETARY ROTATING LENS PANEL

—the cross-front movement. On more advanced technical cameras it is the frame holding the lens panel rather than the panel itself which slides vertically. This movement may have a rack-and-pinion or a worm drive for more convenient precision adjustment. Various alternative mechanical arrangements have been proposed, for example a planetary rotating lens panel. Thus in Fig. 15.8 a rotating panel A with centre O carries a smaller rotating lens panel B with centre O'. Appropriate adjustment of A and B can bring the lens in any position within the circle C, the radius OC representing the maximum parallel displacement in any direction.

If the normal position of the lens panel is at the centre of its vertical as well as horizontal travel, lowering it provides a drop front movement. This is useful if it is duplicated—as is usually the case—by similar lateral displacements of the rear standard. For by raising the

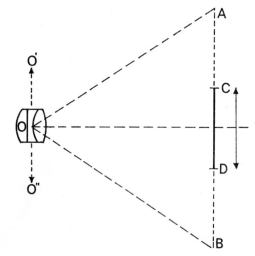

FIG. 15.10. PARALLEL DISPLACEMENT UTILIZING THE WIDE-ANGLE FIELD OF A LARGER CAMERA FORMAT

film or plate CD along AB—equivalent to movement of the lens between O' and O''— enables it to cover any part of the area of a larger format AB. A maximum rise of the lens would be equivalent to utilizing the portion DB of the image area AB; the effect is identical to that obtained by using the lens with a larger camera format AB and trimming away the portion AD of the picture obtained. Only with the rising front we can use the smaller camera and film format CD in the first place.

A prime condition for utilizing the parallel displacement features of the camera is adequate coverage of the lens. For a parallel displacement of the image CD between A and B in Fig. 15.10 the lens must of course cover the angle AOB (see also § 136). This angle therefore limits the distance—in the direction O' or O''— through which the lens can be moved in practice relative to the film. For example, to utilize a full 10 cm vertical displacement (combined front and rear) with a 210 mm lens on a 13 × 18 cm or 5 × 7 inch film, the lens would have to cover an angle of nearly 80° against its normal angle of 55° to just cover the 13 × 18 cm format without decentring. The required angle of coverage for a given parallel displacement decreases (or the usable displacement with a given lens increases) at close subject distances, and especially in macrophotography when the angle subtended at the lens by the film format decreases (Fig. 11.2, § 136).

When the marginal portion of a wide-angle field is utilized in this way by employing the rising front or other parallel displacements, the image on the film will naturally suffer from the effects of marginal portions of any wide angle view: fall-off in illumination (§ 86 and § 87) and of definition, as well as wide angle perspective distortion (§ 34).

The most often quoted practical application of the rising front movement (whether this is obtained by raising the lens only, by raising the lens and lowering the back or by parallel tilts of both the front and the back) is the photography of tall buildings from a comparatively close viewpoint. Thus in Fig. 15.11 the lens in its normal position O records on the film AB a field stretching from A' to B', i.e. including a great deal of foreground but not including the top of the tower. By raising the lens to O', its angle of view shifts to take in the subject field from A'' to B'', leaving out most of the (unwanted) foreground but including the top of

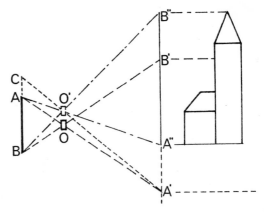

FIG. 15.11. RISING FRONT USED IN ARCHITECTURAL PHOTOGRAPHY

the structure. The total angle covered by the lens is in fact $A'O'B''$, which would cover the foreground, building and top of the tower on a film format CB. With the rising front however only the portion AB is utilized, where CA would take in the foreground previously included on the film with the lens centred at O.

The rising front and other parallel displacement are used wherever the film plane must remain parallel to a principal subject plane— in the case of Fig. 15.11 parallel with the verticals of the building, to keep them parallel in the image. Pointing the whole camera upwards would of course also include the top of the tower in the view of the lens, but the vertical lines in the image are then no longer parallel (§ 38). The same applies to downward views of buildings from a high viewpoint; the film plane must again remain vertical if vertical lines of the building are to be reproduced parallel in the image. To cover the required angle of view the lens is then decentred downwards by dropping the front and/or raising the rear frame.

A lateral displacement to the left or right may be required where horizontal line of an object are to be rendered parallel in the image, but where it is not possible or desirable to set up the camera squarely in front of the object. An example might be a photograph taken in a mirror hanging on a wall, where the mirror should appear undistorted in shape. Setting up the camera opposite the mirror would show the reflection of the camera itself, so a viewpoint obliquely in front of the mirror surface with the camera lens displaced laterally yields an undistorted view without reflection of the photographer (Fig. 15.12).

FIG. 15.12. CROSS FRONT IN PHOTOGRAPHING VIA A MIRROR WITHOUT REFLECTION OF THE CAMERA

FIG. 15.14. COMBINED CENTRE AND BASE TILT

223. The Swings and Tilts. The two terms are used interchangeably for the angular displacement of the front and rear standards, though the tilt is sometimes implied to mean inclination about a horizontal axis and the swing about the vertical axis.

The vertical axis for the swing of the lens standard is usually located in the centre of the supporting frame and hence runs through the lens axis. The same applies in most cases to the vertical movement of the axis of the rear standard which runs through the centre of the film format.

There are two common ways of locating the horizontal tilt axis: in the centre of the lens panel and the rear frame respectively (centre tilt—Fig. 15.13a) and at the bottom of the standards (base tilt—Fig. 15.13b). In their final effect on the image it matters little where the tilt axis is located, but the two methods have various handling advantages and drawbacks which were for a number of years the subject of controversy. Several cameras therefore incorporate both types of tilt (Fig. 15.14); others may have a base tilt on one standard and a centre tilt on the other.

For small tilt adjustments or fine adjustments the centre tilt requires less refocusing, especially on images near the centre of the image area

when only the rear tilt is used, since the distance d in Fig. 15.13a remains substantially the same. With a base tilt the standards must always be readjusted axially as well, i.e. the camera refocused during tilting to allow for the change in d' in Fig. 15.13b.

The centre tilting axis on the rear standard is often offset behind the supporting frame so that the latter clears the frame support to permit insertion of the film holder. This feature limits the utilizable tilt (the dotted outline in Fig. 15.15 represents the limiting position) and also increases the minimum separation between the rear and front standards. This limitation does not apply to the swing about a central vertical axis, since there the whole supporting frame of the standard swings. With a base tilt the mechanical movement is limited only by the presence of the monorail support, i.e. the standard could in theory be tilted through 90° each way until it lies flat against the monorail.

In practice the usable tilts and swings are limited by optical considerations; many cameras provide a greater movement range than could ever be utilized.

FIG. 15.13. CENTRE TILT (a) AND BASE TILT (b) ABOUT A HORIZONTAL AXIS

FIG. 15.15. OFFSET CENTRE TILT ON REAR FRAME

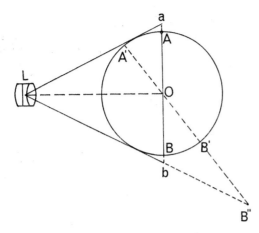

FIG. 15.16. OPTICAL LIMITS OF ANGULAR
DISPLACEMENT OF FILM PLANE

224. Optical Limits of Swings and Tilts. The optical limit of a swing or tilt on the rear standard is given by the evenness of illumination in the image plane. Provided the lens covers the format, the film plane AB in Fig. 15.16 can rotate through a full circle without any part of it going outside the angle of the lens. (In Fig. 15.16 the angle aLb is slightly greater than the angle subtended by AB at L, but except with an extremely short focus lens this angle does not become greater than the diagonal of the image of which AB represents the longer side.)

On swinging or tilting the image plane to the position $A'B'$, A' is obviously nearer to the lens than the image centre O while B' is further away and we can expect a variation of image illumination from A' to B'. With a normal focus lens (focal length approximately equal to image diagonal—§ 134) this difference in lens-to-film distances between A' and B' would with for instance a 30° swing lead to a variation in light intensity of around $2\frac{1}{2}$:1. With a 45° swing the ratio would be of the order of $5\frac{1}{2}$:1. This is however further complicated by the changes in the obliqueness with which the light reaches the film; at A' the angle of incidence decreases and so the image would get brighter still, while at B' the angle $OB''L$ becomes so acute that the cosine law (§ 86) further reduces the illumination there. With a short-focus wide-angle lens the variation of image intensity can therefore become considerable with moderate swings. Where greater angular displacements are used, the photographer must therefore compensate for

this brightness variation by suitably varying the intensity of illumination over the subject.

With the front swings the change in illumination of the image area is less significant as the lens-to-film distance does not change sufficiently to affect the illumination in the image plane. So only the effect of the cosine law has to be considered as the lens axis sweeps away from the centre of the image.

The maximum usable swing is approximately equal to half the difference between the diagonal angle the lens actually covers on the film or plate and the angle of field (§ 87). Thus in Fig. 15.17 a lens with an angle of field of 2β with a utilized angle of 2α to cover the image diagonal AB would have to sweep through an angle δ to make the limit of its cone angle $A'LB'$ coincide with AL. The angle δ is simply the difference between the half angles β-α. For instance with a wide angle lens of a 90° angle of field used as a normal focus lens (§ 134) covering a 54° angle on the image format, the difference between the half angles 45° — 27° = 18°. Even with a 100° wide-angle lens

FIG. 15.17. OPTICAL LIMITS OF ANGULAR
DISPLACEMENT OF LENS PLANE

the half angle difference is only 23°. (The actual permissible swings are slightly greater because the lens plane is usually tilted or swung parallel with the sides of the image and not with the diagonal.) The 20° to 30° limiting tilts and swings found on less advanced technical or view cameras do not therefore seriously impair the versatility of such a camera.

225. Effects of Angular Displacements. It is convenient to consider the front and the rear swings or tilts separately, i.e. postulating for a given camera and subject set-up that:

(*a*) The lens plane is kept fixed (except for focusing) and the rear or image plane of the camera swung or tilted; or

(*b*) That the image plane is kept fixed and only the lens axis inclined.

Camera movements according to (*a*) then primarily control the proportions of an object's image (see § 38 and § 96). This is generally referred to as the perspective controlling feature of the camera movements, though strictly speaking perspective is controlled by the choice of viewpoint (§ 34).

Tilting or swinging the lens as under (*b*) primarily controls the distribution of sharpness in the image (§ 96). A lens tilt combined with an angular displacement of the whole camera can however be equivalent to a rear tilt (§ 229).

In utilizing the angular movements of the camera back the situation is taken one step beyond the state of affairs indicated in for instance Fig. 5.10 (§ 38): with the camera pointed at the subject and the back in its normal or neutral position (i.e. in a plane at right angles to the lens axis) the image plane is already inclined with respect to at least some of the subject planes. Hence certain horizontal and/or vertical subject lines will appear to converge in the image, and the back swings and tilts then serve to alter, neutralize or even reverse this convergence.

Thus in Fig. 15.18a, representing a plan view of a building *ABCD*, the image in the plane *A'B'C'* at right angles to the lens axis *LB* yields the conventional representation as in Fig. 15.18b. On swinging the camera back—assumed to take place about the axis *B'* so that *B'B"* remains unchanged in height in the image—until *A"C"* is parallel to *BC*, the face *BC* of the building appears rectangular as in Fig. 15.18c. This movement changes not only the convergences of the *horizontal* lines of the faces *AB* and *BC*, but also their relative length. For *A"B'* in

Fig. 15.18a, which is equivalent to the dimension *x"*, is shorter than *A'B' = x'*. The length of the other face *BC*—whose projection becomes

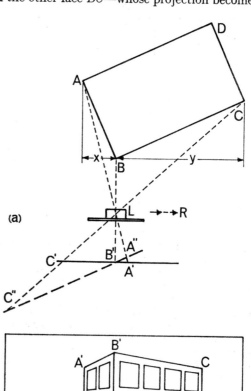

(a)

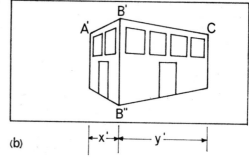

(b)

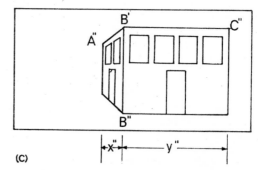

(c)

FIG. 15.18. EFFECT OF SWING ON PERSPECTIVE AND PROPORTIONS

y' without the swing and y'' with the back swing—increases, for y'' corresponds to $B'C''$ which is longer than $B'C'$ $(= y')$.

The width in the image of the face AB is narrowest when the plane $C''B'A''$ is at right angles to the direction ALA'', for $A'B'$ is then the hypotenuse of a triangle of which $A''B'$ is one side.

On swinging the image plane further still as in Fig. 15.19a so that BC and $C'''A'''$ converge towards E, the perspective of the face AB becomes still more violent. That is to say, the horizontals converge still more strongly. On the other hand the horizontals of the face BC now diverge, leading to the completely unnatural perspective effect of Fig. 15.19b. Note that the apparent length of the face AB $(= x''')$ is again increased compared with Fig. 15.18c; the length of the face BC $(= y''')$ is however also further increased. (It should be noted that this example is hypothetical in that it is not always possible to obtain a back swing as great as that shown in Fig. 15.19 on most cameras—for the reasons indicated in § 234.)

The proportions of the image are affected in the same manner, though opposite sense, on swinging the image plane to GF, parallel with AB in Fig. 15.20. It is now the face AB which becomes parallel, stretched in width (since $B'F$ is much longer than $B'A'$) and the face BC is foreshortened to its shortest rendering, since GB' is shorter than $B'C'$. Further inclination, to make the plane $FB'G$ converge with AB towards H, would render the face AB of the building in a similar manner to the face BC in Fig. 15.19; the length of the face BC, corresponding to $B'G$ in Fig. 15.20 would however increase again. It should be noted that the various perspective distortions of Figs. 15.18c, 15.19b and 15.20b are all distortions of the image of Fig. 15.18b which in turn depends on the viewpoint of the lens L. For the sake of clarity, the plan views of Figs. 15.18a, 15.19a and 15.20a are not drawn to scale; in practice the distance BL is usually appreciably greater than LB' even for close-up subjects. (In macrophotography depth of field problems—§ 117—become considerable when we try to represent depth of solid objects.) With architectural subjects the object distance BL is often several hundred times the image distance LB'.

We have however seen before (§ 35) that the perspective effect—i.e. the degree of convergence of the horizontals in for instance Fig.

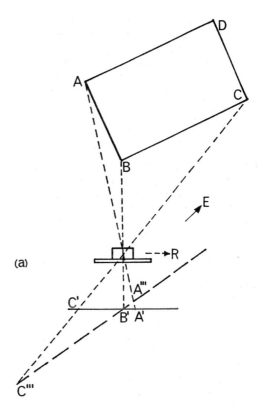

(a)

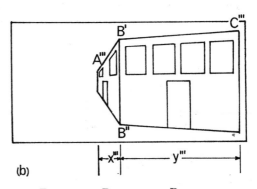

(b)

FIG. 15.19. PERSPECTIVE REVERSAL

15.18b—depends on the object distance BL. The greater this distance, the less pronounced the convergence of the horizontal lines and the "flatter" the perspective. To achieve a rendering as in Fig. 15.18c with the horizontals of the side BC of the building truly parallel, would still require the same degree of back swing. In other words the image plane $A''B'C''$ in

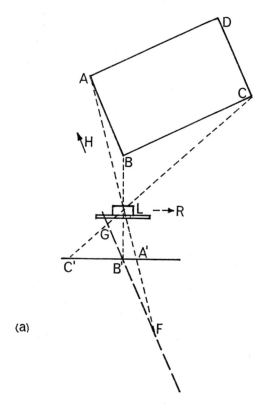

(a)

perspective, the greater its possible distortion by the use of the camera movements. So deliberate perspective distortions on the lines of Fig. 15.19b become more impressive if the object is covered from a close camera distance with a wide-angle lens than if the same object is photographed from a greater distance with a longer focus lens.

The viewpoint of the lens L also determines how much of the sides AB and BC is visible in the picture, irrespective of how much the proportions and the convergence of the horizontals of these sides are altered. In other words, swinging the camera back could not for instance hide the side AB of the building; only a change of viewpoint by moving the entire camera in the direction of the arrow R in Figs. 15.18 to 15.20 could do that.

Although the visual clues and the use of the vertical tilt about the horizontal axis are different, the principle is the same. Let AB in Fig. 15.21a be the vertical direction of a building, with the camera lens L set up directly opposite. As long as the image plane $A'B'$ remains vertical, the image of the building appears straight as in Fig. 15.21b. Tilting the image plane away from the top to the position CD makes the verticals converge towards the top of the building as in Fig. 15.21c; compare also

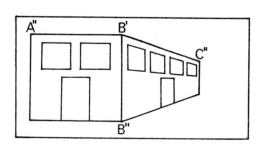

(b)

FIG. 15.20. EXTREME SWING AND PERSPECTIVE

Fig. 15.18a must again be parallel with BC. The conclusion to be drawn from this is that the shorter the object distance, and hence the more pronounced the perspective, the greater is also the effect of a *given degree of swing* on the convergence of image lines (in this case the horizontals). In brief, the more pronounced the

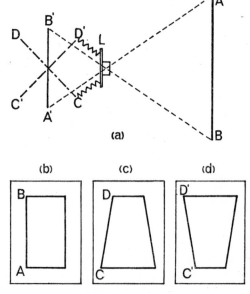

FIG. 15.21. EFFECT OF TILT ON CONVERGING VERTICALS

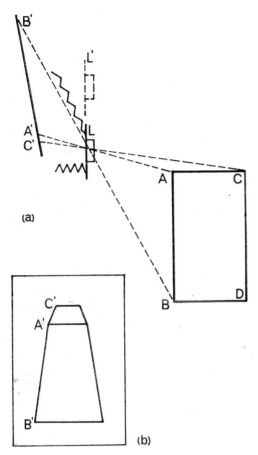

FIG. 15.22. REVERSED PERSPECTIVE CLUES

Fig. 5.10 in § 38. Tilting the image plane into the position $C'D'$ on the other hand makes the verticals of the image diverge towards the top of the building as in Fig. 15.21d: the structure appears to fall over towards the observer. The same effect is obtained when the camera position is more or less level with the bottom of the building and the rising front is used to include the top of the structure in the picture. Although such clues as are available from the viewpoint indicate that the observer is looking up, the perspective distortion counters that by making it seem as if the building were seen from a high viewpoint.

This reversal of clues appears more distinctly in Fig. 15.22. Here the viewpoint of the lens L is high enough to include part of the top surface AC of the building or object, while the image plane is tilted in the same way as it was for the rendering of Fig. 15.21c. The result

in Fig. 15.22b is that the picture is obviously a view from an elevated standpoint, even with respect to the visible top of the building, but the perspective is reversed. The arrangement of Fig. 15.22 is thus in effect Fig. 15.19 turned round through 90°. The arrangement of Figs. 15.18 to 15.20 differs from Fig. 15.21 only in that in the latter we started off with a single object plane at right angles to the lens axis, instead of two inclined object planes.

226. Combination of Swings and Tilts. The angular displacements of the image plane, considered so far separately as swings about the vertical axis and tilts about the horizontal one, can of course also be combined. In that case the convergences of parallel object directions produced by each angular displacement are superimposed. Thus in Fig. 15.23a the image plane $A'B'C'D'$ is tilted with respect to $ABCD$ so that CB and $B'C'$ both converge towards F while BA and $A'B'$ both converge towards E. As a result the square $ABCD$ becomes an irregular quadrilateral $A''B''C''D''$ as in Fig. 15.23b. A circle (shown as a bold broken outline) at the same time becomes a lopsided egg shape.

It should be noted that this distortion occurs whenever the film plane is tilted in two directions with respect to any object plane, a state of affairs which often arises without being noticed. When photographing for instance an interior view with a technical camera, there are always some object planes which are initially at an angle to the film plane. If the latter is then swung or tilted in any direction other than towards or away from such object planes, the shape of the object is distorted accordingly. This may be further enhanced by wide-angle distortion (§ 34) and even image distortion by the lens itself (§ 82).

227. Lens Swings and Tilts for Sharpness in Depth. The principle involved in inclining the lens plane to meet the intersection of the object planes and image planes for maximum overall sharpness was explained in § 86. Though frequently referred to as depth of field extension, depth of field in its true sense—namely the region of tolerance or permissible unsharpness (§ 110) does not come into this at all. In the plane AB in Fig. 15.24 everthing is reproduced equally sharply in the image plane $A'B'$ when the degree of lens tilt is arranged so that the prolongation of AB, $B'A'$ and LC all meet in the same point C.

The depth of field zone at each point still

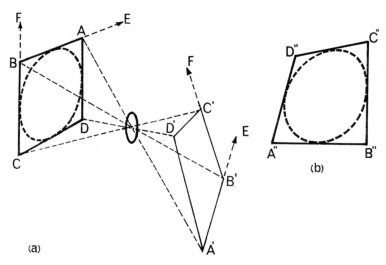

(a)

(b)

FIG. 15.23. COMBINED EFFECT OF TILT AND SWING ON THE REPRODUCTION OF A
SQUARE AND A CIRCULAR SHAPE

covers subject distances at which the image in the plane $A'B'$ is tolerably sharp; at the point E in AB the depth of field zone extends from E' to E'' behind this plane. For the whole object plane AB the depth of field zone is shown by the shaded area bounded by $D'F'$ on the one side and by $D''F''$ on the other. These two lines diverge since the zone gets deeper with increasing distance of the object points from the lens along AB. Any object point protruding

out of the depth zone, as G in Fig. 15.24, would thus be rendered noticeably unsharp even though the distance of G from the camera is between the distances of A and of B.

This leads to the anomalous position of having a distance from the camera at which an object is unsharp, while nearer (B) or farther (E) items are sharp. For the governing factor is no longer distance in front of the lens (actually distance from a plane at right angles to the lens axis).

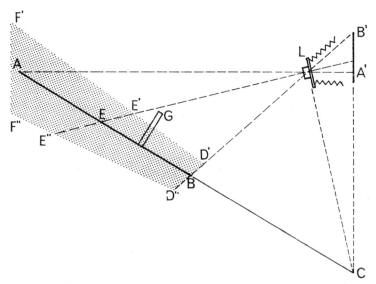

FIG. 15.24. DEPTH OF FIELD WITH LENS SWING

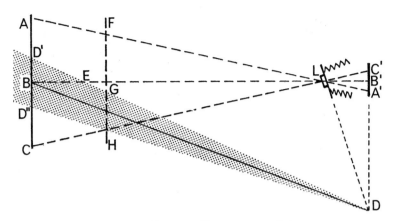

FIG. 15.25. LENS TILT FOR DIFFERENTIAL SHARPNESS

With the object, lens and image planes inclined to each other as in Fig. 15.24, distances have to be measured from the plane AB.

The lens swing can equally restrict the sharpness across the subject area. In Fig. 15.25 the points A, B and C of an object would normally yield corresponding sharp image points A', B' and C' when the lens L is correctly focused. On swinging or tilting the lens, the plane of maximum sharpness in the object lies along BD, where D is the point of intersection of the lens plane and the image plane. Within the plane ABC the depth of field limits of the plane BD extend to D' and D''. Within this region of the subject the image is sharp; items from D' to A and from D'' to C are unsharp. This lateral restriction of the depth of field is however accompanied by a longitudinal extension as well: the near limit in the centre of the field is E, which is nearer than it would have been with the lens untilted.

In Fig. 15.25 the "band" of sharpness $D'D''$ (which is at right angles to the plane of the illustration) stretches across the centre of the subject. By bringing the object plane nearer to the camera (or for that matter by refocusing the lens) the sharp band can equally be along one edge of the subject field, as GH in the plane FH. By tilting and swinging the lens the band of sharpness can be made to run more or less obliquely across any part of the field.

The lens may also have to be inclined when the back is swung or tilted for perspective control, to achieve uniform sharpness over the film plane. In Fig. 15.26 the film plane is swung from $A'B'C'$ to $A''C''$ to correct the perspective

rendering of an object ABC. If the lens plane is not swung, the depth of field zone (shown shaded) covers the whole of the wall AB but only about half of BC. With the lens panel swung so that LL', CB and $A''C''$ all meet in a point E, the whole of BC will be sharp in the plane $A''C''$. The actual lens swing required may be less if the plane GH is chosen as one of optimum sharpness to get the best compromise of depth of field over BA as well as BC.

228. Combination of Parallel and Angular Displacement. On swinging the lens, the lens axis sweeps away from the centre of the film

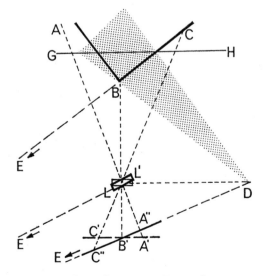

FIG. 15.26. LENS SWING FOR DEPTH CORRECTION WITH BACK SWING

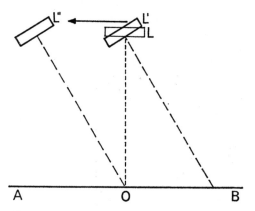

FIG. 15.27. PARALLEL DISPLACEMENT MADE
NECESSARY BY LENS SWING

is limited only by the degree of tilt possible of the front and rear standards.

When using this method to increase the rising front (or cross front) movements, the distance between the front and rear standard on the camera bed or rail must also be increased, e.g. by moving the front standard to C. Otherwise the effective horizontal distance between A' and B' is reduced by the double tilt and the image becomes unsharp. For this parallel displacement therefore the tilt is used for coarse adjustment and the built-in rising front movement of the camera for fine adjustment, since this involves no change in the lens-to-film distance.

area (Fig. 15.27). So it is usually desirable to displace the swung lens parallel to the film plane from L' to L'' as well to bring the lens axis back to the centre O of the film area.

The most usual combination of parallel and angular displacement serves to increase the range of possible parallel displacement. By tilting the whole camera upwards from AB to $A'B'$ (Fig. 15.28) and then tilting the rear and the front standard forward again to A'' and B'', the effective parallel displacement D

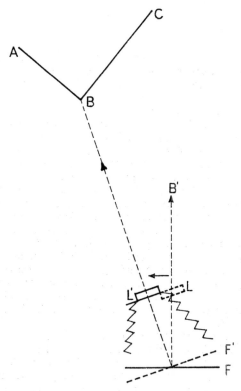

FIG. 15.29. EQUIVALENCE OF FRONT AND
REAR SWINGS

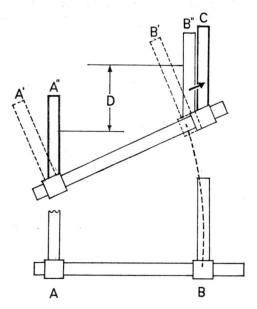

FIG. 15.28. EXTENDED PARALLEL DISPLACEMENT
WITH FRONT AND REAR TILTS

229. Equivalence of Front and Rear Swings. As the swings (and tilts) of both the front and the rear camera standards involve an inclination of the optical axis to the film plane, the same results can often be achieved by using either the front or the rear swing. Thus the situation of Fig. 15.29 can be arrived at by pointing the camera either in the direction B and swinging

the film plane from F' to F, or by pointing the camera in the direction B' and swinging the lens followed by a parallel displacement from L to L'. With the correct amount of back swing this can at the same time ensure optimum sharpness over the whole of the film. Pointing the camera at B is more convenient since the required subject field is seen on the ground glass screen straightaway; pointing at B' first requires some guesswork. But this shows that even a camera with a swing of only the front or the back is still reasonably versatile—if less handy—for perspective and sharpness control. This is useful where a lens swing and parallel displacement are provided by a bellows attachment on a miniature camera or when using a technical camera with a reflex rear unit which makes a rear swing less practical.

A number of hand-stand cameras, including the technical press types, permit a limited rear swing coupled with a rising and/or cross front movement only (§ 238).

A swing of only one standard (front or rear) does not of course permit the extended parallel displacement of Fig. 15.28.

230. Film and Plate Holders. Technical and other cameras using sheet films and plates employ light-tight flat holders for the sensitive material. The holders fit on to the camera back underneath or in place of the ground glass screen and are fitted with a sliding closure or shutter which is withdrawn once the holder is in place on the camera back. In Britain the whole holder is usually called a dark slide; in the U.S.A. this term refers to the sliding shutter or draw slide only. Often the holder slides on to the back in grooves; a retaining catch holds it in place while the draw slide is withdrawn, to prevent the holder itself from being pulled out of its grooves during this operation.

The simplest plate holder is the single metal slide made of stamped sheet steel or nickel with a thin sheet metal draw slide. This is also the cheapest, lightest and most compact holder, but is rarely used for plate sizes above 9×12 cm or 4×5 inches. In larger formats the single metal holder may not be sufficiently rigid to avoid distortion and even to protect plates against breakage.

In the holder (Fig. 15.30) plates are inserted underneath a rebate A at one end and held in place by spring loaded retracting lugs B at the other. Springy tongues C press the plate against the rebates to keep it accurately in the image

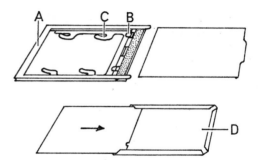

FIG. 15.30. SINGLE METAL PLATE HOLDER

plane. Sheet films are loaded into sheaths D of thin metal to provide some stiffness and the loaded sheath inserted in the holder like a plate.

Modern sheet film holders for all formats are somewhat thicker in construction—mainly to provide extra rigidity—and may take either one or two sheets of film. The film A in Fig. 15.31 slides into the holder from the opened end B, going underneath ledges C and is held in the image plane by a backing plate D with spring pressure. The draw slide E runs in a further light trapped groove above the film plane. Some holders will take either plates or sheet films with this arrangement, the movement of the backing panel D providing sufficient clearance for the thicker plate support.

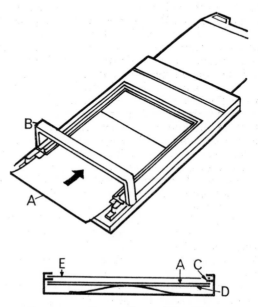

FIG. 15.31. SINGLE SHEET FILM HOLDER

Double holders consist essentially of two single holders built back to back and are often but little thicker than a single holder. When one film is exposed, it is only necessary to turn the holder round on the camera back, which is quicker than putting down one holder and picking up the next.

To identify films and film holders, the latter are generally numbered or carry plastic panels for writing details of the emulsion type loaded. With many types of holder the draw slide has two distinctive sides (e.g. of different colour or other markings on the handle); if the draw slide is habitually inserted one way round on loading the film holder and the other way round after exposure in the camera, it becomes easy to identify which films and holders have been used and are ready for processing. Often the two sides of the draw slide can be differentiated by touch to permit correctly orientated reinsertion even when working in near darkness. Film holders may show a number of other refinements such as ejector mechanisms to permit easy removal of the film or plate, mechanical coupling of the draw slide (via a Bowden type cable) with the camera shutter to close the latter as the draw slide is withdrawn, etc.

Most sheet, film and plate holders are currently all-metal in construction; older designs—still in use—often are of wood and may be single or double plate holders. These still take sheet films with the aid of film sheaths as in Fig. 15.30 or simply by backing up the film with a piece of card or other material of the same thickness as a glass plate. In some designs the draw slide is a flexible curtain shutter, formed of thin strips of wood glued on an opaque fabric (roller blind or curtain slide). To uncover the plate when the holder is on the camera, this curtain or blind is drawn aside by means of a tag at the back of the holder. The curtain draw slide is used particularly with bigger formats where a rigid draw slide is rather bulky to handle. Sometimes only the end section of the draw slide is hinged, enabling the slide to be folded back on itself once it is pulled out most of the way.

By virtue of their construction, double plate holders with curtain shutters afford better protection of the plate against entrance of light while the holder is being carried or is in use, for both plates are completely enclosed by the two curtains. When one of the plates is uncovered, the curtain drawn back slides over the other, thus giving the plate not being exposed double protection.

Plate holders with curtain draw slides should not be left lying about with the curtains withdrawn. The free edge of the blind has then nothing to hold it in place and the very thin wood may get out of shape, thus preventing easy closing of the curtain. To ease the movement of the curtains in their grooves the best lubricant is paraffin wax; other lubricants (oil, soap or graphite) may lead to particles getting on the plates and causing light spots during exposure (pinholes).

Plate holders with rigid shutters (solid or hinged) use an elastic packing of thick velvet pressed against the draw slide to ensure light-tightness of the latter. After long use, wear of the velvet may reduce the efficiency of the light trap. It is therefore customary to protect the plate holders by carrying them under the focusing cloth and by keeping the cloth over the holder when drawing the slide and making the exposure. Thin wood or ebonite draw slides sometimes let through enough light to fog plates (especially with high-speed emulsions) if the holder is left exposed to full light for any length of time. Such draw slides are also almost transparent to infra-red rays and therefore useless with infra-red sensitized materials.

Double plate holders with rigid draw slides are of two patterns. One consists essentially of two single holders combined back to back, with each half being loaded separately. After drawing the corresponding draw slide, the plate is inserted and kept within the rebates by turn buttons. In book form holders the frame consists of two hinged parts. The plates are loaded without pulling out the draw slides A (Fig. 15.32); instead the holder opens along its hinge D and one plate is dropped into the rebate of the free opening. This partition of blackened metal C, carrying also pressure springs, is then turned down over the loaded plate, secured by turn buttons and the other plate dropped into its bed. After that the holder is closed and secured by a sliding bracket. A drawback of the book form holder is that the hinged construction carries with it some risk of light leakage, especially if it is made of wood and the latter has warped. That risk is greatly reduced with metal plate or film holders, though these are subject to distortion by mishandling unless very solidly constructed.

A special type of plate holder, widely used at one time by press photographers in Britain, permits loading in daylight by employing envelopes of stout opaque paper, each containing

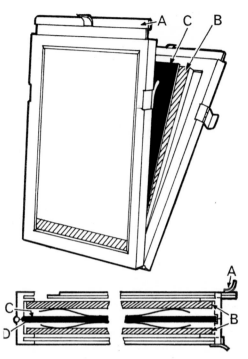

FIG. 15.32. BOOK FORM DOUBLE PLATE HOLDER

one plate (Mackenzie-Wishart envelopes). The envelope is opened on withdrawing the draw slide of the adapter, and closed when this is pushed back.

231. Reducing Adapters. It is often possible to use in a plate holder plates of smaller sizes than specified for the holder. For this purpose reducing adapters—thin wooden or metal frames with an opening for the smaller plate size and a rebate for retaining the plate—are inserted in the plate holder. The adapter with its smaller inserted plate is thus handled like a plate of the larger format. It is possible to have a set or kit of these carriers fitting in each other, each corresponding to a given plate size. One risk is however that the plate surface in such an adapter is not in exactly the same plane as a plate of the correct size loaded without an adapter. This may have to be allowed for in focusing on the ground glass screen.

A more reliable way is therefore the use of a back adapter to fit on the camera back and to take plate or film holders of the required smaller size. This system is employed also where roll film adapters (§ 240) are to be fitted to a technical camera.

Multi-exposure plate and sheet film holders also exist, where two exposures can be made on the two halves of the film or plate format. These may have two draw slides to uncover the two halves of the film surface separately, or a single slide with a masking aperture. Unlike multi-exposure cameras (§ 204) this arrangement only permits exposures in succession on the two halves of the film format, as the same camera lens (and shutter) is used for the two exposures.

232. Magazine Holders. A number of early cameras employed plate magazines which permitted plates to be placed in succession in the image plane inside the camera. Such systems still survive in certain specialized cameras—for instance for aerial photogrammetry—but are too bulky and impractical for use in technical or view cameras.

One magazine system used for sheet film employs a special holder which takes six sheets of film in individual sheaths. These are stacked behind each other and transferred after each exposure from the image plane into a magazine drawer. Film changing involves withdrawing the magazine drawer from the holder and pushing it back again.

233. Film Packs. The most widely used magazine system for sheet film was the film pack, a packing forming a changing box for 12 or 16 films. First issued in 1903 by the Rochester Optical Co., this consists of a number of films in a light-tight container which is loaded into a film pack adapter.

Each of the 12 films P (Fig. 15.33) is attached (on one of its short sides) by an adhesive strip A to a long band B of lacquered opaque paper ending in a tab L. The 12 films (only two are shown in Fig. 15.34) are placed in a pile in a thin sheet metal box with a fixed interior partition, which is extended as a kind of metal gutter, and with a rectangular cut-out within which the film is exposed. The tabs of the films are led round the gutter and project from the casing. They are covered with a band (of the same paper) which forms the safety cover of the pack. Between the fixed partition and the pack of films there is a plate of thin metal. It is held

FIG. 15.33. FILM AND TAB OF FILM PACK

FIG. 15.34. CONSTRUCTION OF FILM PACK

away from the partition by springs and presses the safety cover against the cut-out and the films against the safety cover. Strips of felt press the tabs together at the point where they emerge from the casing, and another strip of felt presses the curved portion of the paper bands against the convex surface of the gutter.

In use, the pack is placed in an adapter interchangeable with the film or plate holders of the camera. This having been done, the rear tab (the tab of the safety cover) is pulled so as to uncover the first film. The pull must be steady and gentle; a violent, sudden pull may tear the tabs before the films have been changed. After the first film has been exposed it is transferred to the rear compartment by pulling the tab marked No. 1 until there is felt a resistance, due to the extra thickness of the film and adhesive strip. The protruding length of the band of black paper is then torn off by pulling it sideways against the metal edge of the adapter. The changed film remains attached to a sheet of black paper bearing the number 1, thus allowing of the negatives being identified. The second film is thus in place ready for exposure. After it has been exposed it is changed by pulling tab No. 2, and so on. When the twelfth film has been changed the pressure plate is pressed against the cut-out and closes it. The pack can then be removed from the adapter in daylight and replaced by a fresh one. After removing the exposed films from the metal box the latter is thrown away. The frail construction of film packs renders them very liable to be bent by any abnormal pressure, and this may lead to difficulties in changing or to

the occurrence of streaks of fog, particularly along the edges.

In addition to the risk of light leakage, the flatness of the film in a film pack is not as good as of a sheet film in a sheet film holder. This is partly due to the thinner film base in film packs (usually 0·08 mm against 0·2 mm of sheet film) and the fact that carelessness in handling, including uneven pulling of the tabs, can distort the films lying ready for the next exposure. Currently very few film manufacturers produce film packs.

234. Polaroid Film Packs and Sheet Film Adapters. The film pack principle survives in the Polaroid film pack used in current instant-picture cameras using the Polaroid Land process (§ 215). The pack here contains both the negative sheets N and the positive sheets P in stacks in front of and behind the pressure plate A (Fig. 15.35). Each negative and positive combination is joined by a paper leader or tab T with a supplementary tab T'. The first positive sheet belonging to the first negative in the exposure position is in the back of the pack at P'. After the exposure, pulling the supplementary tab T' brings the main tab T between the spreading rollers R of the camera; pulling this tab runs the negative and positive sheets together through the rollers, spreading the developing chemicals between them (Fig. 15.36). Development takes place outside the camera; after the appropriate time (15 seconds to 2 minutes) the negative and positive are peeled apart. On withdrawing this sandwich from the camera, the next positive sheet moves into the back of the pack in the position P'

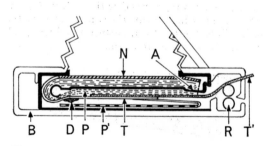

FIG. 15.35. POLAROID FILM PACK CONSTRUCTION

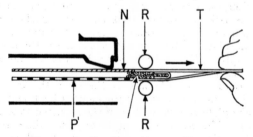

FIG. 15.36. DEVELOPMENT OF FILM IN POLAROID PACK CAMERA

in Fig. 15.35. A tab T and T' is thus sandwiched between each pair of positive sheets.

Before use the front opening of the pack is covered by an opaque sheet of paper; this is withdrawn (after loading the pack in the camera) by pulling an initial tab. Removal of the partly used pack from the camera ruins the top film in place at the time.

The camera back B containing the spreading rollers and slots, but without the rest of the camera, is also available in a special form to fit the back of technical and similar cameras. The distance between the position of the film plane in the back and the normal ground glass screen must be allowed for by an appropriately modified focusing screen attachment.

A special adapter also exists for single Polaroid sheet films. This is a camera back of standard film holder fitting for most 4×5 inch ($10 \cdot 0 \times 12 \cdot 7$ cm) cameras, and incorporates the rollers necessary for spreading the processing chemicals. The negative and positive sheets are loaded together in the holder, the positive sheet and a protective paper withdrawn for the exposure, pushed back into the holder and the negative-positive sandwich withdrawn together between the pressure rollers for processing.

235. Rapid and Repeating Backs. Rapid backs available for some studio cameras allow the focusing screen to be quickly replaced by a film or plate holder, the draw slide of which has already been drawn. Such a back is interchangeable with normal full-size film holders for the camera. It consists of a board with slide bars accommodating a pair of connected frames which can be pushed along the bars between two stops, thus positioning either frame in the image plane of the camera back. One of the frames carries a focusing screen and the other takes normal film holders, the frames being so constructed that the surfaces of the film and of the ground glass screen come to lie in exactly the same plane when centred behind the camera back. Velvet light traps in the sliding frame carrying the film holder prevent light from reaching the film after it has been uncovered. The centre of the board carries an aperture of the dimensions of the film, and sometimes a detachable mask for alternative smaller sizes. This is the aperture behind which the ground glass screen or film holder are located for viewing or for exposure respectively.

The working procedure with this rapid back consists of moving the frames to position the ground glass screen for viewing, and placing a loaded film holder into the second frame. The draw slide of this holder is withdrawn ready for action. Once the photographer has focused and arranged the image on the screen, he closes the camera shutter, slides the moving frames to bring the film into the taking position and makes the exposure. Notches placed at the proper points of the slide bars automatically engage with a spring bolt on the sliding frame unit to ensure accurate location in both positions (viewing and taking) of the frames.

In place of a single film or plate holder a roll film adapter (§ 240) can be used. This permits reasonably quick exposure sequences, while still retaining the facility of viewing the subject on the ground glass screen between exposures and retaining also the versatility of the technical camera movement.

Advanced rapid backs of this kind may have the sliding movement operated by a Bowden type cable and linked with the camera shutter so that the change-over operations (including closing the shutter before, and opening it for, the exposure) take place automatically within less than a second.

Another type of repeating back uses a frame with a plate holder taking a single oblong shaped plate (e.g. 6×13 cm), successive portions of which are brought into position behind an aperture in the supporting panel of the back. Several exposures can then be made side by side on the same plate (e.g. three exposures 4×6 cm) in rapid succession. This type of repeating back has been used for police and

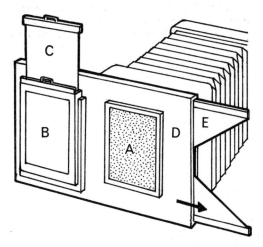

FIG. 15.37. RAPID BACK FOR QUICK CHANGEOVER FROM FOCUSING TO EXPOSURE

identity photography. In the early days of colour photography repeating backs of similar type but with three separate plate holders were used to obtain three-colour separation negatives of a subject in rapid succession—for instance before a sitter in front of the camera in the studio was likely to move appreciably.

236. Ground Glass Screens. The screen of a technical or view camera is usually plain ground glass. As it is important to be able to see the screen area for composing the image on it, full focusing magnifiers are used as accessories only to check maximum sharpness of selected image spots.

On technical cameras the ground glass screen usually carries a grid of parallel horizontal and vertical ruled lines. These help in accurately lining up an image, especially to check that the camera back is truly vertical in architectural and similar photography, where vertical subject lines have to be parallel in the image. A square grid is also an aid to squaring up the camera correctly in copying. The screen may also carry ruled rectangles to show reduced image sizes obtainable with reducing adapters (§ 231).

The corners of the screen are often cut off to permit air movement into and out of the camera as the bellows extension is varied; these corner openings also permit a check on the vignetting of the lens by looking directly towards the lens and observing the shape of the lens aperture (see also § 86).

Attachable to the rear of the camera is a focusing cloth. This black opaque cloth screens off extraneous light while the operator inspects the image on the screen. On some cameras the cloth is supported by a light metal frame fixed to the back of the camera, forming a kind of

hood which keeps the cloth clear of the operator's head. This arrangement is more comfortable, especially in hot weather, as well as being more hygienic. While the focusing cloth used to be the traditional trade mark of the professional photographer, it is often replaced nowadays by a folding or a bellows hood. Such attachments may incorporate a mirror when the camera is used at a low level, so that the photographer can look downwards on to the screen and at the same time see the image upright (though reversed), as with a reflex camera (§ 206). The main difference is in this case that the mirror reflects the light rays between the screen and the operator rather than between the lens and the screen. This mirror therefore need not move out of the way for the exposure, especially if the film or plate holder is inserted underneath a sprung focusing screen.

237. Technical Press Camera. Derived from the hand-stand camera, i.e. a scaled down baseboard type technical camera (§ 200), this camera type is not only easily portable but also quicker to set up than the monorail type view camera. The back has the shape of a shallow square or rectangular box A (Fig. 15.38) whose base is the image plane and which has hinged to one side the baseboard B which closes down over the box like a lid. This baseboard carries a runner track C on which the lens standard D can travel forward or back. When the standard is pushed fully against the back, all parts of the camera are contained within the rear box A, so that swinging up the baseboard completely closes the camera (Fig. 15.38, right).

Opening the camera ready for use only involves opening the baseboard and pulling the lens standard forward on its runners—usually to a

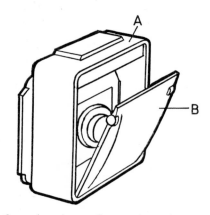

Fig. 15.38. Technical Press Camera Open (left) and Closed (right)

point of engagement for the infinity focusing position with the lens used. The camera can then be used either like a view camera, mounted on a tripod or stand, the image being observed on the ground glass screen at the rear; or for hand-held shooting of static or moving subjects, using a viewfinder for viewing (§ 285) and a rangefinder for focusing (§ 294). The rangefinder is coupled with the focusing movement, i.e. a sliding section of the baseboard, both being controlled by a knob with a rack-and-pinion drive. On many press cameras the coupling takes place via a multiple cam which permits the use of two or three interchangeable lenses. An alternative form of press camera uses a scissor extension movement instead of a baseboard (similar to Fig. 14.13, § 208).

The most usual film or plate sizes for technical press cameras are 9 × 12 cm and 4 × 5 inches (10 × 12·7 cm) some may go down to 6·5 × 9 cm (2½ × 3½ inches) or up to 13 × 18 cm (5·0 × 7 inches).

238. Technical Press Movements. The medium size technical camera has many of the movements of the regular technical or view camera, though often not the same movement range, and can be used for many of the commercial photographic purposes of the view camera. Movements of the lens standard include swings and tilts about vertical and horizontal axes as well as vertical and horizontal parallel displacement.

The back may provide a fixed degree of rearward tilt by swinging the baseboard beyond its normal position at 90° to the back. The main purpose of this so-called drop baseboard is however to keep clear the field of view of wide-angle lenses with which the lens standard must be moved almost fully back to the rear end of the baseboard. In position *A* (Fig. 15.39) the baseboard then obtrudes into the angle of view unless it is swung down to position *A'*.

The baseboard may permit double or even triple bellows extension by supplementary beds sliding inside each other, similar to Fig. 15.6 (§ 218) as used in older view camera designs.

Up to about 10 to 15° of a fully adjustable back swing in all directions is possible with an extension back used on some cameras of this type. Sliding rods *A* (Fig. 15.40) at the four corners of the main box frame *B* of the camera permit the rear panel *C* (which carries the ground glass screen and takes the film or plate holder) to swing away from the camera body at any corner or edge. The rods are fixed to the rear panel in ball joints *D*; a bellows *E* provides

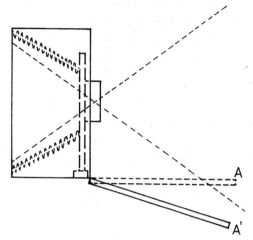

FIG. 15.39. DROP FRONT MOVEMENT TO CLEAR VIEW OF WIDE-ANGLE LENS

a light-tight connection between the rear panel and the camera body during the use of this swing movement.

239. Rigid and Modular Press Camera. Where rapid shooting ability is important but focusing adjustment beyond a normal range from infinity down to 1 to 1·5 metres (3 to 5 feet) and camera movements are not, there is little advantage in having bellows. Some press cameras are therefore constructed as a rigid box to take lenses—often complete with shutters—on tubes of different depths, according to the focal length involved. The lenses fit into a helical mount on the camera for focusing while rangefinder and shutter controls link up automatically with the

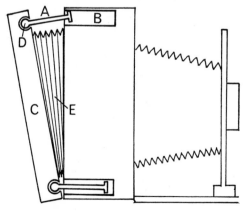

FIG. 15.40. REAR SWINGS WITH EXTENDING BACK

appropriate control elements on the camera. Such cameras can take either sheet films in holders or roll films in roll film adapters and magazines for perforated 70 mm film (§ 197). The rigid camera construction is essential also for applications like aerial photography out of the open cockpit of light aircraft, where wind pressure is liable to distort and damage bellows.

Rigid medium-format professional cameras also exist as roll film models without the alternative of using sheet films, but fitted with some of the refinements of advanced miniature cameras, such as rapid film transport, coupled rangefinder, built-in exposure meter, etc. The more versatile versions are developed as fully modular hand cameras on the lines of Fig. 14.15 (§ 211).

Their bulk tends to make medium size press cameras—which are primarily intended for hand-held shooting—awkward to hold comfortably. Anatomically shaped hand grips are therefore usually available and may be attachable or permanently fitted to the camera body (Fig. 15.41). The grip may incorporate a cable release to screw into the camera shutter or may take accessories such as flash guns. Two grips may be fitted where a two-handed hold is essential for maximum steadiness (e.g. in hand-held aerial photography).

240. Roll Film Adapters. Roll film may be used in a suitable roll holder with any camera designed for sheet film or plates. As such adapters are normally made only for commonly available roll films (i.e. the No. 120 size—§ 196)

and 70 mm perforated film, the maximum picture size is nominally 6×9 or $5\cdot7 \times 7\cdot2$ cm ($2\frac{1}{4} \times 3\frac{1}{4}$ or $2\frac{1}{4} \times 2\frac{7}{8}$ inches). Hence such adapters are typically used on the smaller hand-stand and press cameras rather than on large format technical cameras—except when a longer exposure sequence is needed.

A typical roll film adapter consists of a housing B with swing open back A (Fig. 15.42) mounted on a panel C of the appropriate dimensions and with fittings for attachment to the camera back in place of the ground glass screen or sheet film holder. This panel also incorporates a draw slide D. The film spools are loaded on to an insert E which in turn fits inside the housing B. The film runs round the insert and is held flat in the image plane by a pressure plate. When the insert is loaded into the roll holder, it couples up with a film transport knob or other provision for advancing the film from frame to frame. The transport may be controlled visually or automatically through a counting device (§ 300).

If several magazines are available, switching over between different film types (e.g. black-and-white and colour) and rapid film changing from a magazine with a fully exposed film to one with fresh film becomes possible. It is also feasible to have films preloaded on the inserts with the beginning of the backing paper ready threaded; on placing an insert inside the roll film adapter housing it is then only necessary to advance the film to the first exposure. Certain cameras use such an insert system for rapid

FIG. 15.41. PRESS CAMERA WITH ANATOMICAL HAND GRIP

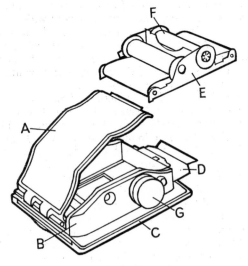

FIG. 15.42. ROLL FILM ADAPTER

film changing even without an interchangeable roll magazine.

Some roll film adapters cater for different picture sizes with the same camera—e.g. 6 × 9 and 6 × 6 cm. Such adapters differ only in the size of the picture opening in the supporting panel (C in Fig. 15.42) and in the gearing of the film counting mechanism. Similar roll adapters exist for perforated 70 mm film in cartridges, providing up to around 50 exposures 6 × 9 cm (or 70 exposures 6 × 6 cm) at one loading.

Roll film adapters of this type are generally usable with all cameras taking standard sheet film holders. Special types designed for specific cameras may incorporate refinements such as couplings with a film transport system in the camera (e.g. the magazines of roll film reflex cameras—§ 242) or may incorporate a rapid transport mechanism in the magazine itself. This may be a crank or a push-pull bar as used in certain press cameras.

241. Panorama Cameras. Professional cameras enabling large groups of people or extended views to be taken may scan the view while recording it on a long strip of film or record the whole view simultaneously with a special optical system. Scanning cameras use either a swivelling lens with a stationary film or a rotating camera with a moving film.

The swivelling lens arrangement is shown in Fig. 15.43. The lens L, pivoted about its rear nodal point N sweeps the subject space from A to B, recording the image in the curved film plane between A' and B'. A slit C at right angles to the length of the film $A'B'$ restricts the image at any point to a narrow section of the lens angle. If the swivelling point is correctly located in the rear nodal point, the image on the film is sharp, undistorted and continuous, though recorded in succession strip by strip.

The scanning sweep may take several seconds (according to the size of the camera) which is the taking time for the exposure, though the effective exposure time is that which the slit takes to sweep its own width and may only be a fraction of a second. (It is thus possible, when taking for instance a group, for a person at one end of the view to run behind the group and take up a position at the other end before the sweep is completed, and so appear twice in the same picture.) The optical conditions for ensuring a sharp and continuous image are those of the Moëssard tourniquet (§ 98).

Panoramic cameras of this type have been made for roll film as well as for perforated 35 mm miniature film. The angle of coverage (the angle ANB in Fig. 15.43) is usually about 140°. As only the central section of the lens's angle of view is utilized, the image is free from wide-angle distortion, which is also neutralized by the displacement of viewpoint and the use of a curved image plane (see Fig. 5.7 in § 34). This same movement however causes panoramic perspective in the image (§ 39), in other words all horizontal straight lines in the subject appear curved towards the horizon line in the image. (The horizon line in the subject is curved, being the circumference of a horizontal circle with the point N as its centre; curves in the subject

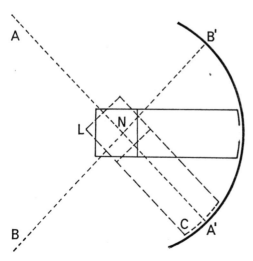

FIG. 15.43. SWIVELLING-LENS PANORAMIC
CAMERA

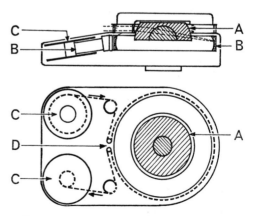

FIG. 15.44. PANORAMIC HORIZON CAMERA

running parallel with this horizon line will appear straight in the picture.)

In panoramic cameras using a moving film the whole camera turns on a vertical axis through the rear nodal point of the lens while a roll of film passes steadily across the focal plane. A slot is again used to restrict the image to one vertical strip across the width of the film. The movement of the latter must be accurately synchronized with the movement of the image across the focal plane as the camera rotates; this image motion compensation is similar in principle to that used in aerial cameras and microfilm cameras (§ 213). Cameras of this type have been made for roll film and can cover a full 360° (or even more) sweep right round the camera position.

Horizon cameras which cover a field of nearly 360° with a single exposure use a hemispherical lens A (Fig. 15.44) which projects an image on to a strip of film B wound around the inside of a drum just below the lens. The film runs between two spools C and the only point of the view not covered is the area D where the film enters and leaves the drum. Such a camera needs a special shutter which simultaneously uncovers the whole periphery of the hemispherical lens. The image recorded is subject to the same laws of perspective as that produced with a swivelling or rotating panoramic camera.

CHAPTER XVI

THE MODERN SINGLE-LENS REFLEX

242. Roll film and miniature single-lens reflexes—roll film reflex layout—magazine systems—35 mm reflex. 243. Mirror movements—space problems with swing-up mirror—alternative movement systems—folding mirrors—pellicle reflex. 244. Mirror damping—risks and causes of camera vibration. 245. Image orientation on reflection—geometry of image reversal—mirrors in reflex viewing systems. 246. Pentaprism systems—upright and laterally correct final image—45° viewing—unusual reflex layouts. 247. Reflex screen accuracy—finder masking. 248. Screen illumination—light scatter on the ground glass screen—field lenses and Fresnel lenses—screen illumination with wide-angle lenses. 249. Screen types and focusing aids—screen magnifiers—split-image biprism wedge—prism angle and aperture limitation—microprism screens. 250. Interchangeable reflex viewing systems—eye-level pentaprism and waist-level hoods. 251. Reflex automation—intercoupling of lens aperture, mirror and shutter—instant-return mirrors.

242. Roll Film and Miniature Single-lens Reflexes. From the 1950s onwards, the single-lens reflex camera (§ 206) became—as the roll film and miniature reflex—one of the most popular camera types for amateur and professional photography, and evolved to advanced designs with numerous refinements.

Roll film reflexes usually take 6 × 6 cm (strictly 5·7 × 5·7 cm or 2¼ × 2¼ inch) square pictures; the slightly oblong 5·5 × 6·9 cm format (10 exposures per No. 120 roll) also has a limited following. The argument for the square negative shape was that it could be trimmed down to either a horizontal or an upright format during print making. It had the drawback of wasting some film area (the untrimmed full square format is comparatively rarely utilized). The normal focal length of the lens employed with such cameras (§ 134) is "normal" relative to an oblong trimmed down picture shape rather than the full 5·7 × 5·7 cm square. A 5·5 × 6·9 cm image can however be enlarged to standard paper formats with practically no trimming and the normal focal length for this format is about one-third longer than that for the 6 × 6 cm format. Hence the larger negative—according to this argument—needs less enlargement to a given print size, leading to some gain in image definition and quality. In practice the convenience of the square frame still holds the balance, at any rate with roll film reflexes.

In its layout the roll film reflex is basically a square box which houses the mirror system and screen, nearly always without bellows. The

focusing adjustment is built into the lens mount. (Extension bellows are often available for close-up work—see § 311.) There are three basic ways of accommodating the roll film spools and the transport system.

(*a*) The spools may be held in chambers attached to each side of the reflex box. This is the traditional layout followed by the first roll film reflexes (Fig. 16.1). The film runs between spools *A* and *B* in chambers housed inside the projections *C* and *C'* at the side of the camera. These projections also provide a convenient grip on the camera body.

(*b*) The film may run vertically between spools housed in chambers *D* and *E* within the box structure (Fig. 16.2). This makes the camera more compact, though the basic box is usually

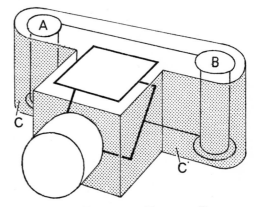

FIG. 16.1. HORIZONTAL ROLLFILM REFLEX
LAYOUT

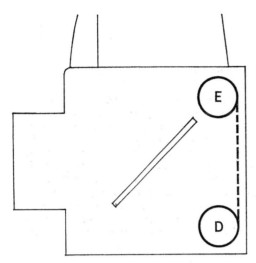

FIG. 16.2. VERTICAL ROLLFILM REFLEX
LAYOUT

slightly higher than is required for the mirror housing alone.

(c) The film is in a separate magazine attachable to the rear of the main camera body (Fig. 16.3), as with roll film adapters for view and press cameras (§ 240). On the roll film reflex it permits rapid film changing not only at the end of a roll—the photographer simply replaces the fully exposed magazine by a fresh one—but also in the middle of a film, for instance when switching from black-and-white to colour film or vice versa. Alternative magazines may take different picture formats (for example 12 exposures 5·7 × 5·7 cm, 16 exposures 4·5 × 5·7 cm and so on) or perforated 70 mm film. To make such changing possible, the magazine usually has a light-tight slide which is inserted to close the film aperture before removing the magazine from the camera. Often elaborate interlocks prevent removal of the magazine from the camera unless this slide is inserted.

The 35 mm miniature reflex was a scaled down development of the roll film reflex of type (a) layout. The image format, as in non-reflex 35 mm cameras (§ 209) is usually the full 24 × 36 mm size with the film running horizontally; the limitation of turning the camera round for upright views is generally overcome by an eye-level pentaprism viewing system (§ 246).

243. Mirror Movements. The movable mirror between the lens and the film in a reflex camera takes up a certain amount of space and requires the lens to have a corresponding minimum back focus—i.e. separation between the rear element of the lens and the film plane. Lenses whose effective focal length is to be shorter than this minimum separation must be inverted telephoto or retrofocus systems (§ 156). While the space required for the reflex system cannot be eliminated, it is possible to reduce it by certain modifications of the mirror movement.

Most wasteful of space is the straight-forward swinging mirror pivoted at its two rear corners like a simple door. In Fig. 16.4 the lower edge A of the mirror M travels through the path shown by the broken line to A' as the mirror swings up to M'. While the lens could be in the dotted position L' for viewing via the mirror or for the exposure, it must in fact be positioned at L to clear the mirror path AA'.

The mirror is made as small as possible without cutting off any of the picture projected on to the screen in the camera top. This is comparatively easy with a reflex camera having a fixed lens. With interchangeable lenses a mirror

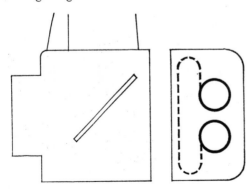

FIG. 16.3. ROLLFILM REFLEX WITH FILM
MAGAZINES

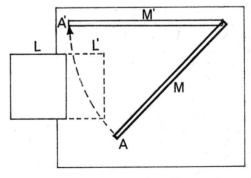

FIG. 16.4. REAR-HINGED FORWARD
SWINGING MIRROR

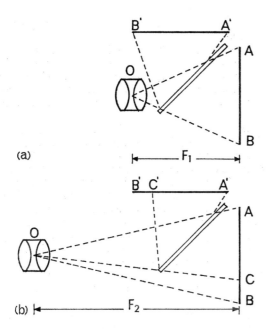

(a)

(b)

FIG. 16.5. MIRROR SIZE AND ILLUMINATED
SCREEN AREA

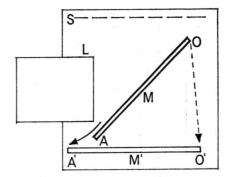

FIG. 16.7. BOTTOM HINGED SWINGING AND
SLIDING MIRROR

just big enough for a short focal length may be inadequate with a lens of longer focal length. Thus the mirror in Fig. 16.5oa is just large enough to cover the whole light cone from a lens of focal length F_1, so that the screen $A'B'$ shows the full view corresponding to the image AB. With a lens of focal length F_2 in Fig. 16.5b the same mirror is too small to cover the whole light cone AOB and in fact only takes in AOC. So the screen only shows part of the image $A'C'$, corresponding to AC, while the portion $C'B'$ remains dark.

Various alternative mirror systems have been proposed and used to reduce the space required between the lens and the film plane. Thus in Fig. 16.6 the mirror M moves up and backwards to the position M', so that its lower edge A moves straight up to A', requiring less movement clearance at the front. In Fig. 16.7 the same movement is turned upside down, so that the mirror slides down into the position M' while the rear edge O moves downwards to O'. A special shuttering arrangement S is necessary to cover the underside of the screen, preventing entry of light to the film. A similar protective shutter is also needed in the folding mirror type (Fig. 16.8) where the mirror is pivoted at A and folds into half about the axis O. To move out of the light path, O swings down to O' while B folds over towards A.

A way of drastically reducing the space required for the mirror movement is to make the mirror itself so small that it only covers a central portion of the image, and to move it vertically out of the way (from M to M' in Fig. 16.9).

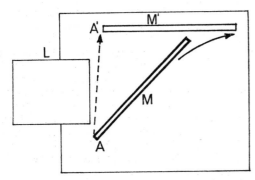

FIG. 16.6. REAR HINGED SWINGING AND
SLIDING MIRROR

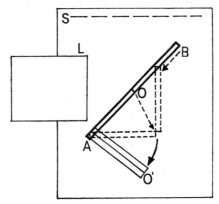

FIG. 16.8. FOLDING MIRROR

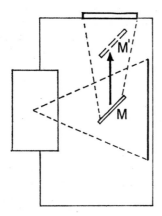

FIG. 16.9. PERISCOPE REFLEX SYSTEM

The camera itself can then be as compact as a normal 35 mm rangefinder model (§ 204) and needs a separate viewfinder system since the mirror only serves for focusing on the central area of the image. Strictly speaking this is no longer a reflex camera. Vertical-lift mirror systems to cover the full screen area have however been used in reflex attachments (§ 312).

A reflex system which eliminates the problems of mirror movement (though not of course the space required for it) is the use of a fixed semi-reflecting pellicle *P* in place of a movable mirror (Fig. 16.10). This pellicle is a thin film of transparent plastic stretched over a rigid frame and carries a vapour deposited metal layer. The latter reflects about 20 to 30 per cent of the light up to the focusing screen *G*, letting 70–80 per cent pass through to the film *F*. A camera with this arrangement must have a focal plane shutter *S* in front of the film though this could be an auxiliary capping shutter if a

lens shutter is used for the main exposure control.

Pellicles have been used as beam splitters in one-shot colour cameras (§ 55) since the early 1900s, and are the most elegant way of solving the vibration problem (§ 244) of single-lens reflex cameras at the expense of slight loss of working speed.

244. Mirror Damping. In early reflex cameras the mirror was raised by hand. On modern reflexes the mirror is usually spring driven; as it flies up out of the light path a fraction of a second before the actual exposure, its angular movement momentum may be transmitted to the camera, yielding an unsharp picture through camera shake. This vibration is not easy to suppress by mounting the camera on an ordinary tripod; it is more readily absorbed when the camera is held in the hand.

There are two moments where vibrations can interfere with the exposure: At the start of the mirror movement, and when the mirror reaches its final position (e.g. *M'* in Fig. 16.4).

The initial angular momentum, as the mirror is tripped and starts moving up from its rest position, can be minimized by balancing the rotating masses. With careful design, the residual angular momentum of the camera about a horizontal axis at right angles to the lens axis may be negligible.

The most obvious vibration source is the second stage when the mirror slams into its raised position. Miniature and roll film reflex cameras incorporate damping systems to brake the mirror towards the end of its travel. Appropriate design of the moving masses helps to minimize residual vibration. Mirror movements of the types shown in Figs. 16.6, 16.7 and 16.8 are often easier to damp than a straight upswing of Fig. 16.4. Not all camera manufacturers, however, pay sufficient attention to this problem and the damping on less expensive miniature reflexes often consists of little more than a strip of foam plastic or sponge rubber to cushion the impact of the moving mirror. For shots where camera vibration is particularly harmful (exposures with slow shutter speeds, macro-photography, etc.) some reflex cameras permit manual pre-releasing of the mirror so that the exposure can be made when all vibrations have died down. (Cameras with this feature often have fairly elaborate damping arrangements for the mirror as well.)

Two further points must be noted. First, the roller blind travel of a focal plane shutter

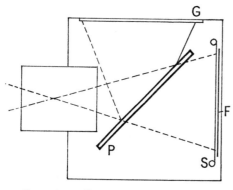

FIG. 16.10. PELLICLE REFLEX SYSTEM

can also cause vibration. Second, the noticeable "kick" of modern single-lens reflexes with instant-return mirror (§ 251) due to the return movement of the mirror, takes place after, and therefore does not affect, the exposure.

245. Image Orientation on Reflection. To overcome the inconvenience of a waist-level view of the laterally reversed image on the reflex screen, the viewing direction and the image orientation can be re-directed to provide a correct eye-level view. The first—and simplest—method is to fit a second mirror M_2 (Fig. 16.11) above the screen. Observation of the image C via the mirror M_2 yields a more or less direct or eye-level view, but the picture is once more inverted as in D. More elaborate reflecting systems reverse the image laterally while keeping it upright.

At this point it is as well to clarify the terminology of image reversal. In Fig. 16.11 the lens L projects on the film an image B of the object A; this image is inverted, but laterally correct. This becomes clear if we consider the appearance of the object and image from the observer's viewpoint E. The object as seen by the observer appears as A' (the orientation A is that of the perspective representation in Fig. 16.11). B appears to the observer as B'; this is inverted, but laterally correct in the sense that it is not a mirror image of A'. On turning B' through 180° in its own plane, the orientation becomes identical with A'. It is

therefore misleading to describe B' as laterally reversed; an inverted and laterally reversed image would appear as F. Lateral reversal—whether in the vertical or horizontal direction—therefore implies that one of the image directions is turned round through 180°, but not the other direction—as is the case with F relative to A'. The image C formed on the screen appears to an observer looking straight down on it as in C' which is again a mirror image of A' and is laterally reversed, though upright. The mirror M_2 inverts the vertical orientation of the image C to form D, but not the lateral orientation. D' as seen by the observer is therefore again a mirror image of C': this double reversal once more makes D' laterally correct with respect to A', though the whole image is inverted; D' in fact is identical with B' in its orientation.

To resolve this apparent confusion it is only necessary to remember that reversal of the image (whether laterally or vertically) involves a mirror effect: one of the directions of orientation is changed but not the other. An image seen in a mirror is always reversed. Inversal on the other hand changes the orientation of two directions at right angles to each other (e.g. vertical *and* horizontal). Hence an inverted image is right reading (laterally correct) when viewed upright. A real image produced by a simple converging lens (or equivalent lens group) appears inverted to an observer (e.g. at E in Fig. 16.11) looking in the direction towards

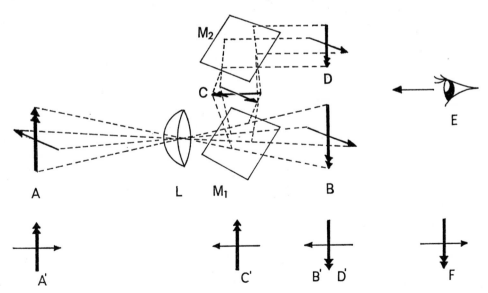

FIG. 16.11. IMAGE REVERSAL AND INVERSAL

the lens and the object. (Additional lens or prism systems can reinvert the image to produce an upright and laterally correct picture.)

From this follows a simple rule for the re-orientation of images by reflecting surfaces. An odd number of reflecting surfaces always yields a laterally reversed image (which may or may not be upright); an even number of surfaces forms a laterally correct image. Further, the orientation of the image (upright or inverted) will depend—even when the image is laterally correct—on the disposition of these reflecting surfaces. When such a surface is used to transmit the image into a new plane, the reflecting surface is tilted relative to the plane of the first image (for instance $AA'BB'$ in Fig. 16.12) and to the plane of the new image $A''A'''CC'$. Any image direction parallel with the axis of tilt remains unreversed and any image direction at an angle to the axis about which the planes are tilted becomes reversed. Thus in Fig. 16.12 the reflecting surface S is tilted about the axis OO'. The image directions AA' and $A''A'''$ are parallel with this axis and are therefore unaffected. The image direction $B'B$ is at right angles to OO' so that CC' is reversed laterally with respect to BB'. This applies in all cases to the view as seen looking towards the object and the reflecting surface from the viewpoint E.

To achieve a final image which is upright but

FIG. 16.12. REVERSING EFFECT OF MIRROR DIRECTIONS

laterally reversed with respect to the screen image (which itself is already laterally reversed due to the mirror M_1 in Fig. 16.11) any reflecting system must therefore have an even number of surfaces tilted about an axis parallel to BB' and an odd number of surfaces tilted about an axis parallel to AA' in Fig. 16.12.

246. Pentaprism Systems. When two reflecting surfaces, such as $ABCD$ and $EFGH$ in Fig. 16.13, are inclined to each other along two parallel axes, they produce a double lateral reversal of the original image. Thus when viewed from J, the image $KK'LL'$ appears as shown at Q, the resulting reflection $MM'NN'$ would be the same way round as when seen from the viewpoint I. As the axes of the two mirrors, and hence the directions AB and EF are also at an angle to KK' the mirrors in addition invert the image as shown at O. (O is identical in appearance with Q because the observer at J faces forward—as shown by the small arrow j, while at I he faces in the opposite direction.) The image O, corresponding to $MM'NN'$ is, however, still the laterally reversed picture of the ground glass screen $KK'LL'$. It is, however, now in a position where it could be viewed from the other direction—i.e. from the point I' and then appear upright and laterally correct as in P. This is achieved by simply placing another reflecting surface in a plane parallel to $MM'NN'$. As seen from I' there are now three reflecting surfaces between the eye and the image $KK'LL'$; hence the view P is reversed left to right with respect to $KK'LL'$. There are two reflecting directions with respect to the vertical orientation of the image ($ABCD$ and $EFGH$ are together responsible for one vertical inversal) so the image P still appears upright.

This arrangement is the basis of the eye-level pentaprism finder system of modern single-lens reflexes. The surfaces $ABCD$ and $EFGH$ as well as a reflecting surface in the plane of $MM'NN'$ of Fig. 16.13, are all faces of a so-called roof prism (from the orientation of the two upper surfaces), also called a pentaprism because of the pentagonal cross-section of the prism A in Fig. 16.14a.

(The top view Fig. 16.14b shows the disposition of the roof surfaces d and e in relation to the front surface c. The reflecting surfaces d, e and g are silvered.) The focusing surface B is often the underside of a condensing lens C to provide more even image illumination (§ 248).

Integral with the eye-level pentaprism finder

FIG. 16.13. REFLECTION WITH ROOF MIRROR ARRANGEMENT

is an eyepiece lens or lens assembly D. This provides a view of the whole screen area. Fig. 16.15 shows the complete sequence of image formation from the object A through the lens B, the mirror C, the film D, reflex screen

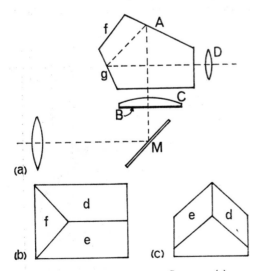

FIG. 16.14. PENTAPRISM IN SECTION (a), TOP VIEW (b) AND REAR VIEW (c) OF ROOF PRISM

E, pentraprism F and eyepiece G. The orientation of the object is shown by a_1b_1. The successive points of reflection of the image forming rays are designated by a_2b_2 up to a_7b_7.

The reflecting surfaces of this arrangement can also be surface silvered mirrors and these are used in the so-called Porro finders, as attachments to fit on top of a focusing screen of a reflex camera. The Porro attachment is usually lighter and cheaper than a pentaprism unit—especially with larger picture formats. A pentaprism is however easier to make precisely and is not subject to mechanical mounting variations, etc., which can affect the mirrors of a Porro unit.

The pentaprism is not the only eye-level prism system for viewing reflex screen images. Fig. 16.16 shows an alternative arrangement of a plain and a roof prism with five reflecting surfaces (the reflections at right angles to the plane of the illustration are not shown). This arrangement brings the eyepiece as far backward as possible, and was designed for a single-lens reflex camera with built-on film magazine behind the main reflex body (§ 242 and Fig. 16.3).

As a compromise between eye-level viewing in the direction of the subject and waist-level

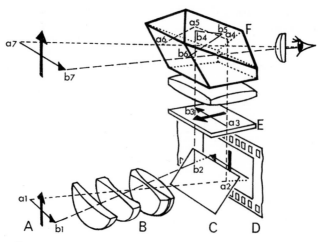

FIG. 16.15. COMPLETE PENTAPRISM AND REFLEX SYSTEM

viewing down on to a screen, some photographers prefer to look at the screen image at a 45° angle. This is often more convenient for viewing when for instance the camera is mounted on a

FIG. 16.16. MULTIPLE PRISM EYE-LEVEL VIEWING UNIT

stand. One form of such a 45° viewing unit, shown in Fig. 16.17, uses a roof prism A (not a pentaprism), combined with a simple inverting prism B. Like the conventional pentaprism, this has three reflecting surfaces (one direction

of reflection is at right angles to the plane of Fig. 16.17); the use of the second prism B in place of the inclined front surface g of Fig. 16.14a redirects the light upwards at 45°. The gable angle of the roof prism therefore slopes down towards the front of the camera instead of up. The image as seen in the eye-piece is again upright and right-reading.

Fig. 16.18 shows one of a number of less orthodox reflex arrangements proposed. This has a downward swinging mirror M which is semi-reflecting. The screen is at the bottom of the camera and the image is located in the plane

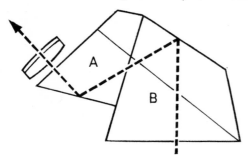

FIG. 16.17. 45° PRISM EYE-LEVEL VIEWING UNIT

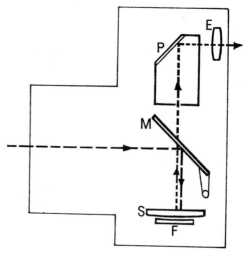

FIG. 16.18. REFLEX CAMERA WITH VIEWING IMAGE PLANE IN THE BASE

of a spherical mirror surface S. From there it is reflected up through the simple roof prism P whose two reflecting surfaces provide an additional reversing reflection at right angles to the plane of the diagram. The image is reduced in size, and the prism P can be much smaller than the usual pentaprism in a conventional single-lens reflex camera. This makes the whole camera more compact, but precludes focusing on the screen. Instead the latter uses a small supplementary mirror F almost in contact with and at a slight angle to the rear reflecting surface S, which, at this point is transparent. When the image is not correctly focused, a displaced picture is seen in this area, somewhat analogous to the displaced image in a focusing wedge set in the screen (§ 249).

Semi-reflecting main mirrors with a supplementary mirror to direct part of the light downwards have been used in through-the-lens exposure measuring systems. These will be discussed more fully in the section dealing with exposure metering.

Proposals exist in the patent literature for reflex cameras which turn the whole mirror, screen and pentaprism arrangement upside down. Here the screen is also in the camera base and the mirror swings forward about an axis near its bottom rear end, similar to the arrangement of Fig. 16.18. A pentaprism is then arranged underneath the screen and built into a hand grip for the camera (Fig. 16.19). The advantage claimed is that the bulk and weight of the pentaprism disappears from the

camera top, while a hand grip may be regarded as an aid to a firmer camera hold, especially if the photographer can rest the camera back against his forehead. This scheme has not so far appeared in a marketed camera model.

247. Reflex Screen Accuracy. The screen of a reflex camera is often claimed to show "exactly" the field of view recorded on the film.

This is true in the sense that the reflex screen shows faithfully the changes in the angle of view with interchangeable lenses and also at different distances down to the closest macro range; it is not subject either to parallax (§ 287) or to image angle errors (§ 285). Usually however the screen shows less than the image area recorded on the film. With a 35 mm reflex camera the difference should ideally correspond to the masked area of a colour transparency mounted in a standard slide frame—i.e. a 23 × 34 mm format or just over 90 per cent of the film image area. A corresponding reduction would apply to the nominal 6 × 6 cm roll film format. Since colour transparencies on reversal colour films are not easily cropped, this arrangement permits the photographer—at any rate in theory—to frame his subject precisely to the dimensions of the image when the colour slide is projected on a screen. In addition the screen frame should be accurately centered and parallel to the film image frame. On some less expensive single-lens reflexes the screen area may be as much as 20 or 30 per cent smaller than the film frame, to cover up centring and alignment errors. When negative materials are used, this is not of great importance since the excess area recorded on the film is easily cropped during enlargement. In practice an image loss larger than the ideal 10 per cent is still frequently acceptable, since few photographers frame their subjects absolutely precisely on the reflex screen. Gross inaccuracies are however a nuisance.

248. Screen Illumination. The image becomes observable on the ground glass screen because the latter scatters light. The light reaching the observer is greatest in a direction in line with the lens O in front of the screen G (Fig. 16.20), i.e. the direction a. The screen also scatters light in directions b and c, but the light intensity there drastically decreases, as shown by the relative length of the arrows a, b and c. The eye at E_1 therefore sees a much brighter image at A (the centre of the screen) than at B near the edge, since from the latter position it only receives the light scattered over a greater angle c' and correspondingly reduced in intensity.

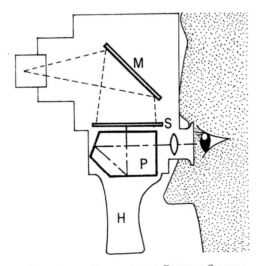

FIG. 16.19. UPSIDE-DOWN REFLEX CAMERA

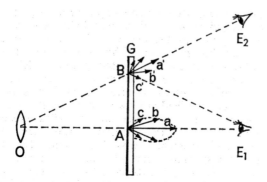

FIG. 16.20. LIGHT INTENSITY DISTRIBUTION ON
GROUND GLASS SCREEN

zones of the lens are displaced towards the flat face (i.e. ground glass plane) while still retaining the surface curvature of the original lens. This

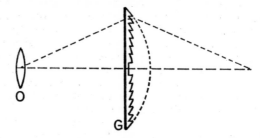

FIG. 16.22. THE FRESNEL LENS

Hence the ground glass screen image becomes darker towards the edges and corners. To see a brighter image at B, the eye would have to be in a position E_2—which is feasible when observing the rear screen of a technical camera but not with a modern reflex camera where the position of the eye is fixed by the eyepiece of the viewing system.

(The exact shape of the so-called polar curve of light scattering—the dotted line joining the arrow tips of a, b and c—depends on the coarseness and other factors of the ground glass screen. It is however the same for different regions of the screen.)

The most obvious way of overcoming this corner darkening is to make the focusing screen the matted flat side of a plano-convex lens. The latter then acts as a field lens, deflecting the main ray a' at B (Fig. 16.21) back to the eye at E. Rays at intermediate points are deflected similarly.

mainly eliminates unnecessary glass, so that a Fresnel field lens can be quite thin. Usually the field lens is moulded in plastic, and such Fresnel screens are also available for placing over the ground glass screens of larger cameras.

The finer the Fresnel pattern, i.e. the closer the concentric rings are together, the less disturbing the ring structure becomes; however the manufacturing precision of the curvatures and hence the efficiency of the screen also decreases with a finer pattern. To reduce the required curvature of the Fresnel section (thus making the more precise manufacture of finer screens possible) some reflex cameras use both a Fresnel screen and a lower-power field lens above it (Fig. 16.23). Another way is to curve the bottom surface of the pentaprism so that this together with a comparatively thin field lens provides the necessary convergence of the viewing rays (Fig. 16.24).

For optimum evenness of screen illumination the converging power of the field lens should be

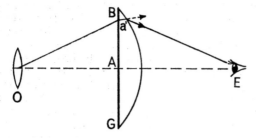

FIG. 16.21. USE OF A FIELD LENS

The required focal length for such a field lens depends largely on the distance AE and is in practice about 50 mm in a 24×36 mm miniature reflex camera. As this calls for a very thick and heavy field lens, many reflex cameras use a stepped Fresnel field lens. Here concentric

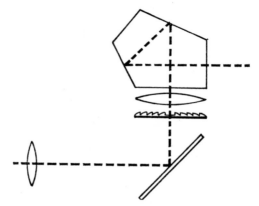

FIG. 16.23. FRESNEL LENS COMBINED WITH
FIELD LENS

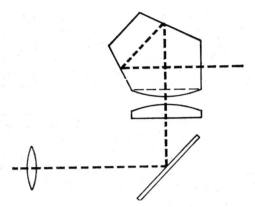

FIG. 16.24. FIELD LENS WITH CURVED
PENTAPRISM FACE

matched to the angle at which the rays from the camera lens reach the focusing screen, and hence to the focal length of the camera lens. Generally this match is made for the normal or a slightly longer focal length of the camera lens (§ 134) and is then adequate for all but ultra-wide angle lenses. With the latter the image brightness at the edges of the screen falls off much more drastically, so that the field lens can no longer compensate adequately.

This increased fall-off is due also to the natural light loss (§ 86), as a result of which the relative intensity a'' in the direction of the principal ray CO' is less than a' for the light reaching the screen from a longer focus lens at O since the angle BOA is smaller than $CO'A$. The smaller value of the angle BOA in Fig. 16.25 also means that from B (with a long focus lens) rays b' with a smaller scattering angle and hence great intensity would reach the eye at E.

From C on the other hand only the more strongly scattered rays c''—already less intense than the similarly scattered rays c—reach the eye-piece or eye at E. As these light loss factors are cumulative, the loss of image brightness on the screen when using a wide angle lens is much more abrupt than the loss of illumination towards the edges of the image on the film. So while a focusing screen is the most precise way of establishing the limits of the field of view when using extreme wide angle lenses (finder accuracy becomes more difficult to maintain with wide angle optical viewfinders) it is also the least efficient from the point of view of image brightness.

249. Screen Types and Focusing Aids. The ground glass screen is not the most effective means of assessing sharpness, so most modern reflex cameras incorporate one or more aids to improve the visual differentiation between a sharp and an unsharp image.

As visual focusing on a screen is limited by the resolving power of the eye, the most obvious way of improving sharpness assessment is to magnify the screen image optically. To do so over the whole screen area would need a very large optical system, and some reflex cameras use a small high power magnifier set in the centre of the screen (Fig. 16.26). This is effective with a fine grain screen and even more so with a clear screen where a sufficiently powerful magnifier (e.g. 10× or more) can isolate the aerial image. The magnifier interferes however with an unobstructed view of the whole picture.

A more popular focusing aid is the split image wedge, a pair of transparent prism wedges A and B (Fig. 16.27) arranged side by side with their inclinations in opposite directions. The axis OPQ along which the two wedge surfaces are at the same level also coincides with the image plane of the screen—the ground surface in the case of a ground glass screen.

Fig. 16.28 shows the operating principle. When the lens L is focused on a point F_1 in front of the image plane, the eye sees this

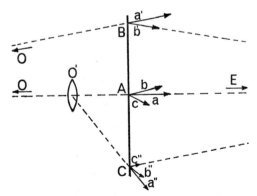

FIG. 16.25. EFFECT OF WIDE-ANGLE LENS
ON SCREEN BRIGHTNESS

FIG. 16.26. CENTRAL CONTACT MAGNIFIER

FIG. 16.27. FOCUSING SCREEN WITH SPLIT-IMAGE
WEDGE

area is clear and not matted. They would be-
come unsharp only when the point F_1 or F_2
is too far in front or behind the focusing plane
respectively; when the split-up halves of the
image are so far apart, that they are no longer
visible within the comparatively small wedge
area.

The effect of the split wedge is thus similar
to that of an optical rangefinder (§ 294) and
has the same advantage of permitting more
rapid and more precise assessment of the point
of maximum sharpness. This is because the
eye has a higher vernier acuity (ability to
detect discontinuities of outline) than an ability
of judging absolute sharpness.

The slope of the biprism determines the
degree of displacement of the two split part
images for a given lack of sharp focusing (i.e.
a given location of the image plane in front or
behind the crossover plane of the biprisms).
At the same time the slope (prism angle) is one
of the factors which determines the smallest
aperture which the camera lens can have to still
fully illuminate both halves of the biprism
simultaneously. The greater the slope, the more
abruptly the two halves of the image are dis-
placed and thus the more precisely the observer
can determine a lack of focus. But with a
greater angle the lens must have a larger aperture
(lower *f*-number) as otherwise the one or other

image through the wedges, each of which dis-
places the image in a direction opposite to the
other. So the image is split up and the two
halves displaced as in Fig. 16.28a. When the
image is formed in the cross-over plane of the
wedges, i.e. the focusing surface, no splitting
up occurs and the image is continuous (Fig.
16.28b). If the focusing point F_2 (Fig. 16.28c)
is behind the focusing plane, the wedges again
deflect the image forming rays in opposite
directions, and the two halves of the picture are
split up and displaced in directions opposite
to Fig. 16.28a. The two halves of the split
image still remain sharply visible as the wedge

FIG. 16.28. EFFECT OF SPLIT WEDGE

half of the biprism goes dark on viewing. A split-image biprism can therefore have a steeper angle if all the lenses to be used with the camera are large aperture ones; it must have a shallower slope when smaller aperture lenses are used. In practice, prism angles employed range between about 3° and 6° and limiting lens apertures between about f/5·6 and f/2·8. Accordingly the lens must be focused at full aperture when using such a split-image device.

In place of a single biprism, a prism pattern can be used, consisting of a large number of minute triangular or tetrahedal pyramid elements (Fig. 16.29). Here each pair of adjacent prism faces splits up a light ray going through them and so yields a pair of displaced images across each "trough" in the prism structure (across c and d in Fig. 16.29a and across c, d and e in Fig. 16.29b). In both illustrations the solid lines represent troughs ground or moulded into a glass or plastic plate; this leaves prism apices at the meeting points of the dotted lines. A microprism grid of the structure of Fig. 16.29a thus splits up an incorrectly focused image point into four points, and a grid like Fig. 16.29b into six points. The effect on the image is that outlines become coarsely broken up when not fully sharp, to become abruptly smooth and continuous at the point of maximum sharpness. The same considerations of prism slope and camera lens aperture apply with microprisms as with biprisms.

Often reflex cameras combine two or more

FIG. 16.29. MICROPRISM GRIDS WITH SQUARE BASE (a) AND TRIANGULAR BASE (b) PYRAMIDS

of these focusing aids. For instance the screen may have a biprism in the centre, surrounded by a microprism grid ring and either a ground glass or clear glass (which gives a brighter image without however focusing sharpness) for the rest of the area. Alternatively a microprism grid may form a centre focusing spot surrounded by a ground glass or clear glass screen.

250. Interchangeable Reflex Viewing Systems. Eye-level pentaprism systems appeared originally in two forms: as an accessory to fit on to the hood of a waist-level type reflex camera, and as a permanently built-in integral eye-level reflex system. The accessory pentaprism quickly evolved into the interchangeable finder system permitting a switch-over from a hood for waist-level viewing to a pentaprism for direct eye-level use. A number of advanced reflex miniatures offer a range of interchangeable viewing systems and interchangeable screens to permit the use of full ground glass, clear glass (for aerial focusing), combined ground glass and biprism, etc., focusing, according to which type is most suitable for specific applications. Orthodox reflex viewing without pentaprism is useful when a camera is employed for copying or close-up work on a vertical stand; there it is more convenient to observe the screen (which is now vertical) rather than to look down through the back of the camera. Interchangeable viewing units also permit the adaptation of the camera to through-the-lens exposure metering.

Permanently built-in integral pentaprism optical systems are less costly than interchangeable ones, especially when the latter are combined with interchangeable screens. On the other hand a number of high-precision and high-price reflex cameras feature fixed screens and prisms because of the greater precision obtainable. The location of the focusing plane with an interchangeable screen cannot be any more accurate than the mechanical placement of the screen itself. And here the tolerances are extremely small with a 35 mm camera; the precision imposed by depth of focus considerations (§ 126) may easily be greater than the achievable mechanical precision in interchangeable units—especially when working with large-aperture lenses.

With bigger-format roll film reflexes the depth of focus limits are more favourable owing to the larger picture format and the—usually—lower maximum aperture of the lenses employed. The same mechanical tolerances therefore become more acceptable.

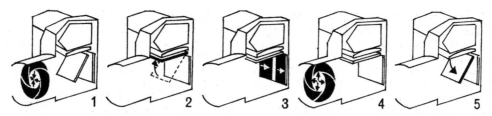

FIG. 16.30. RELEASE SEQUENCE OF FOCAL PLANE SHUTTER CAMERA

251. Reflex Automation. To become successful as an action camera, the single-lens reflex had to overcome two limitations of its system: the time delay between viewing and exposure, and the disappearance of the visual image at the moment of exposure. The first was achieved by an intercoupling of the mirror, shutter and aperture controls; the second by the instant return mirror which snaps down again after an exposure so that the "blackout" time only lasts a fraction of a second.

Various manual, semi-automatic and automatic preset diaphragm systems are used to stop down the lens from the full opening used for focusing and viewing to the working aperture (§ 283). In addition the interlinking between the lens, shutter and mirror involves a sequence of operations which on modern reflexes takes place automatically within a fraction of a second of pressing the release button. With a focal plane shutter camera such a sequence may involve (Fig. 16.30) the following steps, starting from the camera with the mirror down and the lens fully open for viewing:

1. The lens aperture closes to the preselected value;

2. The mirror swings up;

3. The shutter opens and closes for the exposure;

4. The lens aperture reopens to its full size;

5. The mirror swings back down again.

Steps 1 and 2 can take place in reverse order, as can 4 and 5. On less extensively automated cameras the mirror may only come down again during the film transport and shutter tensioning, while the aperture may have to be reopened by hand.

On a camera with lens shutter, the shutter must be open for viewing while the film is protected by a capping plate or auxiliary shutter in the back of the camera. The release sequence on pressing the release button therefore becomes more complex (Fig. 16.31):

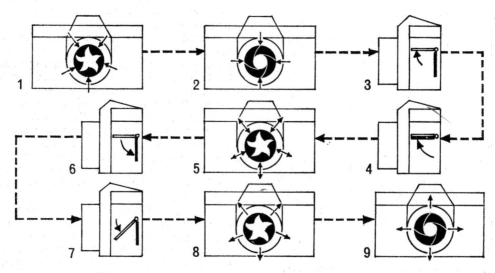

FIG. 16.31. RELEASE SEQUENCE OF LENS SHUTTER CAMERA

1. The shutter closes;
2. The aperture closes down to its pre-selected value;
3. The mirror swings up;
4. The capping plate or auxiliary shutter opens;
5. The shutter opens and closes for the exposure;
6. The capping plate or auxiliary shutter closes down;
7. The mirror returns to its viewing position;
8. The shutter opens again for viewing;
9. The lens iris reopens to its full aperture.

Steps 1 to 5 again take place during a fraction of a second. But as the sequence calls for more complex mechanical linkages, the instant return mirror feature is rarer in lens shutter reflexes, so steps 6 to 9 frequently take place only during retensioning of the camera to advance the film and recock the shutter.

CHAPTER XVII

SHUTTERS

252. Shutter Function and General Types. The shutter, one of the two principal means of controlling the amount of light reaching the sensitized film emulsion during an exposure, regulates the length of time during which the light acts. It therefore involves a device for opening and shutting off the light path between the subject and the film (hence the term "shutter") and some means of timing the open period. In the earliest days of photography the shutter was the cap of the lens which was removed and replaced to make the exposure. Modern shutters are mechanical devices of comparatively complex construction which can provide a range of reasonably accurately timed exposures down to as short as 1/2,000 second. These exposure settings are also known as shutter speeds; the shorter the exposure time, the higher or "faster" the shutter speed.

The maximum speed obtainable with shutters for normal professional and amateur cameras is determined by mechanical limits. These shutters consist of blades, leaves or blinds whose movement speed in opening and closing is limited by their inertia and by the forces that can be applied to the moving parts (as well as by the springs or other power sources that are built into the shutter). Special shutter systems—often relying on electro-optical or magneto-optical effects—are used in certain scientific cameras to achieve considerably shorter exposure times. Extremely short exposures in high-speed photography

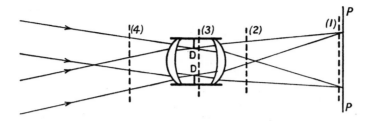

FIG. 17.1. POSITIONS (1, 2, 3, AND 4) FOR OPERATIONS OF SHUTTER

(down to fractions of a microsecond or less than one millionth second) are also obtained by using high-speed flash systems as light sources.

Shutter types can be classified by their position in the light path of the camera, by their geometry of opening and closing, or by their mechanical construction or actuation. The last named refers to the way the power needed for operation is applied: in so-called everset shutters this is obtained directly by pressure on the shutter release or on a cable release (§ 264). To obtain higher shutter speeds the shutter is controlled by powerful closing springs which have to be tensioned for each exposure; these shutters are often described as preset.

253. Different Positions for the Shutter. If we consider the beam of light (see Fig. 17.1), which forms an image in the plane PP after passing through a lens, we can see that the cross-section of the beam *as a whole* is smallest in the plane DD (which is the position of the diaphragm), but that each pencil of rays has its minimum section in the image plane.

As the velocity of the moving parts of a shutter is limited by their having to start from rest, and stop as soon as the limit of their travel is reached (excepting some special types of shutter for aerial photography), it is obviously important to place the shutter where the beam

has its smallest cross-section. For very short exposures this is best done by uncovering the different pencils of rays where they have the least section by placing as near as possible to the image plane an opaque blind pierced by a narrow slit, which can sweep over the whole surface of the image, as indicated by (1) in Fig. 17.1. The principle of the shutter is shown in Fig. 17.2.

In considering such a *focal-plane shutter* we must distinguish between the effective exposure time, which is the time for which each pencil of rays is allowed to fall on the film, and the *total time of travel*, which is the time taken for the slit to travel across the whole image. The relative positions of the camera and subject may change during the total time of travel, and if this happens, different parts of the image will not correspond to the same phase of the movement. The distortions then introduced are usually negligible except in the case of extremely rapid motions of the subject or the camera. It is possible that the image will be sharp although distorted, owing to the great difference between the effective exposure time and the total time of travel (§ 270).

For longer exposures it is better to allow all the pencils of rays to reach the image plane simultaneously and to do this the shutter is placed as close to the iris diaphragm as possible, as shown by (3) in Fig. 17.1. This allows the

FIG. 17.2. FOCAL PLANE SHUTTER

shutter to be most compact. As all the film is exposed at the same time, a sharp image will not be distorted, and the exposure received by each part of the film will be roughly proportional to the intensity of illumination at that point in the absence of the shutter. This type of shutter is also known as a diaphragm shutter or as a blade or leaf shutter, since it consists of metal (or plastic) blades which open and close. An alternative term, referring to the position between the lens elements, is *between-lens* shutter.

For reasons of convenience (such as the easy adaption of shutters to any lens or camera without the necessity for special fitting, and great flexibility in the choice of shutters, lenses, and cameras) the shutter is sometimes placed in positions other than those mentioned; it can be behind or in front of the lens as shown by (2) and (4) in Fig. 17.1. In these positions the shutter has the disadvantage of both the focal-plane and diaphragm types. The various parts of the film are not exposed simultaneously, and the possibility of distortion is introduced (this effect is not so pronounced as with the focal-plane shutter). Front-lens and behind-lens shutters are used on some inexpensive amateur cameras to simplify the fitting of separate lens and shutter units. The behind-lens shutter is also used where a camera with a blade or leaf shutter has interchangeable lenses. The shutter is then built into the camera and the lens is mounted interchangeably in front.

Since the size of the shutter opening must be considerably greater than the diaphragm, especially when the angle of view is large and the shutter is some distance from the lens, the exposure time for a given velocity of the moving parts will be greater. In particular the times of opening and closing, during which the shutter is only partially open, become of considerable importance, affecting the efficiency of the shutter and the sharpness of the image (§ 254). A shutter of this type should not open from the centre, since, while it is partially open, it cuts off the more oblique rays although allowing the majority of those only slightly inclined to the axis to pass through, thus exaggerating the differences of illumination between the centre and edges of the image (§ 86). If, however, the shutter opens from one side and closes at the other (e.g. by the movement of an opaque screen with a rectangular aperture) the image at the beginning and end of the exposure will be formed only by rays passing near the edge of the diaphragm. Since the rays passing near the edges of a lens are those having the greatest aberrations, the sharpness of the image will be reduced if the time of partial opening of the shutter is an appreciable fraction of the total time of opening.

Fortunately, the various problems are only of importance when the shutter is at a considerable distance from the lens or the exposure time required is short.

In terms of the geometry of their opening and closing action, shutters which open from the centre of the light path outwards are sometimes referred to as *central shutters* (especially in Germany). More often this term distinguishes the blade or leaf shutter from the focal plane type of Fig. 17.2.

254. Efficiency of a Leaf Shutter. Except in the case of a shutter working in the plane of the image, a shutter always takes a certain time to reach its maximum aperture, after which it remains fully open until it begins to close again. The closing also occupies an appreciable time. This is shown in Fig. 17.3 which is traced from a cinematograph film and depicts the complete action of a diaphragm shutter (P. G. Nutting, 1916). The exposure time of the images is $1/30,000$ sec, and the interval between two successive images is $1/1,000$ sec. When the shutter is set for an exposure of $1/100$ sec it takes about $4/1,000$ sec to open; it remains fully open for another $4/1,000$ sec, and takes a further $3/1,000$ sec to close, making a total time of opening of about $11/1,000$ sec.

If a moving object is brightly illuminated, it can act on the photographic emulsion during almost all the total time of opening—say during $1/100$ sec. But the exposure received by the film will not be equivalent to $1/100$ sec exposure, owing to the appreciable time during which the shutter is partially open. In this case the effective exposure time is only about $7/1,000$ sec. Thus in photographing a moving object, the disadvantage of an exposure of $1/100$ sec as regards blurring of the image is not fully compensated by the ability of an exposure of this duration to record shadow details.

The course of the opening and closing action of the shutter can be traced in a graph such as Fig. 17.4, usually obtained on the cathode ray tube of an oscilloscope (§ 278). The graph plots the degree of opening in per cent of the diaphragm area uncovered against time (e.g. in milliseconds). The shutter begins to open at the

FIG. 17.3. OPENING AND CLOSING OF DIAPHRAGM SHUTTER

point O until the blades have fully uncovered the light path at A. The shutter then stays open until B when the blades begin to close, reaching the end of the movement at the point C in time. The length OC is the total opening time of the shutter, but it does not represent the effective exposure in terms of the amount of light reaching the film. In Fig. 17.4 this amount of light is the area underneath the curve $OABC$, which is less than the area $ODEC$ corresponding to a perfect shutter which would fully open (and close) instantaneously. The ratio of these areas—$OABC/ODEC$—is defined as the efficiency of the shutter.

At one time shutter speeds were simply measured as the time OC, i.e. the total open time, so that shutters of low efficiency led to under-exposure. By current national and international standards shutters are calibrated according to their effective exposure time rather than the total open time. The effective exposure is obtained by constructing a rectangle $FGG'F'$ which is equal in area to $OABC$. This involves finding two points K and L on the opening and closing part of the curve such that the approximate triangles FKA and $KF'O$ are equal in area, similarly also that $LGB = LG'C$. (If the opening and closing curve sections are approximately straight lines of even gradient, K and L are level with 50 per cent on the vertical axis of the graph, and the above relationship of the area follows from simple geometry.) The time interval $F'G'$ is then the effective exposure time of the shutter, i.e. the time corresponding to the

amount of light the shutter lets through. The efficiency becomes the ratio $F'G'/OC$.

It is the time $F'G'$ on which the calibration of modern shutters is based. The efficiency then does not affect the exposure, but it does influence the action stopping power of the shutter, since the total open time of an inefficient shutter can be very much longer than its effective time so that bright moving objects may show more movement blur than they should.

The shutter efficiency depends on both the speed to which the shutter is set and on the lens aperture with which it is used. With some shutters, operating at their shortest exposures, the blades begin to close as soon as they are fully open, and the full aperture is only used momentarily. On the other hand, at relatively long exposure times the times taken by the shutter blades in opening and closing are substantially the same as in very short exposures, the difference in time being almost entirely due to the increased period at full aperture. Thus the use of a shorter exposure time produces a curve $OAB'C'$ in Fig. 17.4 and the efficiency becomes the ratio $F'H/OC'$. Since OF' has remained the same and $HC' = G'C$ (the closing time, which also remains constant) the efficiency drops.

When the diameter of the diaphragm is reduced, the *new* full aperture is completely uncovered before the shutter blades have finished opening, and similarly the shutter blades have to close a certain amount before they begins to reduce the aperture. Thus, even if the shutter begins to close again as soon as it is fully open, the complete aperture has been used for a certain definite time. This is shown in Fig. 17.5 where the lens aperture is reduced from the level FG to HH'. At this aperture the shutter behaves as if it had the curve $OA'B'C$; by the same arguments as before the effective exposure time becomes $F''G''$ instead of $F'G'$, and the efficiency (effective exposure time/total open time OC) increases.

This also means that with a shutter calibrated in effective exposure times at full aperture the exposure of the film increases if the lens is stopped down to compensate for increasing

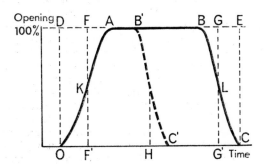

FIG. 17.4. DIAPHRAGM SHUTTER CURVE

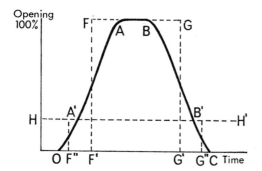

FIG. 17.5. EFFICIENCY AT REDUCED APERTURE

subject brightness. In practice this is only rarely a serious problem; partly because the exposure latitude of the film in most cases covers such variations, and partly because the lens is normally stopped down when slower shutter speeds are used, where the change in efficiency due to stopping down is proportionately less. A shutter is best characterized by its minimum efficiency, since the efficiency is of most importance when the exposures are short and are therefore being made at large apertures.

255. Desirable Characteristics of a Shutter. These are rather numerous, and are rarely found combined in a single shutter.

A shutter should act the moment it is released, with no appreciable lag; it should work with as little vibration as possible to avoid camera shake, and it should not bounce on closing (which might give a second image of the bright parts of the subject). For portraiture silent operation is advantageous. It should not limit the field even when the lens is considerably off-centre, nor limit its effective aperture. It should work equally well in different positions; it should be light, compact, and strong, and it should be possible to adjust the exposure time after the shutter has been tensioned without risk of upsetting the mechanism. Its efficiency should be as great as possible. It must not open during setting if it is to be used on a camera in which the sensitive surface is normally otherwise uncovered. Lastly, it should give a reasonable range of exposures which are correctly calibrated and consistent.

Most serious errors are caused by failure to fulfil the last condition. A shutter cannot be expected to give consistent exposures over a period of years, for even although not in use it is impossible to prevent the steel of the springs changing slightly. For this reason springs should not be left stretched longer than necessary, and the shutter should not be kept set in the intervals between use. But over shorter periods (months) the exposure time should be the same at the same setting, especially when the shutter is used several times in succession. Inconsistency is particularly common in old shutter designs using a friction brake or air brake, instead of escapement (§ 263) or electrical circuits (§ 267) to control the exposure time.

The calibration of the different settings of a shutter is often far from the truth. In general (for shorter exposures) the true time of exposure is greater than the indicated value. This, however, may be purposely arranged to allow for the fact that amateurs tend to under-expose rather than the reverse. In other cases there is no simple relationship between the times given and the real ones, and with some cheap shutters the indicated times of say 1/60 and 1/125 sec may all be effectively the same as the slowest speed of 1/30 sec; with other shutters times indicated as the shortest may in fact be the longest. The calibration of shutters is susceptible to temperature changes owing to unequal expansion of the various metals used in construction, and variations in elasticity of the springs.

A number of national standards lay down permissible tolerances for diaphragm shutters at ±30 per cent of the indicated effective exposure time at full aperture for shutter speeds of 1/250 sec and higher; the permissible tolerance with slower speeds is ±20 per cent. Most modern camera shutters keep within this range and with high quality precision shutters manufacturers often aim at tolerances of less than half the permissible limit.

On modern shutters the range of exposure times usually follows a geometrical progression, each exposure being half the preceding one (e.g. 1/15, 1/30, 1/60, 1/125 second, etc.). Older shutters often have irregularly spaced times (e.g. 1/2, 1/5, 1/10, 1/25, 1/50 second, etc.).

Exposures longer than 1 sec are not usually made automatically, largely because the timing mechanism required becomes comparatively bulky. Automatically timed longer exposures are, however, available on shutters using electronic circuits for timing control (§ 267), and a few diaphragm shutters for larger cameras have special escapements permitting presettable times up to ½ min. Mechanical timing units are also available separately and are used with a cable release (§ 280) which screws into a socket on the shutter.

Shutters used on technical and similar cameras with direct ground glass screen focusing also have a special setting at which pressure on the release opens the shutter and keeps it open indefinitely—e.g. for focusing and for long time exposures—until closed by a second pressure on the release button or control. This setting is usually marked T (time) or—on older shutters of German origin—Z (Zeit). On single-lens reflex cameras with diaphragm shutters (§ 251) the shutter automatically opens whenever the mirror is in the light path for viewing and focusing on the reflex screen, and then closes before the mirror moves out of the way, in order to open and close again for the exposure.

In addition, most shutters have a setting where the shutter opens on operating the release, and closes again on letting go of the release button or lever. This serves for shorter time exposures and is usually marked B (now usually referred to as "Brief time" though originally standing for bulb, from the method of releasing the shutter by air pressure from a rubber bulb) and sometimes as Z on older German shutters. Preset shutters must be tensioned (§ 252) before being used at the B (but not at the T) setting.

256. Historical Shutter Types.

Like cameras, photographic shutters went through numerous stages of evolution between the lens cap of the first professional photographers and the almost universally used diaphragm and focal plane shutters of today. Some of these stages are listed here not just for their historical interest, but because designs derived from them are still used on the one hand in inexpensive amateur cameras and on the other in certain specialized photographic equipment.

One of the earliest mechanical shutters was the simple drop shutter or guillotine. This consists of an opaque screen, with a cut-out portion at least equal in size to the aperture to be uncovered running in guides and either falling under its own weight or pulled by springs (see Fig. 17.6). Such an arrangement was used in 1845 by Fizeau and Foucault for photographing the sun, but it was not generally employed until the introduction of the wet collodion process in 1855. It then appeared as a clumsy arrangement fitted to the lens hood, the speed of falling being controlled by the slope of its frame. Later it was used as a metal plate passing between the elements of the lens and helped by an elastic band (Jamin, 1862).

Before this, however, in 1858, the rectangular guillotine shutters had been replaced by a

FIG. 17.6. THE SIMPLE DROP SHUTTER

circular one (Fig. 17.7), which was much less clumsy. The old movement in a straight line was replaced by rotational movement about an axis close to the aperture, which was either in front of the lens hood or close to the diaphragm. The screen can be an opaque sector making a complete revolution each time.

The efficiency of this type of shutter depends largely on the ratio of the length of the opening a to the diameter d of the lens opening to be uncovered. The longer a, the smaller the proportion of the exposure time which the shutter spends in uncovering and in recovering the lens opening. Increasing the opening of, for instance, a rotary guillotine shutter however raises two other problems: (a) the travelling speed of the guillotine while the shutter is open becomes less uniform since it has to accelerate from rest and variations in the travel speed reduce efficiency; (b) the fastest shutter speed

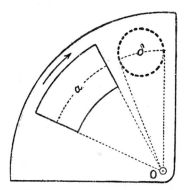

FIG. 17.7. ROTARY SHUTTER

FIG. 17.8. LANCASTER ROTARY SHUTTER

FIG. 17.9. BERTSCH ROTARY SHUTTER

obtainable is reduced with larger shutter openings since the actual velocity of the moving part (across the centre of the lens opening) cannot be increased much beyond about 25 metres per second.

The rotating guillotine shutters of Lancaster (Fig. 17.8) and Bertsch (Fig. 17.9), with efficiencies of 50 per cent and 70 per cent respectively were widely used at one time, but their exposure times were much longer than those usually required in modern practice.

Derived from the guillotine shutter is the roller blind design in which a flexible blind with a rectangular opening in the middle runs between two rollers at each side of the aperture (Fig. 17.10). The movement is spring driven, the spring tension controlling the exposure time. The use of a comparatively long blind as against a rotating plate permits more time for acceleration before the shutter actually opens, and the fastest shutter speed is of the order of 1/20 to 1/50 sec. This shutter, first suggested by Relandin in 1855, is always used either in front of or behind the lens, the latter being more convenient and permitting different lenses to be used in the same shutter. Except in its position in the camera, this system can also be regarded as the forerunner of the focal plane shutter.

257. Later Types of Guillotine Shutter. Shutters developed from the rectilinear type of guillotine shutter are used on a number of hand cameras, but in order to combine reason-

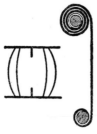

FIG. 17.10. ROLLER-BLIND SHUTTER

able efficiency with compactness, the shutter is made of two thin steel plates one covering the aperture before exposure and the other after. The time between the first plate beginning to uncover the aperture to the second plate closing it corresponds with the time of passage of the opening in the simple type. For long exposures the plates are worked independently; for very short, or instantaneous, exposures the second plate is automatically released by the first one when it reaches the end of its travel; or alternatively the first plate actuates a mechanism which releases the second plate after a predetermined time. In setting a shutter of this type the two plates either move so that the aperture is never uncovered, or in conjunction with an auxiliary plate which, having covered the aperture during setting, returns to its original position and takes no further part in the shutter's working.

Fig. 17.11 shows diagrammatically how such a shutter works, the driving springs, ratchets and shutter release being omitted for clarity. In the position of rest (position I) the plate A rests against the stops cc and engages by means of the pins dd the plate B, the solid part of which covers the aperture. To set the shutter, plate A is drawn to the left. It covers the opening in B then drags B with it until it is stopped by studs ee (as shown in position II). When the shutter is released, A is set free, and under the force of the driving spring moves to the right and uncovers the aperture (as shown in position III). When it has completely passed the aperture it engages plate B and pulls it over so as to cover the aperture again (position IV). The greater the length of the slots in A in which the pins dd slide, compared with the diameter of the aperture, the greater is the efficiency of the shutter.

258. Flap Shutters. Different types of flap shutters worked directly by hand had been in use for some time when J. W. T. Cadett, in 1878, made a shutter of this type in which the flap was raised by pressing a pneumatic bulb. This apparatus was very clumsy and was fixed to the lens hood. A much neater model was made by C. Guerry in 1880 (Fig. 17.12), and shutters of this type were made for portrait photographers. They could also be placed inside the camera (shown dotted in Fig. 17.12) to make the shutter action invisible to the sitter in front of the camera. One drawback was that the lower part of the subject received more exposure than parts above the level of the camera. The shortest exposure time obtainable was around

FIG. 17.11. ACTION OF GUILLOTINE SHUTTER

⅓ sec. By using a second flap parallel with the first (Joubert, 1880) shorter exposures become possible (Fig. 17.13). The exposure was still uneven across the image, the centre now receiving up to 40 per cent more than the upper and lower edges.

Various types of behind-lens shutter are derived from the flap principle. Thus the multi-flap shutter (Fig. 17.14) consists of a number of light flaps pivoted on horizontal axes and just overlapping in their extreme positions. The main disadvantage of this system is that the light emerging from the lens is never completely

transmitted; the flaps, which are always parallel, only pass the horizontal rays completely when they are themselves horizontal but then cut off an appreciable part of the oblique rays. Similarly, if they are partially opened or closed, they transmit completely only some of

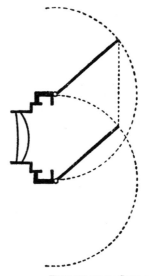

FIG. 17.13. DOUBLE-FLAP SHUTTER

the oblique rays. Thus this shutter never has an efficiency greater than 33 per cent. Although with a shutter of this type exposures as short as 1/400 sec could be made (Kraus, 1894), it was soon abandoned for general use. It has been used occasionally in aerial cameras, however, and leaves have been arranged radially so as to give a perfectly symmetrical field. A device also used was that of momentarily stopping the blades of the radial pattern when fully open, and an efficiency of 80 per cent was achieved.

The bellows shutter, at one time used by portrait photographers, was also derived from

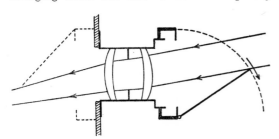

FIG. 17.12. GUERRY SINGLE-FLAP SHUTTER

FIG. 17.14. MULTI-FLAP SHUTTER

FIG. 17.15. BELLOWS SHUTTER

the flap shutter and consisted of two opaque black bellows built on light metal frames, rather like Japanese lanterns. When closed, these form a hemisphere opening about a vertical axis (Fig. 17.15 shows a top view). The image portion receiving maximum exposure is the vertical axis, usually also the position occupied by the subject. The shortest exposure time is similar to that of the simple flap shutter.

259. Double-guillotine Shutters. Although in principle a double-guillotine shutter, opening and closing from the centre (Mann, 1862), is for use in the diaphragm, numerous models have been made for use before or behind the objective. One of the best early designs (L. R. Decaux, 1893), was frequently used behind the lens without any difficulty if of sufficiently large aperture. This is due to the fact that the time during which the shutter is fully open nearly always represents more than half the total time of operation of the shutter.

In this shutter, which is represented closed and open in Figs. 17.16 and 17.17 (E. Wallon,

La Revue de Photographie, 1906 and 1907) the two blades V_1 and V_2, instead of having rectilinear movement, are guided by horizontal grooves a_1b_1 and a_2b_2, and joined by a long member to the end of the arm B_1B_2, which rotates about the pivot M and is brought into its position of rest by the spring r. The driving spring R is coiled round the piston rod in the body of the pump P. This pump is full of air, which the piston, under pressure of the spring R, compresses to the end of the cylinder, where it escapes through very small holes, the exact size of which may be regulated by rotation of the button p to obtain different exposures.

An extension of the piston rod carries a rack which engages in the toothed wheel Q, which is directly connected with the setting lever, and which is fixed to the cam S which forms the vital part in the mechanism. When the key for setting the shutter is pressed, the rack moves towards the right, thus compressing the driving spring and turning the sector S anti-clockwise. This presses by the tip x on the pin G of the lever L, which is joined at M on the arm B_1B_2, and which is slightly displaced from its position of rest sufficiently for the sector to pass by, the lever returning quickly to its normal position, and pin G being thenceforth pressed against the sector. The triangular pin C of the cam is then caught in the notch e of the bolt D, which pivots round N and is acted on by the spring t, the shutter thus being set without any movement of the blades V.

If the bolt D is lowered by pressing on the rod K, the pin c is set free and on being released the spring impresses on the cam a rotation in

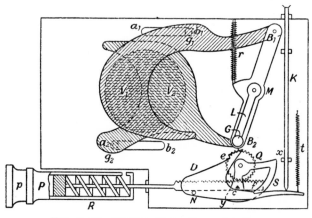

FIG. 17.16. DOUBLE-PLATE SHUTTER—SET

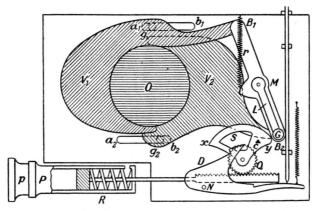

FIG. 17.17. DOUBLE-PLATE SHUTTER—OPEN

the opposite direction to that previously described. The lever L is pushed towards the right, but in this direction it engages the arm B_1B_2, and consequently moves the blades of the shutter, the aperture of which is fully opened when the cam has turned through about 90°, the pin G being pressed against the cam. Before this pin is set free, thus allowing the shutter to close, the whole of the sector S shown by the arc xy must pass under it. The time this takes to pass is the time of full aperture, after which the plates close under the influence of the spring r. The air brake does not act appreciably during the actual opening or closing of the shutter, the air not being sufficiently compressed to have any effect on the driving spring R. In fact, the action of the brake only affects the duration of the exposure at full aperture.

For very long "time" exposures, the holes in p through which the air escapes are almost completely closed. The movement of the cam is then very slow when the pin G approaches the end x of the sector S, and if there is no longer any pressure on the rod K, the pin c is stopped by the notch f before the blades close; a second pressure on K releases c and the shutter closes.

The times of opening and closing are about $1/400$ sec; the shortest time at full aperture is also about the same, so that the shortest total exposure is about $1/120$ sec, with an efficiency greater than 60 per cent. This rises to about 80 per cent for an exposure of $1/50$ sec, and increases continually with the exposure, as is the case with the majority of shutters.

One attraction of the double guillotine shutter is its comparative simplicity in construction, and it is used—though with more modern timing controls than an air brake—in a number of simpler amateur cameras.

260. Diaphragm Shutters. The first shutter with several pivoted blades opening like the leaves of an iris diaphragm and operated simultaneously by an internal ring concentric with the diaphragm appears to have been made in 1887 by Beauchamp and Dallmeyer.

Some of these shutters, with a large number of blades (e.g. up to 10), are actually iris diaphragms, the leaves opening just sufficiently to form the boundary of the desired aperture. The shutter thus controls the aperture and the exposure time simultaneously, a feature used again on certain modern programmed shutters. The efficiency of these shutters is not particularly good, about a maximum of 50 per cent for a uniform movement of the leaves, but this can be slightly increased by choosing a suitable movement.

With an orthodox diaphragm or leaf shutter, having the shutter blades separate from the iris, the efficiency depends on the exposure time (§ 254). The leaf shutter is today the most widely used type fitted within the lens elements or just behind the lens; it provides a wide range of reasonably accurately timed exposures which often extend from 1 to $1/500$ sec or in special cases up to $1/1,000$ or $1/2,000$ sec. The exposure times of a good diaphragm shutter are very consistent over long periods of operation.

Generally the number of leaves is three or four, but sometimes may be two or five. For a suitable form of leaf the external diameter of the casing of the shutter should, for a given aperture, be smaller as the number of leaves is made greater (Lan Davis, 1911), although

FIG. 17.18. FIG. 17.19. FIG. 17.20.

FIG. 17.21. FIG. 17.22. FIG. 17.23.

THEORETICAL FORMS OF TWO, THREE AND FOUR-LEAF DIAPHRAGM SHUTTERS

manufacturers have not always made the best use of this fact. The table below gives the theoretical diameter of the casing for different numbers of leaves, the diameter of the aperture being taken as unity.

Number of leaves .	2 or 3	4	5	6	8	10	20	30
Diameter of casing	2	1·93	1·83	1·73	1·59	1·49	1·26	1·17

Figs. 17.18–17.23 show the theoretical forms of leaves corresponding to shutters fitted with 2, 3, or 4 leaves, according as to whether these pivot around points (marked by small circles) situated on the edge of the aperture or on the edge of the casing. The actual form of the leaves differs from the theoretical shape mainly to provide the necessary strength around the pivoting points and to counter-balance the mass of the blades rotating about the pivots for smoother action and reduced wear.

The shape of the opening during the opening and closing movements of the blades is a multi-pointed star (Figs. 17.24 to 17.26) with the same number of points as the shutter has leaves.

The space saving advantage of having several leaves is, however, to a great extent counter-balanced by the fact that, for a given method of construction and the same law of movement, the efficiency diminishes as the number of leaves increases.[1] The table below gives for different

[1] This law would not hold for leaves in the form of sectors dividing the diaphragm into equal parts and opening by a translatory movement of each of the sectors in a direction along the length of its centre line, or by rotation around a pivot at some distance away. Such arrangements, however, present considerable difficulties in practice.

FIG. 17.24. FIG. 17.25. FIG. 17.26.

OPENING SHAPES WITH THREE-, FOUR- AND FIVE-LEAF DIAPHRAGM SHUTTER

numbers of leaves (J. Demarçay, 1905) the efficiencies calculated for the case in which, instead of turning round pivots, each one slides in a direction parallel to a radius, the assumption being made, in agreement with general practice for the shortest exposures, that no escapement or brake is used.

Number of leaves . .	2	3	4	6	∞
Efficiency . . .	0·424	0·367	0·351	0·341	0·333

With all shutters, and especially with those of this type, the minimum exposure increases very rapidly with the diameter of the aperture,[1] but at the same time the efficiency tends to diminish because the exposure can only be reduced by a change in the time of full aperture.

261. Operation of the Diaphragm Shutter. The typical diaphragm shutter with three to five blades (according to the diameter of the aperture to be covered) has the blades moving reciprocally out and in. This is represented diagrammatically in Figs. 17.27 and 17.28 (E. Wallon), for the case of a three-leaf shutter, one leaf only being shown to avoid complicating the figure. The leaves V pivot round the points P in a fixed ring and are operated by the pins g engaging in the radial notches k of the movable ring A. It will be seen that the movement of the leaves from the closed to the open position corresponds with a very small rotation of the ring A.

[1] Considering shutters of the same type and different diameters d working in the same time, and supposing that the thickness are not increased, the energy absorbed, $\frac{1}{2}mv^2$, varies proportionally to d^4, since m is proportional to d^2 and v to d. Therefore mechanical damage could occur in a very large shutter which opens and shuts in the same time as a small one.

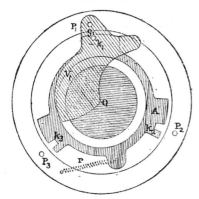

FIG. 17.27. THREE-BLADE DIAPHRAGM SHUTTER, CLOSED

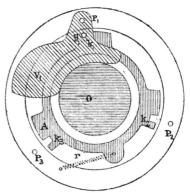

FIG. 17.28. THREE-BLADE DIAPHRAGM SHUTTER, OPEN

The ring A may be controlled by two different methods; either by direct action of the trigger release and without previous setting, for "time" and "bulb" exposures and relatively short exposures of about $\frac{1}{8}$ sec with very low efficiency, or by using, after setting, a driving spring and a braking system, the only rôle of the release then being to set free the pieces which were locked in setting the shutter.

The movement of the lever to set the shutter engages a spur which is integral with the ring A in an arm which, from the moment of release, is connected with the driving spring, the setting being effected without any movement of the leaves, thus removing the risk of the aperture being uncovered. At the moment of release the ring A starts to rotate and continues to do so until full aperture is reached. The braking system now comes into play and prolongs the time of full aperture as required until the spur in the ring A frees itself from the arm to which it was previously fixed, the leaves then closing under the pull of the spring.

In the diaphragm shutter the spring tension governs the speed with which the shutter opens and closes, which determines the shortest exposure time or fastest shutter speed. This fastest speed depends primarily on the stresses which can be imposed on the moving members of the mechanism and is thus faster, the smaller the shutter. While reciprocating blade shutters used in miniature cameras may go up to 1/500 sec, the limit with large shutters for technical cameras is usually 1/60 or 1/125 sec. Higher speeds are possible with non-reciprocating blade movements or by restricting the maximum opening of the shutter (§ 265).

262. Braking Systems. To provide a range of

slower speeds or longer exposure time, early shutters used a friction brake or an air brake. Present-day shutters work with an escapement or with electronic control circuits (§ 263, 267).

The friction brake consists of a disc of leather between a fixed and a rotating plate, the latter being linked to the spur in the ring A of Fig. 17.27 so that when the shutter is open, the ring has to move against the friction of the brake before it disengages the spur and the shutter can close. The exposure times are selected by adjusting the angle through which the disc bearing against the leather brake pad has to turn. As might be expected, the friction—and hence the effective exposure time—is subject to appreciable variations, not only through progressive wear (which shortens the exposure times) but also through the influences of atmospheric humidity, temperature, etc.

The air brake as a timing device permits greater accuracy and consists of a cylinder closed at its two ends and fitted with a piston having a narrow slot communicating with the two ends of the cylinder. Displacement of the piston compresses the air on one side and rarefies it on the other. The resistance to the movement of the piston depends on its original position and has a minimum value when the two compartments at the ends of the cylinder are equal. The variation of exposure is controlled by displacement of the piston P (Fig. 17.29) before the shutter is released. This is effected by rotation of the disc D, which is graduated in exposure times (1 sec to 1/250 sec), and which engages the cam C moving the bent lever L, one end of which is fixed in the piston through a longitudinal slot in the cylinder, and the other, by means of the curved arm B, to a drum containing the driving spring.

The air brake is also subject to accuracy variations through changes in temperature, air pressure and wear between the piston and the cylinder which increases the rate at which the air can leak past the piston. In some air brake systems, such as that shown in Fig. 17.16, where the air escapes through a hole in the cylinder, any dust or dirt partially plugging the very fine hole appreciably affects the exposure settings.

263. Escapement Controlled Diaphragm Shutters. Most modern diaphragm shutters use a clockwork escapement mechanism which can be completely enclosed in the shutter and is thus better protected. It consists of a gear train with an escapement mechanism similar in function to a watch escapement. In the fully open position of the shutter the ring actuating the blade is arrested by a lever or ring in engagement with the gear train; before the shutter can close, the ring has to clear the gear train. The degree of engagement—and hence the time taken to run through the gear train—is adjusted by a cam connected to the shutter speed setting control. The cam may either be continuous, permitting the setting of any intermediate speed, or stepped to provide accurate settings at the marked speeds but without intermediate points. In this case the shutter speed control engages at the various marked settings. The calibration is usually fairly accurate and with the most precise designs well within the tolerances laid down by various standards (§ 255).

To obtain the highest speeds on some shutters, an extra driving spring is brought into operation, which speeds up the whole operation, and leaves the efficiency practically unchanged. With shutters of this type, reasonably high speeds can be obtained; on the smaller models, speeds of 1/500 sec with efficiencies of 60 per cent are obtainable. At 1/125 sec, the efficiency is about 74 per cent, and at 1/30 sec, about 92 per cent.

264. Everset Diaphragm Shutters. There are in use a great number of everset diaphragm shutters which usually indicate speeds of 1/30, 1/60 and 1/125 sec (on older shutters 1/25, 1/50 and 1/100 sec), in addition to T and B. In these shutters, the action of pressing the shutter release first sets the driving spring, and the shutter is triggered by further pressure. On these shutters, the various speeds are obtained by variation in the tension of the driving spring, or, on some, an escapement mechanism controls the action in much the same way as on a preset shutter.

Everset shutters fitted to many cheaper cameras have an efficiency, even at slow speeds, of rarely more than 75 per cent and often much less. Since the driving spring has to be tensioned by the release movement, the spring force that can be used (without appreciable risk of shaking the camera while pressing the release) is limited

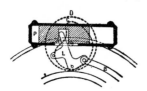

FIG. 17.29. SPEED ADJUSTMENT BY AIR BRAKE

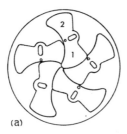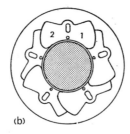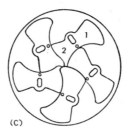

(a) (b) (c)

FIG. 17.30. SWING BLADE SHUTTER

and 1/125 sec is usually the top speed of an everset shutter. One advantage of this system is that it eliminates the need for a separate tensioning mechanism, and on inexpensive cameras the need for coupling a shutter tensioning drive with the film transport. For this reason, precision everset shutters are also used on technical and other large size cameras where a separate tensioning action is liable to be forgotten in operation, so that an exposure might be missed.

265. High-speed Diaphragm Shutters. The main mechanical limitation of the top speed of diaphragm shutters described so far is not only the inertia of the moving members and the spring tensions that can be used without pounding the mechanism to pieces, but also the reciprocating action of the blades which have to accelerate and decelerate twice during each opening and closing cycle.

Two methods have been used to solve the latter problem: (a) swing blades which swing out of and back into the shutter opening without reversing their movement direction, and (b) separate sets of blades for opening and for closing.

The swing blade system is illustrated in Fig. 17.30 which shows the shutter closed before the exposure (a), open (b) and closed after the exposure (c). In phase (a) it is thus section 1 of each blade which closes the lens opening while

in phase (c) it is the section 2 of the blades which obstructs the light. To retension the shutter for the next exposure the blades must swing back again to their starting position; while an auxiliary shutter closes the lens opening. Some early designs even permitted the driving ring to move in alternate directions for alternate exposures, thus obviating the need for the auxiliary capping shutter; the tensioning and speed control mechanism is then, however, more complex and bulky.

The shutter shown in Fig. 17.30 permits exposure times down to as little as 1/1,000 sec. The longer blade travel makes greater acceleration possible while the more balanced blade shape reduces the stresses on the mechanism and thus permits the use of more powerful driving springs. For slow speeds the actuating ring has to clear an escapement mechanism in the open position of the shutter, and described in § 263. A drawback of this shutter is that the swing blade movement needs more space, increasing the diameter of the shutter casing for a given opening diameter.

The use of two separate sets of shutter blades also overcomes, the drawback of reciprocating blade action (Fig. 17.31). Each blade only moves in one direction during the exposure; one set to open the shutter and another set to close it. This, however, also requires separate driving rings for the two blade sets and an

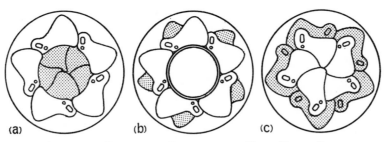

(a) (b) (c)

FIG. 17.31. DIAPHRAGM SHUTTER WITH DUAL BLADE SETS

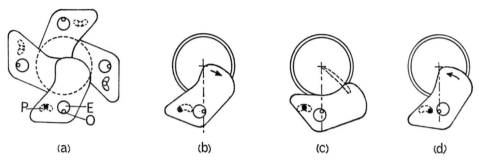

FIG. 17.32. DIAPHRAGM SHUTTER WITH EXCENTRIC BLADE DRIVE

inter-coupling system to release the closing blades immediately the opening blades have reached the end of their movement. To tension the shutter, the opening blades must close again and the closing blades open; if they do so in this sequence, no separate capping blade or shutter is necessary during tensioning.

Another approach to increased shutter speeds is to replace the direct to-and-fro reciprocation of the blades by a smooth orbital motion which smoothly dampens most of the moving momentum at the end of the opening and closing stages. A four-blade shutter of this type (Graflex 1000, 1959) uses excentric shafts E rotating about an axis O to drive each shutter blade (Fig. 17.32). During the first quarter of its revolution the eccentric shaft moves the shutter blade against a pivot P before the blades open; each blade then swings out of the aperture circle during only 40° of further shaft rotation (Fig. 17.32c) and swings back again during a further 70° of rotation. The last 64° of the eccentric revolution serves to brake the blade movement after closing. Thus the blade slides out of the way, reverses its direction by a swinging movement instead of by coming to a sudden stop, and slides back again. The efficiency even at the top speed of 1/1,000 sec is of the order of 75 per cent while the shutter opening is about 25 mm.

The "run up" period in which the shutter is still closed during the opening cycle is also the basis of shutters which reach extreme speeds by only opening partly. At speeds up to 1/500 sec the blades start from a normal closed position as shown in Fig. 17.33a. For higher speeds of 1/1,000 and 1/2,000 sec the blades start from a position of greater overlap as in Fig. 17.33b, so that the first phase of the blade travel still keeps the shutter closed. In opening the blades only partially clear the shutter opening (Fig. 17.33c) before the blades swing shut again. In Fig. 17.34 the curve AOA' is the opening curve of such a shutter; increasing the overlap at the beginning of the travel keeps the shutter closed below the opening level CC', so that the total opening period AA' is reduced to BB'.

The effective exposure times are reduced in proportion; with this type of shutter the efficiency is never greater than 50 per cent at the top speed. If the normal minimum exposure time is 1/500 sec with an opening of day 20 mm, it can become 1/1,000 sec if the blades open only to 10 mm and even 1/2,000 sec by reducing the maximum opening further. So when the maximum lens aperture for the fully opening shutter is $f/2$, 1/1,000 sec would be obtained with a limiting aperture of around $f/4$ and 1/2,000 sec at $f/8$. The obvious drawback of this system

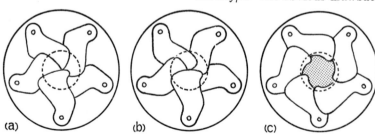

FIG. 17.33. PARTIAL OPENING OF SHUTTER BLADES FOR HIGHER SPEEDS

100%

C - - - - - - - - - - - - - - C'

A B B' A' Time

FIG. 17.34. OPENING CURVE WITH PARTIAL
 SHUTTER OPENING

is that the use of ultra short exposure times usually requires maximum apertures and the combination of $1/2,000$ sec at $f/8$ could be utilized only in very bright light conditions or with high speed films.

266. Multi-stage Rotary Shutter. The efficiency of a rotary shutter as shown in Fig. 17.7 (§ 256) can be increased by making the sector a complete circle and letting it rotate at a steady speed instead of accelerating and decelerating. The exposure time can be reduced by increasing the speed of rotation to the limit of the mechanical strength of the material and of the bearings—this limit can with a sector diameter of for instance 10 cm be well in excess of 10,000 revolutions per minute. To isolate one

of the 200 or more shutter opening cycles per second in such a system, one or more progressively slower shutters can be added without reducing the maximum shutter speed or efficiency.

A multi-blade rotary shutter using this principle is the Aerotop (1952) shown in Fig. 17.35. Here four sectors A_1, A_2, A_3 and A_4 rotate in synchronism in front of the opening D, between them uncovering and recovering the shutter opening once during every revolution. The sectors can rotate at up to 150 revolutions per second, which with a sector opening angle of 108° yields an effective exposure time of $1/500$ sec with an efficiency of well over 90 per cent. A second rotary shutter B with a sector opening B' rotates at about 20 revolutions per second and covers the lens opening during six out of every seven opening and closing cycles of the discs A_1 to A_4. Finally, a solenoid-actuated shutter C operating effectively at about $1/25$ sec selects one of the opening phases of B whenever required for the exposure. At the operating speeds of B and C the efficiency can still be at least as high as of the rotating blades A_1 to A_4. In use, the rotating blades are set moving a few seconds before an exposure is required, allowing them to reach steady speed, and the exposure made by operating the shutter C.

This rotary shutter is of course very large in comparison with the effective shutter opening and was developed for aerial cameras with an opening D of about 10 cm diameter. The fastest shutter speed can be increased further by

FIG. 17.35. MULTI-BLADE ROTARY SHUTTER (AEROTOP) CLOSED (LEFT) AND OPEN (RIGHT)

reducing the sector opening of the rotating blades A_1 to A_4: with an angle of 54° the exposure time becomes 1/1,000 sec with an efficiency of still over 80 per cent. Maximum speeds with appropriately adjusted openings and dimensions are of the order of 1/3,000 sec with an efficiency of at least 50 per cent at full aperture.

267. Electronic Shutter Control. The escapement controlling the exposure time (§ 263) in a diaphragm shutter can be replaced by an electromagnetic device which holds the shutter blades open while current flows through a solenoid, and lets the shutter close as soon as the current is interrupted. This is the principle of electronic shutters—so-called because the control circuit uses "electronic" semi-conductor devices such as transistors. In most cases the shutter itself is mechanical in its operation, being spring driven in the manner described in § 261. The electrical circuits serve only to control the open time at exposure times longer than the minimum exposure of the shutter. This minimum time—the top shutter speed—is thus mechanically controlled by the driving spring and the opening and closing rates of the blades. The electric speed control does not affect the shutter efficiency.

In the larger sizes, electronically controlled diaphragm shutters are used on studio and other professional cameras because the timing system is less subject to wear, provides a greater range of long exposure times and is a little more accurate than a mechanical escapement. Such electronically controlled shutters also permit remote control (§ 281). In amateur cameras small electronically controlled diaphragm shutters greatly simplify exposure automation systems, replacing a complex chain of mechanical scanning and linking elements between an exposure meter and the shutter by a compact and often more reliable electric circuit.

Electronically controlled shutters must be distinguished on the one hand from true electronic shutter systems—electro-optical and magneto-optical devices used only in very specialized cameras—and from electro-magnetic shutters on the other. In the latter, discussed in § 269, electro-magnets are used in place of springs to open and close the shutter, and not just to control the open time.

268. Electronic Control Circuit. The timing circuit of the electronically controlled shutter involves three main elements:

(a) A solenoid or electro-magnet fed from a small battery. This attracts an armature or

FIG. 17.36. ELECTRONIC SHUTTER CONTROL: STARTING POINT (COMPUR)

other device which prevents the shutter from closing after it has opened.

(b) A resistor-capacitor system, also fed by the same battery. The battery current charges the capacitor to the battery voltage, but takes a certain time to do so, depending on the resistance of the charging circuit. A resistor is thus ultimately responsible for the timing control.

(c) Two or more transistors, diodes or other devices which abruptly cut off the battery current to the solenoid—thus allowing the shutter to close—when the voltage on the capacitor has reached a given value in the course of charging. Transistors are compact semi-conductor elements, first developed in the late 1950s which can—like an electric valve—act as a non-mechanical switch in a circuit.

Figs. 17.36 to 17.38 show the arrangement and operation of a typical shutter control circuit. A battery B supplies current through the switch S_1 to the solenoid M. The current also passes through the transistor 2 and a fixed resistor E. Part of the current flows through another resistor F to the base contact of the transistor 2; this makes the transistor conducting. At the beginning of the cycle there is not sufficient current to make the transistor 1 conduct. Normally the switch S_1 is open and S_2 closed; the latter short-circuits the capacitor C. The shutter is shown with one blade only for clarity.

On pressing the shutter release, current flows through the switch S_1, attracting the armature L to the solenoid M. The shutter blades open and are held open as the pawl linked to the armature blocks the movement of the rotating member N. This remains blocked as long as the armature L is attracted to the magnet M, as shown in Fig. 16.37.

With the switch S_1 closed, the battery B also begins to charge the capacitor C through the resistor R. The shutter contains a series of such

FIG. 17.37. ELECTRONIC SHUTTER CONTROL:
OPEN HOLD

resistors which can be switched into the circuit by moving the shutter speed setting ring. The bold line in Fig. 16.37 shows the path of the holding current of the solenoid, while the bold broken line is the path of the control current through the resistor R and capacitor C as well as to the base of the transistor 2.

As soon as the capacitor has reached a specified voltage, this voltage—applied to the transistor 1—makes the latter conduct. This diverts the current from the base of the transistor 2 so that the latter ceases to conduct. Once the transistor 2 ceases to conduct current, the holding current flows along the heavy path in Fig. 16.38. The solenoid M now releases the armature L, pulled away by spring action, which in turn releases the rotating member N to disengage the shutter driving ring and allow the shutter blades to close.

The arrangement of the transistors 1 and 2 in conjunction with the resistor E ensures a rapid switch-over of the holding current from the path in Fig. 17.37 to that in Fig. 17.38 (Schmitt trigger). Numerous other triggering arrangements, some with up to four transistors and other elements, have been used for the same purpose.

The system shown in Fig. 17.36 uses a holding magnet, i.e. one in which the armature is normally in contact with the energized magnet and is lifted off by a spring when the current is interrupted. Alternatively, a traction magnet can be used which attracts an armature not in contact with it in the starting position, against spring tension. The holding magnet requires less energy for a given force because the air gap between the armature and the magnet is negligible. A traction magnet may be preferable in certain shutter designs but has to be bigger and the air gap must still not exceed 0·3 mm.

Since the open time of the shutter depends on the value of the resistor R in Fig. 17.36, and this can be very high without increase in physical dimensions, electronically controlled shutters permit a greater range of shutter speeds than a mechanical escapement. The slowest shutter speeds on large shutters for technical and studio cameras range up to about 30 sec, but this is a limit of convenience rather than of design.

The resistor can in principle be a rheostat for continuously variable exposure times. In practice a bank of resistors is used, with a different resistor for every shutter speed, as this gives more accurate timing. The precision depends on the rating of the resistors, and can be within a tolerance of 5 per cent. Temperature variations which effect the resistance will also influence the exposure accuracy. The resistor can even be replaced by a photo conductive cell whose resistance is controlled by the intensity of light falling on it; this provides a particularly neat possibility of direct exposure control of the shutter by the prevailing light.

269. Electro-magnetic Shutters. These cover (a) electro-dynamic systems in which magnets directly operate the shutter blades, and (b) magnetically energized shutters in which magnets operate mechanical elements like the driving ring of Figs. 17.27 and 17.28.

Electro-dynamic shutters are simpler in design, involving only electro-magnets and movable shutter blades. As the field of a magnet is inversely proportional to the distance from the magnetic poles, the shutter needs very powerful magnets to achieve even comparatively small shutter openings. In comparison with the size of the opening to be uncovered, an electro-dynamic shutter is therefore considerably bulkier than a spring-driven one. The speed is limited for a magnet cannot impart the same acceleration, even to lightweight blades, as a spring. It can, however, be singularly vibration-free

FIG. 17.38. ELECTRONIC SHUTTER CONTROL:
CLOSURE AFTER EXPOSURE

since the only moving parts are the blades themselves.

An electro-dynamic shutter with pivoted blades (Leitz, 1961) shown in Fig. 17.39 overcomes the limitation of opening diameter by making the blades *A* and *B* swing about pivots *O* and *O'* into positions *A'* and *B'* to open the light path *FF'*. Applying a current to the electromagnets *CC'* and *DD'* opens the shutter; energizing the magnet *EE'* swings the blades back again to close the shutter. This system,

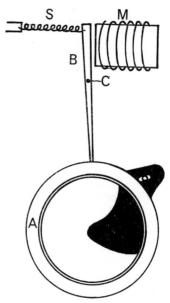

FIG. 17.40. ELECTRO-MAGNETICALLY ENERGIZED DIAPHRAGM SHUTTER

FIG. 17.39. ELECTRO-MAGNETIC FLAP SHUTTER

used in a photomicrographic camera, permits exposure times down to 1/100 sec.

Fig. 17.40 shows an early form of electro-magnetically energized shutter (Stevens, 1934) in which the driving ring *A* for the blades is linked to an armature lever *B* pivoting about a shaft *C*. When a current is applied to the electro-magnet *M*, the latter attracts the armature *B* against the pull of the spring *S*, thus opening the shutter. On switching off the current, the spring *S* pulls the armature away from the magnet, closing the shutter via the ring *A*.

In later versions (Fig. 17.41) the ring *A* carries two armatures *B* and *B'* which each move between an electro-magnet *M* and a permanent magnet *P* (and *M'*, *P'* respectively). In the position shown, the shutter is closed and held closed by the permanent magnet *P*. The current pulse through *M* attracts the armature *B*, opening the shutter; this is then held open by the second permanent magnet *P'*. A further pulse through the magnet *M'* attracts the armature *B'* again to close the shutter. Current thus flows only during opening and during

closing; in between the shutter can remain open indefinitely without drawing power.

The minimum exposure time is limited by the inertia of the mechanical movements and such shutters rarely permit speeds faster than 1/125 sec. The exposure time can, however, be controlled purely electrically by any convenient timing circuit that can deliver two current pulses at the beginning and the end of

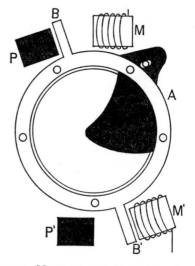

FIG. 17.41. MULTI-MAGNET ENERGIZED SHUTTER

the exposure respectively. The opening and closing movements as well as the timing can be remote-controlled.

270. Focal-plane Shutters. The so-called focal-plane shutter is a drop shutter having a flexible blind consisting of an opaque fabric or of an assembly of metal slats which works in a plane parallel to the film, and, at least in principle, at a very short distance from it. The important feature of this shutter is that it exposes the film piecemeal and can thus be used with a very narrow slit, giving a very short effective exposure time with almost maximum efficiency if the slit passes very close to the image (which it unfortunately seldom does). At the same time, the image may be deformed, the deformations becoming greater as the velocity of the moving parts of the image increases relative

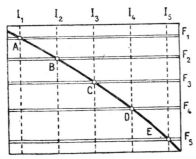

FIG. 17.42. ACTION OF FOCAL-PLANE SHUTTER

to the mean velocity of the slit during its passage across the image.

Suppose, for example, that after equal intervals of time, the slit (Fig. 17.42) occupies successively the positions F_1, F_2, F_3, F_4, F_5 (purposely made unequal distances, since the velocity of the slit is rarely uniform). Suppose, also, that at the same moments the image of a straight vertical moving line occupies respectively positions denoted by I_1, I_2, I_3, I_4, I_5. The little elements of this image which are photographed at each of the moments considered, represented by the points A, B, C, D, E, will therefore not give a vertical straight line in the photograph, but a complex curve depending on movement of the slit, and the image. It becomes a straight line if at all times the velocities are proportional, but would only be vertical if the straight line object remained stationary during the total time of exposure. Obviously, Fig. 17.42 assumes a very extreme and improbable velocity of the image, and exaggerates almost to the point of absurdity

the deformations which are produced in practice. These are not generally serious except in cases such as the images of the wheels of rapidly moving vehicles photographed at close quarters, e.g. cars on a racing track; the circular wheels is in such cases reproduced as an ellipse, and in extreme cases the spokes are actually curved inwards. No shutter placed between the lens would allow of exposures as short as those necessary for photographing on a relatively large scale moving bodies having similar velocities. Of two evils, the least must be chosen, and if one really wants a photograph under such conditions one must be prepared to find it deformed. It should, however, be clearly understood that it is no use trying to make precise measurements on a photograph which has been obtained by using a focal-plane shutter.

It follows from Fig. 17.42 that the actual deformation obtained depends on the movement direction both of the slit of the focal plane shutter blind and of the image on the film, Fig. 17.43 shows the four possibilities, allowing in each case for the fact that the image on the film is upside down and moves in the opposite direction to the subject. Thus if the slit in the shutter blind moves in the same direction as the subject, the image will be compressed (*a*); movement of the shutter slit opposite to the subject extends the image (*b*). If the shutter moves vertically upwards, a subject moving horizontally in front of the camera will appear to lean backwards against its direction of movement (*c*); with the blind running downwards the subject is distorted to appear to lean forward as in (*d*).

In the last two cases it is irrelevant whether the subject moves from left to right or from right to left. The direction of the distortion can however be reversed by turning the camera upside down to invert the direction of the shutter travel. Purely aesthetically, an image of for instance a racing car distorted by leaning forward adds to the visual impression of speed. More complex distortions are obtained if the subject moves obliquely with respect to the shutter travel, and if the blinds accelerate during their run (§ 273).

The distortion is greater, the faster the movement of the image on the film (assuming the blind travel rate to be the same at all shutter speeds). The distortion therefore increases not only the nearer the camera is to the subject, but also the longer the focal length of the lens used.

FIG. 17.43. IMAGE DISTORTION WITH FOCAL PLANE SHUTTER

271. Focal Plane Shutter Designs. The focal plane shutter, the use of which for ordinary photographic practice appears to have been suggested by H. Farmer in 1882, was not made commercially until after its use by O. Anschütz, in 1888, for studying the attitudes of moving animals.

The effective exposure time can be varied in two ways. Variations in the tension of the driving spring affect it, although the extent is only small. In some modern cameras having focal-plane shutters covering a wide range of speeds, the velocity of the blind can be varied mechanically. Apart from special cases, however, the majority of adjustment is carried out by varying the width of the slit.

In its original form the focal-plane shutter consisted of a blind made in two pieces, each attached to a sufficiently rigid rod and joined together by a cord in such a way that the width

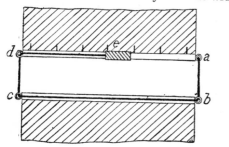

FIG. 17.44. SLIT ADJUSTMENT OF EARLY FOCAL-PLANE SHUTTER

of the slit, that is, the distance between the two rods, could be varied within sufficiently large limits, as shown in Fig. 17.44. Movement of the friction slider e pulls the blind together by the cord passing from a through the rings b, c and d. This clumsy setting system (necessitating opening the camera to change the exposure) was eventually replaced by a series of fixed slits, separated one from the other, in the same blind, by distances which were at least equal to the width of the image (R. Hüttig, 1900). According to the amount of blind which is wound on to the setting roller during setting, so one or other of the slits crosses the image field when the shutter is released, the blind being automatically stopped as soon as one slit has traversed across the whole image. A pointer outside the camera with an indicator mechanism shows the width of the slit available when the shutter is set. The slits are usually arranged in such an order that, merely by changing them, the tension of the driving spring automatically increases as the slit becomes narrower, thus causing the total time of travel to decrease as the slit width decreases, the effective exposure time being decreased in both ways.

As such a shutter would also expose the film during tensioning, i.e. when winding the blind back, an auxiliary or capping shutter is necessary to cover the field automatically during setting.

Modern focal plane shutters avoid this drawback by various devices which at the same time

allow the width of the slit to be regulated from outside the camera. A common earlier arrangement uses two separate blinds, of which one, stretched between the driving roller B (Fig. 17.45) and the setting roller A, has a fixed slit ab, of height usually equal to the width of the image. The other, which runs between the driving roller D and the setting roller C, ends

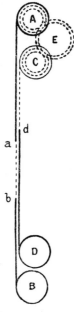

FIG. 17.45. ADJUSTMENT BY TWO BLINDS

at d and is wound round C by means of strips continued from its two sides. The setting rollers A and C are operated by a common key integral with the toothed wheel E which engages simultaneously the pinions mounted on the axes of A and C. The pinion A is keyed to its axle, but the pinion C is held on its axle only by friction. When the blind CD is as far down as it will go, the edge d having passed the limits of the field, the setting key can still be turned and the blind AB raised until the width of the desired slit, as indicated externally on the camera, is obtained between the edges a and d of the two blinds. Ratchet arrangements thereafter prevent any relative displacement of the two blinds, after the width of the slit has been adjusted, both during the operation of the shutter, and also at setting, during the passage through the field of the slit ab, which is covered by the blind CD as soon as the photograph has been taken. In practice the wheel E is linked

with a wheel or disc calibrated in exposure times. During tensioning the blind d is wound back on to the roller C before the blind ab, so that the shutter runs back closed without admitting light to the film.

An early focal plane shutter of high efficiency (G. Sigriste, 1899) formed the slit by two heavily bevelled sharp metal flaps which moved only 0·1 mm from the plane of the sensitive emulsion. The flaps were joined to the front of the camera by bellows and could be adjusted to a slit width down to 0·1 mm. Springs acting as brakes during part of the movement ensured practically uniform velocity to the slit, while variations of the slit width and driving spring tension provided 120 different exposure times from 1/40 to 1/5,000 sec.

272. Two-blind Focal Plane Shutters. Modern miniature cameras use a different design of two-blind shutter, first introduced in the Leica (1924). Which has the advantage of permitting compensation for the variable blind speed (§ 273).

In this shutter, shown in principle in Fig. 17.46, a blind d is wound up on the driving roller D and joined to the outer section A of another roller by strips d' continued from the sides. The second blind c is wound up on the inner section B of the roller A and carries strips c' connected to the second driving roller C. The two blinds run down independently, the effective slit width e being determined by the interval between the two blinds.

At the start of the exposure (Fig. 17.47a) the ends d and c of the blinds overlap outside the image area on the film F. As the first blind begins to run down for the exposure, it uncovers the film once it has passed the run-up distance r; when this blind reaches a position d'' (Fig. 17.47b), it trips the release of the second blind in the roller system AB and the leading edge of the second blind c'' now begins to cover up the film area again. The effective exposure time

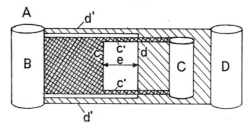

FIG. 17.46. MODERN TWO-BLIND FOCAL PLANE SHUTTER

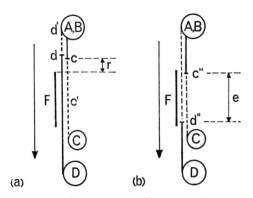

FIG. 17.47. OPERATION OF TWO-BLIND SHUTTER

is therefore the interval between the release of the first and of the second blind.

If the first blind has just fully uncovered the film as the second blind begins to cover it, the exposure is equal to the travel time of the blind across the image and the effective slit width is equal to the image width (assuming, for the moment, the two blinds to move at the same rate). With a medium-format (e.g. 6 × 6 cm) camera this travel time is of the order of 1/25 or 1/30 sec; with a 24 × 36 mm miniature it may be 1/50 to 1/100 sec.

Shorter exposure times involve closer intervals between the blinds. The shorter the travel time, the greater can be the blind separation for a given exposure time, and the easier it is to set a high shutter speed accurately. Shutters with a travel time of 1/100 sec can often reach effective top speeds of 1/2,000 sec. The travel time is important in that it determines the fastest speed for synchronizing instantaneous flash sources or electronic flash.

As the blinds of a traditional focal plane shutter design have to be wound around rollers, they must be sufficiently flexible as well as durable to stand up to constant flexing. The blinds are therefore usually made of fabric (though plastic coated steel foil and segmented metal blinds have also been used) which involves comparatively complex assembly and installation in the camera. Focal plane shutter designs evolved with the aim of simplifying this aspect of construction include all-metal plate shutters which can be constructed as complete sub-groups in much the same way as a diaphragm shutter. In a typical system shown in Fig. 17.48 the shutter blades B and C and their driving arms A and D are mounted on a plate fixed in front of the film. To open the shutter, these arms D pull aside the plates C (Fig. 17.48b); to close the shutter the arms A push the plates B across the picture aperture again (Fig. 17.48c). The arms themselves are spring driven and the interval between the operation of the two sets of arms controlled by an escapement or other timing system.

Notable among other all-metal focal plane shutter designs is a folding flap system operating like a pair of folding doors at opposite sides of the picture aperture. One of the flaps covers the picture aperture in front of the film, the other is folded up against its own side. For the exposure the "closed" flap folds away to one side, followed by the closing of the other flap across the picture opening uncovered by the first flap.

Exposures longer than the travel time of the shutter blinds (i.e. when the image area is fully uncovered) may be timed by various methods. Earlier shutters with a fixed or adjustable slit often used a mechanical brake or a gear train to slow down the travelling rate of the blinds. On two-blind shutters with separately running blinds an escapement mechanism—similar in principle to the escapement of a diaphragm shutter (§ 263) may delay the release of the second blind after the first blind has fully run down. Focal plane shutters can also be controlled electronically with a circuit similar in principle to that described in § 268. The control magnet there holds back the release of the second blind until the resistor-capacitor circuit trips a transistor system to de-energize the holding magnet.

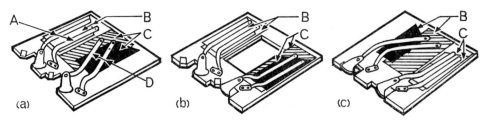

FIG. 17.48. FOCAL PLANE BLADE SHUTTER

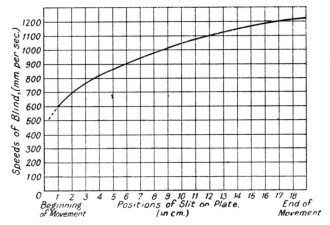

FIG. 17.49. VARIATION OF SPEED OF BLIND DURING EXPOSURE

The control range of such an electronic system may extend from the fastest shutter speed to exposures of several seconds in duration and may be set by switching different resistors into the control circuit or by the resistance of a photoconductive cell in response to the light intensity falling on the cell.

273. Shutter Acceleration and Exposure Uniformity. In the case of most focal plane shutters the velocity of the blind varies quite appreciably during its time of travel. The blind, starting from rest, possesses considerable inertia which, at narrow slit widths, causes the exposure along the edge of the image first uncovered to be considerably greater than at the opposite edge. Even though the tension of the driving springs may be decreasing, the acceleration of the slit is very definite, its velocity at the end being often double that at the start. Fig. 17.49 shows, from the measurements of Verain and G. Labussière (1918), the variations of this velocity in the case of the focal-plane shutter of the 18 × 24 cm cameras of the French Military Aviation.

Figs. 17.50 to 17.52 show the effect of blind speed and speed variation on the exposure. In the ideal case (Fig. 17.50) the shutter moves at constant velocity and consists of a fixed slit formed by one or two blinds. The curve AA' represents the movement of the leading edge of the slit and curve BB' that of the trailing edge. The distance BA along the horizontal axis thus corresponds to the slit width; CC' is the image width, assumed here to be greater than the slit width (i.e. a comparatively narrow slit travelling across the film). The exposure

begins when the leading edge of the slit starts to uncover the image area at K. At this section of the image the exposure lasts until the trailing edge of the slit covers up the image again at L. The effective exposure time is thus ab. The same conditions obtain at the end of the image area at C' which is successively uncovered (N) and covered (M) by the two edges of the slit. The exposure time at C' is thus the interval cd. If the blind velocity (and hence the slit velocity) is constant, AA' and BB' are straight lines and it follows from the geometry of Fig. 17.50 that $ab = cd$, and hence every point of the film receives the same exposure.

As in practice the blind with its slit accelerates, an actual shutter travel graph will have the shape of Fig. 17.51. The movement of the leading and trailing edges of the slit is no longer represented by straight lines but by similar curves AA' and BB' displaced along the

FIG. 17.50. IDEAL FOCAL PLANE SHUTTER TRAVEL CURVE

FIG. 17.51. SHUTTER TRAVEL WITH VARYING
BLIND SPEED

FIG. 17.52. EXPOSURE WITH SEPARATELY
TRAVELLING BLINDS

horizontal axis. The leading edge uncovering the beginning of the image area C at the point K moves more slowly than the trailing edge of the slit which follows slightly later at L. At the beginning of the blind travel the effective exposure time ab is therefore greater than when the slit reaches the far end of the image area C', when the effective esposure is only cd. The distance $LL' = BA = MM'$, being the constant slit width.

This variation in exposure at the beginning and at the end of the blind travel can be compensated approximately in various ways. The simplest is to arrange for a run-up distance between the start of the blind movement and the start of a picture area. Thus if the slit reaches the beginning of the image area only at C' and leaves it at C'', the difference between the exposure times cd and ef is reduced, the velocity of the blind being more uniform over this period. This is helped in part by the fact that the spring tension is also reduced; a spring can even be made to act as a progressive brake towards the end of the shutter travel.

In modern miniature cameras this speed variation of the blind is often compensated by varying the width of the slit during the travel of the blind. This can be achieved almost automatically if the shutter consists of two separate blinds as in Fig. 17.46 (§ 272), with the two blinds starting to travel at different instants in time.

Fig. 17.52 shows the result of this arrangement. The two curves AA' and BB' are still indentical, but are now displaced vertically along the time axis instead of horizontally along the distance axis as in Fig. 17.51. As the leading edge of the slit formed by the first blind begins to uncover the picture opening C at K, the second blind is still at rest. By the time that blind reaches the picture opening at L, it has accelerated to the same extent as the first blind had at K. The relative acceleration of the blinds remains the same throughout the exposure. At any point in the image area the two blinds pass at identical velocities, though these velocities vary for different image points. As a result the effective exposure times ab and cd are the same, but the effective slit width increases from LL' at the beginning of the shutter travel to the equivalent of MM' at the end.

The perfect compensation for the shutter acceleration in Fig. 17.52 is not easily obtainable in practice because it applies only if both blinds have identical accelerations. This would necessitate identical masses and driving spring characteristics—which is rarely achievable. Spring tensions and types may in fact be deliberately varied to compensate for differences in the mass and inertia of the two blinds. With actual shutters, there may thus be some over or under compensation.

The variations in blind speed also affect the distortion of moving objects (§ 270). With an accelerating slit an object moving at right angles to the shutter travel will no longer be distorted as shown in Fig. 17.43c and d, but will have a shape similar to the area $KLMN$ in Figs. 17.51 or 17.52. But as exposures made with a focal plane shutter are rarely used for movement analysis anyway, this is only of academic interest.

The effect of the variable slit width during the travel of the blinds can also be obtained if the effective width of the slit can be changed without changing its real width, and this has been done (Zeiss Ikon, 1935), as shown in Fig. 17.53. When the slit is at one edge of the field the pencil of rays reaching the film (A in diagram), has a larger angle than when at the other edge (B). Thus the effective exposure changes as the slit crosses the film. It can be seen that the change is greater when the slit is narrowest and the effective exposure shorter; this change is as it should be.

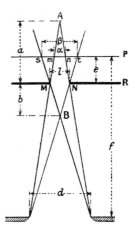

Fig. 17.55. Efficiency of Focal-plane Shutter

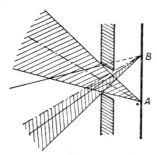

Fig. 17.53. Compensation for Acceleration of the Blind

274. Focal Plane Shutter Efficiency. If the slit of a focal plane shutter is in actual contact with the surface of the sensitive film, the slit fully uncovers any given point on the film instantaneously to the light from the whole lens opening. The effective opening time is then 0 and such a shutter would be 100 per cent efficient (compare § 254). As all focal plane shutters must be mounted some distance in front of the film plane, the shutter takes a short time to uncover the light cone from the lens during the sequence of instants depicted by Fig. 17.54. Thus in Fig. 17.54b part of the light is still cut off and this time interval between Figs. 17.54a and 17.54c corresponds to the

opening time of a diaphragm shutter and leads to a similar loss of efficiency.

Consider a cross-section (Fig. 17.55) through the optical axis perpendicular to the slit. Let d be the diameter of the lens aperture, f its distance from the emulsion P; l the width of the slit MN in the blind R, which is at a distance e from the sensitive film. The planes through the edges of the slit and bounded by the edges of the aperture determine on the one hand a zone MAN inside which the illumination is the same as in the absence of a shutter, and, on the other hand, a zone MBN of which the regions not common with the preceding zone receive light from only a fraction of the lens aperture, which fraction becomes less as the distance from the zone of full illumination increases.

Calculations which cannot be reproduced here show that, when the zone of full light reaches the emulsion layer ($a > e$), the efficiency is equal to the ratio of the sum of the widths of the band mn, cut at the film by the cone of

(a) (b) (c) (d)

Fig. 17.54. Opening Sequence of a Focal Plane Shutter Running at a Definite Distance in Front of the Image

full illumination, and of one of the bands of the penumbra *sm* or *nt*, to the total width of the illuminated band *st*. This efficiency is given by the expression

$$\text{Efficiency} = \frac{1}{1 + \dfrac{de}{fl}}$$

The table given below (M. Pau and L. P. Clerc, 1917), calculated for certain cameras of the French Military Aviation, shows the percentage values of the efficiency for different given widths of the slit.

Focal distance F (inches)	Relative aperture d/F	Distance from the blind to the plate e (inches)	Slit widths (inches)				
			0·04	0·20	0·39	0·78	1·57
10·23	1/5·7	0·51	30·5	71·2	81·4	89·7	94·6
10·23	1/5·7	0·90	19·9	55·4	71·3	83·2	90·8
20·46	1/6	1·57	13·1	37·5	60	75·1	85·7

It should be noticed that the time of exposure is not, as one might think, exactly proportional to the width of the slit, but to the width of the illuminated band *st*, i.e. to the expression $l + (ed/F)$. The exposure is thus proportionally longer for narrow slits than for wide ones. It can be seen from both the expression for efficiency and the table of practical results that the efficiency decreases as the effective exposure time is decreased and also as the lens aperture is increased, and it is unfortunate that these conditions usually go hand-in-hand. On small cameras the efficiency of a focal-plane shutter only becomes of importance at high speeds and large apertures.

We can also consider the efficiency of a focal plane shutter in terms of a shutter curve similar to Fig. 17.4 in § 254. Fig. 17.56 represents the change of light intensity received at any point in the film plane with a shutter arrangement as shown in Fig. 17.54. The rising part of the curve *AB* represents the gradual uncovering of the light cone from the lens from Fig. 17.54a to 17.54c; the stretch *BC* is the period between Figs. 17.54c and 17.54d when the light cone from the lens is unobstructed, while *CD* is the period during which the trailing edge of the slit progressively intrudes into the light cone again. The efficiency of this shutter is then the ratio of the areas $ABCD/AB''C''D$,

FIG. 17.56. EFFICIENCY CURVE OF FOCAL PLANE SHUTTER

or of the length $A'D'/AD$, where $A'B'C'D'$ is a rectangle of the same area as $ABCD$.

The shape of the quadrilateral $ABCD$ depends on the factors indicated above. The minimum efficiency can be characterized in the same way as for a diaphragm shutter, provided the maximum aperture of the lens is quoted as well, since with a focal plane shutter the lens diameter is not a parameter of the shutter.

When the slit width is exactly equal to the diameter of the cone of light from the lens at the point where the shutter cuts it (i.e. if $a = e$ in Fig. 17.55) the shutter "closes" the instant it has reached full opening, as shown in Fig. 17.57. The efficiency is then 50 per cent, since the area of the triangle ABD is half the area of $AB'C'D$. If the slit becomes narrower still, there is no instant when a point on the film surface receives the full light from the lens, and the shutter curve becomes the triangle AEF in Fig. 17.57; the efficiency then drops below 50 per cent in terms of the full shutter cycle of Fig. 17.57. The effective exposure time is also decreased and the result is analogous to that of a diaphragm shutter which opens only partly (Figs. 17.33 and 17.34 in § 265).

It is interesting to note (A. Klughardt, 1926)

FIG. 17.57. REDUCED FOCAL PLANE SHUTTER EFFICIENCY WITH NARROW SLIT

that in the case of a focal-plane shutter of which the blind moves with a uniform velocity, the effective exposure is constant when only the distance of the blind from the sensitive film is varied. The quantity of light is then the same, whatever the position of the shutter may be, if all other conditions remain the same, but this quantity of light is received in a length of time which increases with increasing distance of the blind from the emulsion.

275. Practical Rules for the Use of Focal Plane Shutters. With modern shutters permitting only adjustment of the effective slit width to control exposure time, it is only moving subjects which need special attention. One aspect is the best position for the shutter to keep image distortion reasonably small. We saw in § 270 that the distortion is at a maximum when the slit movement is perpendicular to that of the image, and this arrangement is usually best avoided when photographing rapidly moving objects. With such subjects it is often desirable to swing the camera during exposure so as to keep the image on the film relatively motionless. By this means the distortion may be transferred from the subject to the background. In the photography of subjects such as racing-cars this is not always a bad thing, as it increases the sensation of speed.

Except in the special case just mentioned, the camera should be held quite still during the *total* exposure, which may be much longer than the local exposure. Any movement will cause distortion of the subject even if it does not cause blurring.

Special problems arise when a focal plane shutter is used with flashing or pulsating light sources whose light cycle period is shorter than the travel time of the shutter. Thus synchronization of flash light sources with the shutter is only possible at exposure times where the shutter blind fully uncovers the image area, or with a flash source whose duration is at least as long as the total travel time. Otherwise the picture is unevenly exposed in the travel direction of the shutter. Similarly, flickering lights such as neon, mercury or fluorescent lamps operating from alternating current, produce an image formed of light and dark bands.

On larger (and older) focal plane shutters where exposures are adjusted by changing both the spring tension and the slit width, it is usually best to adopt the greatest speed of the blind possible for a given exposure. This reduces the total time of travel and hence also the possible

deformation of moving objects. The wider slit also leads to improved efficiency.

Where a focal plane shutter with uncompensated acceleration of the blind is used for photographing a static landscape, advantage may be taken of the variation of local exposure from one end of the image to the other to reduce slightly the exposure of the sky and the distance. The camera should then be held so that the shutter slit travels downwards in the image plane, reaching the sky area of the film last.

276. Choice of Type of Shutter. The wide selection of shutter types available at one time for technical and studio cameras (§ 256 ff) is nowadays effectively narrowed down to different types of diaphragm shutters, with older systems being chosen on account of their low cost when demands on shutter performance are modest, as in studio portraiture. The choice between a diaphragm and a focal plane shutter is usually a matter of choosing the appropriate camera, especially among miniatures and miniature or roll film reflexes, since it is not possible to interchange these two shutter types and only rarely feasible to have both on the same camera.

For cameras with interchangeable lenses a focal plane shutter provides the greatest versatility in the choice of lenses since the lens itself is independent of the shutter. Its other main advantage is that it permits shorter minimum exposure time than most diaphragm shutters and is therefore popular among photographers specializing in sports and other rapidly moving subjects. The shutter here must have a blind running very close to the film since high efficiency is indispensable in this kind of work where the exposure is at its absolute minimum. In the choice of a camera with a focal-plane shutter, the question of efficiency is one of great importance.

The main drawback of the focal plane shutter, apart from the image distortion of moving objects, is the difficulty of synchronizing flash illumination with high shutter speeds. For this reason certain press and reflex cameras are fitted with both a focal plane shutter in the rear of the camera and a diaphragm shutter built into the lens, so that the photographer can use whichever shutter type is suitable for the occasion.

With technical and view cameras where the camera design does not allow the easy fitting of the focal plane shutter, interchangeable lenses must each have their own diaphragm shutter. Alternatively, a diaphragm shutter of sufficiently large opening may be used immediately

behind the lens; this does not impair the interchangeability of the lenses while the comparatively limited speeds of such a shutter do not constitute a serious drawback with the type of subject photographed with such cameras.

For general use the modern diaphragm shutter is probably the best and it still permits a certain degree of lens interchangeability on miniature cameras where the shutter is built into the camera and the lenses mounted in front of it. The drawback of this arrangement is that with lenses of longer focal length the shutter is located at some distance behind the lens and subject to the disadvantages of this position (§ 253). This drawback does not apply to a shutter behind the lens in a technical camera, since the shutter there located behind the front lens standard and thus remains immediately behind the lens even at increased camera extensions. For flash photography, suitable synchronizing systems can synchronize any flash source with any exposure time of the shutter.

277. Shutter Testing. Methods available for testing shutters range from simple procedures easily followed by the photographer to determine approximate exposure times at each setting, to sophisticated methods using elaborate equipment to study the full movement of the shutter leaves or blind. Such equipment is used not only in professional shutter testing but also in the course of production control by shutter and camera manufacturers.

A distinction may also be made between photographic and non-photographic testing methods, i.e. those where a light trace or other moving image is photographed in a camera fitted with the shutter under test, and instruments which monitor the light transmission through the shutter at different instants of its opening and closing cycle. These non-photographic methods are the only ones rapid enough for routine testing in, for instance, shutter manufacture.

Most simple methods consist of photographing at a known magnification a luminous or well-lit object moving with a known velocity, and measuring the length of the image registered during the time the shutter is open. As a moving object a steel ball falling freely through a definite distance may be used. Another suitable moving object is a radial line in white on a gramophone turntable which turns at a known rate, or a bright mark fixed to the rim of the wheel of a bicycle, of which, after having exactly determined the gear ratio, the crank is turned at a known rate measured on a seconds watch or a properly-adjusted metronome. In the two latter cases, measurement of the angle subtended at the centre by the arc which is recorded allows the exposure time to be calculated. If this process is carried out with a dark background it is easy, by moving the camera after each exposure to photograph on the same plate, without any risk of confusion, the arcs corresponding to the different shutter settings.

Still another way of shutter testing is to photograph a source of light which is periodically extinguished with known frequency, by sharply displacing the camera during the exposure, in such a way that the different images of the source are distinct from one another and can be counted. For example, an alternating current electric arc may be photographed, or, if greater accuracy is required, a singing flame adjusted to a diapason (U. Behn, 1901) may be photographed in a suitably-equipped laboratory.

A convenient light source using modern technique is a neon lamp supplied by an alternating current at a suitable known frequency.

An entirely visual process which is very suitable for rapid testing in factories consists in having a luminous point which is rotated in a circle by a motor, the speed of which may be controlled and measured. The speed is continuously increased until the image seen on a ground glass, and originally limited to an arc of a circle, closes into a complete circle. The time of exposure is then equal to the duration of one revolution (R. A. Woolven, 1913).

A method of determining the effective exposure is to let the light from a constant light source fall through the shutter on to a photoelectric cell. If the electrical output of the photocell (which is proportional to the amount of light) is integrated by a suitable electronic circuit (e.g. the charging of a condenser) and measured, it will be a measure of the quantity of light transmitted by the shutter, and thus, after calibration, of the shutter speed.

For the complete study of the movement of shutters one can, in addition to the cinematographic process already mentioned (§ 254), project the image of the shutter on to a fixed slit behind which a drum covered with sensitive paper is turning rapidly with a known velocity. On development, this gives a record similar to that reproduced in Fig. 17.58, where is also shown the vibration of a diapason (each complete vibration represents 1/300th second), in such a way that the time of opening, of full aperture, and of closing, may be read off directly. In

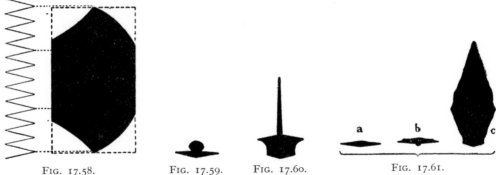

FIG. 17.58. FIG. 17.59. FIG. 17.60. FIG. 17.61.

SHUTTER EFFICIENCY DIAGRAMS SHOWING VARIOUS TYPES OF FAULT

place of a diapason, an intermittent light source (such as a stroboscopic lamp, or a continuous source the light of which is interrupted by a rotating sector wheel) of known frequency may be used. The efficiency is equal to the ratio of the area traced out to that of the rectangle shown by the dotted lines (de la Baume Pluvinel, 1889). By means of this method any peculiar behaviour in the working of the shutter can be investigated, such as the rebounding of the leaves after closing (Fig. 16.50), excessively slow closing (Fig. 17.60), or variations in behaviour for the same setting. In Fig. 17.61, a, b, and c correspond with three consecutive releases of a given diaphragm shutter without any variation in the adjustment of the exposure time (T. Smith, 1911). This method can also be used for the study of focal-plane shutters.

A method suggested in 1905 by M. Hondaille for testing focal-plane shutters is based on the deformation of the images of radii of a rotating disc, photographed as large as possible.

A related procedure for visual routine testing uses a rotating drum with a number of illuminated slits. The camera is arranged so that the slit images move at right angles to the travel direction of the shutter blinds. Viewed from behind

the shutter, patterns similar to Fig. 17.62 become visible and can either be compared with standard template patterns or photographed for later evaluation. The distance w in Fig. 17.62 indicates the slit width (which is seen to increase as the shutter travels in the direction S). The gradient of the edges of the bright strips 1 and 2 at any point is proportional to the velocity of the first and second blinds respectively at that point; if the speed of rotation of the drums in the direction D and the number of slits in the drum is known, the blind speeds can be calculated. The curvature of these strips to the left in Fig. 17.62 shows the acceleration of the blind; the strips correspond in their shape—when inverted—to the curves of Fig. 17.52.

278. Electronic Testing Instruments. The most widely used instrument for the rapid assessment of shutter characteristics is the cathode ray tube oscilloscope (D. T. R. Dighton and H. M. Ross, 1946–7), which plots on the screen of a cathode-ray tube a graph of light transmitted by the shutter against time (Fig. 17.63). The interpretation of such a graph is discussed in § 254.

The spot, which normally remains motionless at the origin, is deflected vertically proportionally to the output of a photocell which receives light transmitted by the shutter. Horizontal deflection is supplied by a single-stroke time-base circuit, which is triggered automatically by the output from the photocell.

FIG. 17.62. FOCAL PLANE SHUTTER TESTING DIAGRAM WITH ROTATING SLIT DRUM; MEDIUM SPEED (LEFT) AND HIGH SPEED (RIGHT)

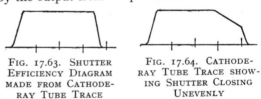

FIG. 17.63. SHUTTER EFFICIENCY DIAGRAM MADE FROM CATHODE-RAY TUBE TRACE

FIG. 17.64. CATHODE-RAY TUBE TRACE SHOWING SHUTTER CLOSING UNEVENLY

FIG. 17.65. CATHODE-RAY
TUBE TRACE SHOWING
LOW EFFICIENCY

FIG. 17.66. CATHODE-RAY
TUBE TRACE SHOWING
CLOSING BOUNCE

The two deflections thus occur simultaneously when the shutter is operated and the graph is traced. The spot returns to the origin, and then travels along the base line putting in timing marks. The screen has long afterglow properties, the pattern lasting long enough for measurements to be made. The timing marks can be made 1/10, 1/100 or 1/1,000 sec apart, and the speed of the time-base can be adjusted to cover a total time of opening from 1 sec to 1/5,000 sec.

Peculiarities of operation may be detected readily from the graph. A shutter which closes unevenly is shown in Fig. 17.64; a shutter with low efficiency in Fig. 17.65 and a shutter with closing "bounce" in Fig. 17.66.

For the study of the motion of the mechanism of shutters, a small discharge flash tube is built into the instrument and may be made to flash at any desired point in the operation, thus enabling the mechanism to be seen momentarily or to be photographed.

The oscilloscope signal can be modified to operate a digital read-out instrument which indicates the effective exposure time in milliseconds on a numerical display. This is particularly suitable for routine testing since it requires no further evaluation and the result is available within a fraction of a second of the actual test.

279. Shutter Releases. The operation of a shutter may be carried out by the direct pressure of a finger on the release lever, or alternatively by means of a flexible release, which may be pneumatic, mechanical or electromagnetic. Direct pressure on the release lever is only suitable for short exposures, and always introduces considerable risk of camera shake, which blurs the image.

This risk is greatest with everset diaphragm shutters (§ 264), where the release lever requires a fairly long travel, as well as appreciable pressure, to tension and then to trigger the shutter spring. A pre-set shutter (including focal plane shutters which are always pre-set) only requires the release of a lock which stops the shutter from opening or running down; therefore the release travel and the pressure required are much less.

With hand cameras (including miniature, roll

film and larger models) the shutter is rarely in a convenient position for a finger to reach the release on the shutter while holding the camera comfortably and steadily. Such cameras therefore nearly always have a shutter release button on the camera body within the reach of a finger of the right hand gripping the camera for shooting. The pressure is then transmitted from this so-called body release to the release lever on the shutter via a system of levers and linkages. Such a system becomes most complex on a folding camera and nearly always increases both the release travel and the release pressure even with a pre-set shutter.

Most body releases use a downward pressure on the release button, and the main risk of camera shake arises from the tendency to push the whole camera downwards with the release. Camera instruction books recommend various ways of gripping the camera to minimize the tendency to move it. Some designers have adopted release movements requiring a sideways or backward pressure (against the body of the camera). Others use large release levers to distribute the pressure over a greater area for smoother action and a more comfortable camera hold.

Some cameras even utilize a pre-tensioned release—which can be used with either a pre-set or an everset shutter (Agfa, 1969). A spring loaded movement is tensioned within the camera body during the film advance. Pressure on a membrane then operates a catch to release a spring which in turn actuates the shutter release proper. With this system very fine triggering with a release travel of under 0·5 mm may be obtained.

280. Indirect Releasing. With large-format technical and studio cameras of variable bellows extension, internal release linkages are not practical. With all cameras used on a tripod or stand, direct release pressure on any part of the camera is particularly likely to lead to camera shake. With such cameras the shutter is generally released with a pneumatic or cable release or with a remote control device.

The pneumatic release consists of a rubber bulb joined by a tube of suitable length to the shutter or the release lever. It is primarily employed on shutters used by portrait photographers, a long rubber tube being much more delicate than a metal one, and it is often very desirable that the photographer should not have to wait beside the camera for the whole of a longer exposure.

Pneumatic releases sometimes have a primitive means of timing longer exposure times, carried out by inserting a connexion carrying a tap, the rate of leakage being controlled by a movable index on a scale calibrated in times of exposure. Present-day pneumatic releases, usually employing plastic tubing, are often used for operating a camera from a distance. The tube carries a rubber ball at one end and a plunger system connected to a short cable release at the other. The cable release is then attached to the shutter. Such releases may have tubing lengths up to several metres. They require larger bulbs and more pressure for long distance operation, since then a larger volume of air has to build up to exert sufficient pressure on the release plunger.

The use of metal releases in photography started at the time when the flexible metal controls for bicycle brakes, invented by E. M. Bowden in 1897, were becoming common. These controls consisted of an unstretchable steel wire cable inside an incompressible sheath, made by winding a metal wire spirally around the cable.

In modern cable releases of this type, designed to screw into the small socket provided on most shutters, the method of operation is reversed. The inner wire is pushed and the outer case kept in tension, usually by the cloth cover which may be plastic or steel reinforced. A spring returns the cable and sheath to their previous positions as before.

These releases are less clumsy than pneumatic bulbs but also fragile, since any bend in the sheath gives rise to a permanent deformation and to friction which prevents the cable sliding easily, and they cannot easily be repaired. The release should not be too curved when rolled up. Special models exist in lengths up to about 3 metres, but long cable releases are harder to operate because of the increased friction.

Bulkier hand camera types fitted with anatomical hand grips (§ 249) may have a cable release built into the grip to provide the convenience of a body release.

Cable releases may incorporate a lock—a clamping screw or other device—to hold the plunger in its depressed position. This is useful with camera shutters not having a T setting to keep the shutter open indefinitely. (Nearly all modern miniature and roll film cameras, whether fitted with diaphragm or focal plane shutters, only have a B setting—§ 255—which

requires pressure on the release during the whole of a time exposure.) For long exposure times the plunger of the cable release is depressed, locked, and released again at the end of the required exposure time.

It should not be thought that the use of a cable release eliminates the risk of shaking the camera completely. The relative motion of the cable and sheath can be too great, and after the shutter has begun to operate the camera is shaken by further movement. For this reason such a release should be operated slowly. The cable between the camera and the operator should also be slack to avoid jerking the camera during releasing.

281. Electric Remote Control. Electromagnetic releases, which have been used for a considerable time in equipment to be worked from a distance (in ballistic or animal photography) consist of a solenoid (electromagnet) which attracts an armature when current passes through the solenoid windings. The movement of the armature is mechanically linked to the shutter release. Such solenoid releases are available for certain technical and press cameras and were used extensively in early systems of flash synchronization.

An electro-magnetic release is usually battery operated and may be worked from distances up to 100 metres. Greater ranges are possible with wireless control where a radio signal in a receiver trips a relay which in turn closes the release circuit. (In many countries radio controlled equipment is subject to licensing by the postal authorities.) In more elaborate remote control systems the release circuit may be linked with an electric motor drive (§ 305) which advances the film in a miniature or roll film camera immediately after releasing, resetting the camera for the next exposure.

Electronically controlled shutters may incorporate an additional electro-magnet for remote releasing. In electro-magnetic shutters (§ 269) the opening magnet can be controlled by a switch at the end of a lead which is plugged into the shutter.

Electronically controlled shutters offer more extensive remote control possibilities which include selecting exposure times and even apertures. This is useful not only for photography from camera positions which may be inconvenient or pose safety hazards for the operator (wildlife and animal photography on the one hand and certain types of industrial work on the other) but also in the studio.

For remote setting of exposure times with an electronically controlled shutter the resistor or both resistor and capacitor of the resistor-capacitor circuit (§ 268) is built into a separate control unit connected to the shutter by a cable. The remote control unit carries a setting dial which selects different resistances and is calibrated in exposure times. The operating range depends on the circuit values. For remote control operation a capacitor system requiring higher resistances is preferable so that the resistance of the connecting cable is small by comparison and does not appreciably affect the accuracy of the settings.

For remote aperture settings a servo motor controlled by a bridge circuit may be used. Fig. 17.67 shows the principle of the bridge circuit. The current from a battery or other source V passes through two parallel branches AB and $A'B'$. No current will flow across a link CD if the resistance ratios formed by the four sections or arms $A'C$, CB', AD and DB follows the relationship $A'C/CB' = A'D/DB'$. The bridge circuit is then said to be balanced. If AB is constructed as a potentiometer P and D is a sliding contact, then movement of D away from its balance point causes a current to flow through an instrument S. This may be an indicating meter or—for purposes of remote aperture control—a servo amplifier. The latter powers a motor which adjusts the contact C along the branch $A'B'$ (also designed as a potentiometer) until the no-current state across CSD is re-established; the motor then automatically stops.

In Fig. 17.68 the branch AB of the bridge

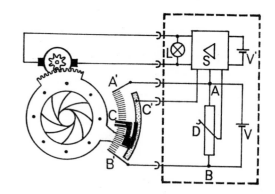

FIG. 17.68. REMOTE APERTURE CONTROL
(COMPUR)

circuit is contained in the control unit (shown in dotted outline) while the branch $A'B'$ is built into the shutter. To adjust the aperture setting, a dial on the control unit (calibrated in stop numbers) adjusts the position of the contact D within the potentiometer AB. The resulting current across the bridge—from D through the servo amplifier S and from there to C' and C—actuates the motor M which turns the iris ring in the shutter. This moves the contact C along the potentiometer branch $A'B'$ until the resistance ratio $A'C/CB'$ again equals AD/DB. At this point the current through S becomes 0 and the motor M stops. The direction of the current through S depends on the direction in which D is adjusted by the aperture selector dial on the control unit; the motor can thus adjust the lens opening in either direction. In practice the circuit also contains transistors which connect the battery V to the bridge circuit only when the position of D is changed; this avoids unnecessary current drain. A lamp L in the amplifier circuit lights up while the motor runs and goes out when the adjustment is completed.

Remote aperture control is also useful for changing from the full lens aperture used for focusing on a technical or studio camera to a smaller working aperture on inserting the film holder. The photographer can then remain behind the camera during this operation and does not have to check the aperture setting from in front of the lens. This particular facility can also be obtained by means of a device like a cable release connected to the aperture adjustment. The release plunger is depressed to the degree required to stop down the lens, the aperture setting being shown on an indicator

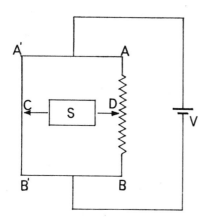

FIG. 17.67. BRIDGE CIRCUIT FOR REMOTE
CONTROL

FIG. 17.69. CABLE OPERATED APERTURE CONTROL (SINAR)

protruding above the lens board and visible from behind the camera. Fig. 17.69 illustrates such a device. The aperture control lever A of the lens is linked to the cable device B which can be pulled outwards by the grip D. Markers C along the protruding plunger of the cable indicate the actual aperture set at different positions of the plunger. The latter can be operated and the selected aperture read off from behind the camera.

In principle a remote control system based on a bridge circuit can also be used for other camera adjustments capable of being calibrated on a scale: focusing, focal length adjustment of a zoom lens, rotation of the whole camera on a motor driven tripod head, etc. Remote control systems are used for such purposes with television and motion picture cameras.

282. Delayed Action Release. Many diaphragm shutters incorporate an additional escapement mechanism which delays the opening of the shutter, once the release is pressed, by about 8 to 10 sec. This enables the photographer to include himself in a group or scene, once he has set up the camera and started the delayed action mechanism (also known as a self-timer). Similar delayed action systems are built into most amateur cameras with a focal plane shutter and there may either take over the function of pressing the release button (or acting on the internal linkages) or hold back the running down of the shutter blinds once the release has been pressed.

For self portraiture and similar applications the delayed action release has the drawback that the exact instant of releasing is not known, which may lead to strained expressions in anticipation of the exposure. Camera operation with an electric or even pneumatic remote release is thus usually more convenient, provided that the release tube or cable can be run outside the

camera's field of view. The delayed action release is, however, a useful aid to shake-free exposures where the exact instant of releasing is not vital. With a hand-held camera this permits a steadier grip not impaired by the need for pressing a button or lever. If the camera is mounted on a tripod (especially a lightweight one) the delay allows any camera vibration due to operating the release button or a cable release to die down.

Separate self-timers—spring driven clockwork mechanisms—are available for attaching to a cable release or screwing into the cable release socket of the shutter. Often the delay is adjustable within wide limits. Earlier designs for delay devices ranged from systems using a slow burning fuse to those depending on the slow flow of a fluid in a pump or air escapement mechanism, similar in principle to the air brake on a double guillotine shutter (§ 259).

283. Interlocking of the Release with the **Aperture Control.** With single-lens reflex cameras (§ 206 ff) where the interval between viewing the image on the screen and exposing can be cut to a fraction of a second, the factor which slows down operation most is the need for stopping down the lens from its full aperture used for focusing, to a given working aperture. Current reflex cameras, therefore, use various means of coupling this operation with the shutter release, incorporating it where possible in the automatic release sequence (§ 216) of the camera.

Automatic stopping down mechanisms are all based on the pre-set aperture control shown in its simplest form in Fig. 17.70. The lens carries two aperture setting rings: one moves a marker along the aperture scale A (or may carry this scale past a marker). This adjustment

FIG. 17.70. MANUALLY PRE-SET IRIS DIAPHRAGM

moves a catch B to a position corresponding to the aperture selected, but does not operate the iris diaphragm itself. The second ring is linked to the iris ring D which carries a lug or other catch C. On turning the iris ring in the direction of the arrow, the travel of the catch C is arrested by B at a position corresponding to the selected opening of the iris. To operate this system, the photographer pre-selects with the setting ring the aperture he wants to use, focuses at the full lens opening and turns the iris ring to its mechanical stop—without reference to the aperture scale—immediately before releasing the shutter.

Tht main problem of linking this movement with the shutter release is to provide a connection between the camera and a range of interchangeable lenses. Fig. 17.71 shows an external coupling system used with cameras which have a release button on the camera front fairly close to the lens mount. The iris ring D is here linked

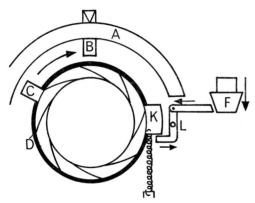

FIG. 17.72. SEMI-AUTOMATIC IRIS FOR INTERNAL COUPLING

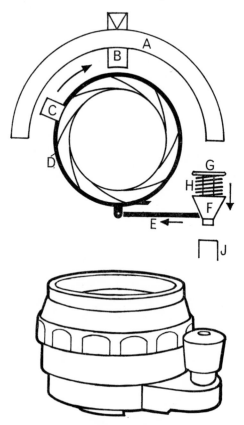

FIG. 17.71. SPRING CONTROLLED IRIS FOR EXTERNAL COUPLING

to a conical shaft F through a lever E. Pressing F downwards in the direction of the arrow moves the lever E sideways until C again hits the stop B. The release button G acts on F through a spring H which is compressed when C and B have met. Immediately after the iris has closed to the pre-set aperture, the button G also presses the release button J of the camera to make the exposure. On letting go of G, a further spring pushes up F again while an internal spring acting on D opens the iris.

The principle of a release-controlled iris for internal linkage is shown in Fig. 17.72. The elements A, B, C and D are the same as before but the iris ring carries a catch K connected to a spring and held in the open position of the iris by a lever system L. Pressure on the release at F releases the catch to allow the spring to move the iris ring until the lug C is again arrested by the pre-set stop B. Further pressure on F then release the shutter. After the exposure the iris ring has to be reopened by hand; this action may also be linked to the tensioning mechanism which brings the mirror down again into the viewing position. The linkage L may have various forms and is suitable also for interchangeable lenses where the connection L and F is made by a pin, lever or other device as the lens is mounted on the camera. This system is equally suitable for diaphragm shutters, whether built into the camera or into the lens.

On reflex cameras with instant return mirror it is desirable to reopen the iris to its full aperture as soon as the mirror returns to the viewing position. There an automatic iris control system similar to Fig. 17.73 may be used (the design details again vary greatly with different

makes). The catch K of the spring loaded iris ring D is held in the open position by a catch M on a further spring-loaded ring N. On pressing the shutter release, a lever or other linkage connected to the mirror pushes the ring N in the direction of the arrow, bringing M to the position M'. This allows the ring D to turn until C is once more arrested by B in the position corresponding to the selected iris opening. The exposure then takes place, after which the returning mirror pushes the ring N (or allows it to move) back to its original position, carrying the catch K with it to reopen the iris to its full aperture.

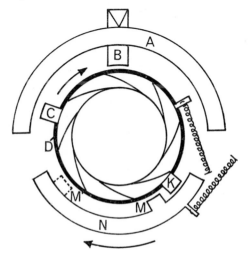

FIG. 17.73. AUTOMATIC IRIS FOR INTERNAL COUPLING

Provided the location of K within the lens mount is the same on all lenses to be used on the camera, this system permits automatic control with full lens interchangeability. In a form similar to that shown it is used most frequently on reflex cameras with a diaphragm shutter. Focal plane shutter cameras may use a corresponding arrangement or a connection through a pin protruding from the back of the lens mount and pushed into the mount by a lever or moving plate within the camera.

Modern reflexes, especially miniature reflexes, provide an automatic iris control system for most of their lenses from short focus to medium long focus. Lenses of longer focal lengths may have only a manual pre-setting feature as in Fig. 17.70, since the distance from the iris control ring to the camera fitting would then necessitate too long a linkage to operate efficiently. Sometimes such lenses have a spring controlled iris operated through a cable release; a twin cable release may synchronize the iris operation with the shutter release on the camera. Such cable control is also useful when the lens is used for macrophotography on a bellows attachment (§ 311), and where the variable bellows extension again makes linkage with the automatic iris control of the camera difficult.

To permit observation of the screen image—and especially the depth of field—at the working aperture, the iris can often be stopped down manually by a so-called depth-of-field preview control. This is a ring or lever which acts on the iris release (e.g. the conical shaft F in Fig. 17.71 or the ring N in Fig. 17.73) without releasing the shutter. The practical value of such visual depth control is limited to medium apertures, especially on the small screen of a miniature reflex camera. At small apertures the image is often too dark for reliable visual assessment of the sharpness near the limits of the depth of field zone.

284. Interlocking with the Film Transport. Among the most common mistakes made by photographers are the taking of two photographs on the same section of film, or (less frequently) winding the film on without exposing it.

To make amateur cameras more foolproof and reduce the number of mistakes of this type, systems have been devised which interlock the various operations. The most usual one is to have the film transport interlocking with the shutter release; in this case the film cannot be wound on until the shutter has been released, and the shutter cannot be released again until the film has been wound on. In more advanced types, the winding of the film automatically sets the shutter, and as soon as the film has been moved the necessary amount, it becomes impossible to wind it further. Operation of the shutter then releases the film transport and permits the next operation.

In some cameras these interlocks can be disengaged, e.g. to permit tensioning and releasing the shutter for deliberate double exposures, or to wind the film through the camera, without exposing it (for instance when reloading a partly exposed film length that has been removed before).

CHAPTER XVIII
VIEWFINDERS, FILM LOADING AND TRANSPORT, ACCESSORIES FOR HAND CAMERAS

285. Viewfinders. Cameras not equipped with a focusing screen, must have a sighting device— a viewfinder or finder—to enable the photo- grapher to check how far the subject is included in the image area on the film at the moment of exposure. The finder may be required to indicate only the direction in which the lens is pointed, but in almost all cases it is used to show the limits of the field covered. The accuracy with which finders do this varies greatly with finder types and cameras, so that checking the finder is a necessary precaution with any camera.

Ideally, the finder should present a view of the subject identical to that recorded on the film at all subject distances and with all lenses. Only a ground glass screen—of the correct size and location—in the back of the camera or in a single-lens reflex camera fulfils these conditions. Separate finders are subject to a number of errors, due partly to lack of precision in manu- facture and partly to the fact that the finder is a separate optical system. The main finder errors are:

(*a*) *Directional errors.* To show the correct view, the finder must point at the same subject as the lens. For objects at infinity this means that the optical axis AB of the lens in Fig. 18.1 must be parallel to the optical axis CD of the finder F. If the finder axis diverges along $C'D'$ (or along a direction at right angles to the plane of the diagram) it can never take in the correct field of view. A specific convergence as indicated by $C''D''$ is, however, used to correct parallax errors (§ 287).

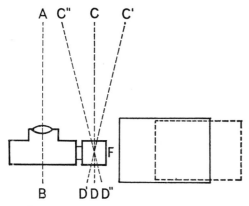

FIG. 18.1. DIRECTIONAL FINDER ERROR

A special directional error arises if the camera is fitted with a rising front or other parallel displacement of the lens (§ 221). The effective viewing direction of the camera—the line AB going through the centre of the lens and the centre of the image format in Fig. 18.2—is shifted so that it diverges from the sighting direction CD of the finder unless the latter provides a corresponding means of adjustment. Generally, however, the effect of parallel lens displacements—as of other camera movements—is best checked on the ground glass screen at the back of the camera, and hand cameras without focusing screens are rarely fitted with movements.

(b) *Levelling errors.* When verticals in the subject as seen through the finder are parallel with the vertical finder edges, the verticals in the film image should also be parallel with the vertical sides of the film format. In Fig. 18.3 the sold rectangle $ABCD$ represents the subject area recorded on the film and the broken rectangle $A'B'C'D'$ the view seen through an incorrectly levelled finder. Levelling errors are due to lack of precision in fitting the finder system (or more

usually, the masks outlining the field of view) in the camera; they have been known to arise even in single-lens reflex cameras. Levelling errors are likely to occur with swing-over reflecting finders (§ 293) which used to be fitted to folding roll film cameras and were turned round on the optical axis when changing from upright to horizontal views.

(c) *Field or angle errors* (framing errors) are present when the finder shows either more or less of the subject field than is recorded on the film. Ideally the angle of view of the finder should be identical with that which the lens covers on the film format. If the finder angle is greater, part of the view seen through the finder will not be recorded on the film. A reduced finder angle is less serious when using a negative film since the superfluous image area

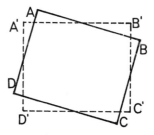

FIG. 18.3. LEVELLING FINDER ERROR

on the film can be cropped during enlarging. With reversal films yielding transparencies, a reduced finder angle is, however, troublesome, as it is less convenient to mask a transparency in its slide frame (see also § 247).

A reduced finder angle is often used in inexpensive cameras to minimize the effect of other finder errors, especially distance and parallax errors (see § 287) as well as directional and levelling faults.

(d) *Distance error.* This is a special case of a field or angle error as in (c) above. Where the camera lens is focused on nearer subjects by increasing the lens-to-image distance, the angle of view covered on the film also decreases (§ 136). With most finders the angle of view remains constant so that at close distances the finder shows more than is recorded on the film unless the finder field is reduced in the first place or compensated by other means.

(e) *Parallax error.* See § 287.

Methods for compensating or correcting finder errors are indicated when discussing the individual finder types.

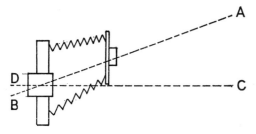

FIG. 18.2. DIRECTIONAL ERROR WITH RISING FRONT

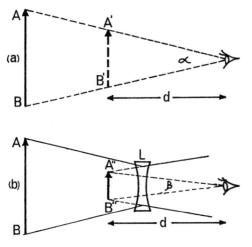

FIG. 18.4. FINDER MAGNIFICATION

286. Magnification. With the exception of open frame finders (§ 288), finders employ optical systems of one or more lenses which yield a reduced (or, more rarely, magnified) image. The finder magnification is the ratio of the visual scale of the image (seen through the finder) to that of the subject observed directly. In Fig. 18.4b a simple finder system based on a diverging lens L produces a virtual image $A''B''$ of the subject AB which appears to be at a distance d from the eye, subtending an angle β. As seen with the unaided eye (Fig. 18.4a) the subject AB subtends an angle α. To subtend the same angle at a distance d from the eye, the subject height would have to be $A'B'$. The finder magnification is then $A''B''/A'B'$.

An approximate visual estimation of the magnification is possible by mounting a measuring tape on a wall and viewing it simultaneously or alternately with the unaided eye and through the finder system, noting the apparent length of a marked distance (e.g. 1 metre) as seen through the finder compared with the tape as seen directly.

A finder magnification of unity or near unity is ideal, since it allows simultaneous viewing of the direct and of the finder image with minimum strain while keeping both eyes open. With finders which have to cover a wide angle of view (to match a wide-angle lens on the camera) a magnification of around 1 makes the finder very bulky. Therefore wide-angle finders tend to use greatly reduced magnifications (often between 0·3 and 0·5). Finders for telephoto lenses on the

other hand need magnifications greater than 1 to enlarge the narrow angle image in which the eye would otherwise discern insufficient detail.

Confusion may arise between finder size and finder magnification when dealing with the focusing screen of a reflex camera. The reflex screen shows what camera makers in their publicity literature call "a full-size image". This, however, compares the finder image with the image on the film and not with the scale of the subject as seen directly by the unaided eye. The visual scale of the screen image corresponds to the visual scale of the subject only if the screen is observed from a distance equal to the focal length of the camera lens (see also § 33). With a miniature reflex camera the visual scale is given by $E_m \times F/250$, where E_m is the eyepiece magnification, F the focal length of the lens in millimetres and 250 mm is taken as the normal viewing distance. A 50 mm lens and an eyepiece magnification of 5 × thus yields a visual finder magnification of 1.0. Obviously the use of long focus lenses increases the visual magnification of the finder system while the use of short focus lenses decreases it.

287. Parallax. The main problem of a finder whose axis does not coincide with the camera lens axis is the parallax error introduced by this difference in viewpoint. The difference between the image in the finder and the image in the camera is of the same order as the differences in the two images of a stereoscopic pair, and becomes more pronounced the nearer the subject is to the camera. It results in two separate viewing errors: a framing error and a perspective error.

The field or framing error arises because the displacement of the finder axis relative to the camera axis displaces the subject frame by a distance equal to the separation of the axes. In Fig. 18.5 the camera lens at O covers a subject field AB while the finder at O' covers a field $A'B'$. The displacement AA' is equal to s, the separation of the camera and finder axes. If the subject distance d is very large compared with s, the displacement AA' and hence the difference between the subject fields covered by the lens and the finder, is small. As s is usually of the order of a few centimetres, the framing error will also amount to a few centimetres—negligible if the subject field is several metres wide.

At nearer distances s, which is constant, becomes more important; with a portrait shot

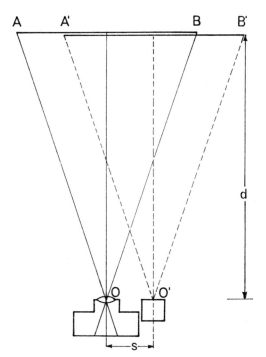

FIG. 18.5. FRAMING ERROR DUE TO FINDER
PARALLAX

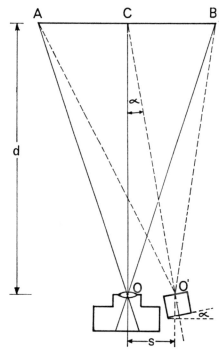

FIG. 18.7. CORRECTION OF PARALLAX FRAMING
ERROR BY INCLINATION OF THE FINDER AXIS

at 1·5 metres or 5 feet it may make the differ-
ence between the head being seen fully in the
finder but its top cut off in the picture.

The direction of the framing error depends on
the relative position of the lens and finder.
Thus a finder mounted at the side of the camera
(Fig. 18.6a) leads to a lateral displacement of
the finder field (dotted frame) compared with

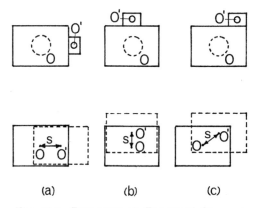

(a) (b) (c)

FIG. 18.6. DIRECTION OF PARALLAX FRAMING
ERROR

the field which the camera records on the film
(solid rectangle). A finder above the lens
produces a vertical displacement (Fig. 18.6b)
and a finder above and to one side of the lens a
diagonal displacement.

The simplest way of compensating the framing
error due to parallax is to reduce the finder view,
for instance to mask off the section BB' in
Fig. 18.5. This is obviously not feasible for very
close distances, as otherwise the finder view with
distant subject would be much smaller than the
view taken in by the lens.

A more accurate method of compensation is
to incline the finder axis so that it converges
with the lens axis in the centre C of the subject
field AB (Fig. 18.7). The angle of inclination
α is the angle OCO' and is given by $\tan \alpha = s/d$.
As s is constant, the angle depends on d; the
inclination must be different for different subject
distances. This compensation can be obtained
either by pivoting the finder on or in the
camera to permit bodily inclination—for ex-
ample as used in the twin-lens reflex system of
Fig. 14.30 in § 207—or by displacing the framing
mask in the finder towards the lens axis. Fig.
14.31 illustrates an arrangement of movable

masks. (This is analogous to a parallel displacement of the lens in a technical camera—§ 232.)

While it is possible to compensate parallax framing errors, there is no way of correcting the parallax perspective error, for the difference between the viewpoints of the camera lens and finder also leads to a perspective change. In practice this means that while the finder may correctly centre on the main object being photographed, the relationship between this and the foreground and background may be quite different in the image recorded by the camera (Fig. 18.8a) and the field seen in the finder (Fig. 18.8b). The only way of overcoming this, suggested for some twin-lens reflex cameras, is to move the whole camera bodily after viewing and focusing, and before the exposure, so that for the latter the camera lens is in the exact position previously occupied by the finder lens. Various camera supports with semi-automatic adjustment exist for this purpose, to give a twin-lens reflex the viewing accuracy of a single-lens reflex. The time delay introduced by this switch-over is, however, necessarily greater than the delay between viewing and focusing in a single-lens reflex.

288. Direct Vision Frame Finder. A simple and—when correctly mounted—perfect finder consists of a frame of sheet metal or wire of the same size as the picture to be formed in the camera. This is fixed to the camera front (on which it can be turned down when not in use) so to follow the lens in all its movements. This frame finder is completed by a sight, fixed near the back of the camera in a position such that a line passing through the sight to the centre of the frame is parallel with the optical axis of the lens when the latter is not decentred (Huillard, 1900). The parallax error with near objects can be corrected to a satisfactory degree in practice by mounting the sight on a sliding stem with a scale corresponding with the various distances of subject. The same result can be achieved by piercing the plate of the sight with several sight-holes, each corresponding with a given distance of the subject.

Instead of fixing the position of the eye relative to the frame by means of a sight (which is always troublesome to a wearer of glasses) a second frame may be used. This is similar to the first, but of smaller dimensions, and so placed that the straight lines joining corresponding corners of the two rectangles

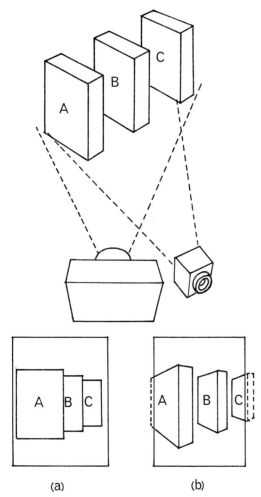

FIG. 18.8. PERSPECTIVE ERROR DUE TO FINDER PARALLAX

meet exactly at the sighting point. In this form, however, the finder no longer automatically follows the decentring of the lens. If the distance between the two frames is one-fifth of the focal distance (L. Benoist, 1897), the decentring of the larger frame must be one-fifth that of the lens. There is then no advantage in using a frame of the same size as the picture.

Frame finders used to be widely employed in press cameras and are popular for action and sports photography because the open frame and image scale of unity facilitate following rapidly moving objects when still outside the subject field of the camera. Such finders are also used on cameras in underwater housings and on space

cameras where diving masks or astronaut's helmets prevent the photographer from getting his eye close to the rear sight of the finder. For cameras with interchangeable lenses the finder may possess additional frames inside the main one to indicate the reduced field of view of longer focal lengths. One slight drawback is that the frame limiting the field of view is seen unsharply when the eye is accommodated to the more distant subject. This is particularly the case with smaller frame finders whose main frame is located nearer to the eye.

289. The Newton Finder. This is derived from the frame finder but fills the space of the frame with a diverging lens. The field of view taken in depends on the distance of the eye from the finder, and the accuracy of framing on having the eye centred behind the diverging lens. To help in centring, a pointer or rifle-type rear sight is provided; this must be lined up with a cross formed by the intersection of the vertical and horizontal axes of the finder, as engraved on the diverging lens. The correct distance of the eye is usually obtained by mounting the finder in such a way that the photographer has to hold the back of the camera against his cheek for sighting. The rear sight can be arranged movably to compensate for parallax. If the front frame with the diverging lens is mounted on the lens panel of the camera and the power of the diverging lens chosen accordingly, the Newton finder can also indicate the correct view when the lens is decentred on the camera. The conditions for the dimensions and other parameters of the Newton finder have been described by Gillon (1900), E. Wallon (1901) and J. Stüper (1962).

Locating a converging lens in the place of the rear sight of a Newton finder forms an inverted galilean telescope (Fig. 18.9) which is the basis

FIG. 18.9. SIMPLE OPTICAL FINDER (INVERTED GALILEAN TELESCOPE)

of most modern optical finders. With this arrangement the finder itself can be quite small for easy fitting in a camera, though the smaller the finder, the lower is also its image magnification and the less accurate its framing. The negative and positive lenses N and P in Fig. 18.9 must be so located for sharp viewing that their focal points coincide at F; the ratio f'/f'' is the image magnification. The field of view is usually bounded by a frame mask m. The larger the image field to be covered, the larger must be the whole finder or the smaller must be the image magnification f'/f''. A finder magnification not much short of 1·0 can be obtained with reasonable dimensions for a normal focal length of lens covering an image angle of 45 to 50°.

On simpler cameras this type of finder has no parallax compensation; in more elaborate forms the framing error due to parallax can be corrected by moving the mask m through a linkage coupled to the focusing system of the camera. If a mask made up of two L-shaped halves is used, the frame can also be reduced in size to correct for the distance error when focusing on nearer subjects (§ 285).

290. Albada Finder Systems. As the boundary frame of all finders discussed so far is at a different distance from the eye than the subject, it is liable to framing errors through two causes:

(a) The unsharpness of the finder frame as seen by the eye;

(b) Displacements of the viewing axis if the eye is not correctly centred behind the finder.

Both these sources of error can be eliminated by projecting a frame boundary into the subject plane at or near infinity as shown in Fig. 18.10 (E. L. W. van Albada, 1932). The system consists of a concave semi-reflecting mirror A and a plate B. The latter carries an aperture C and a white frame B' against a black background, and is placed in the plane of the focal point of the mirror. The white frame B' faces the mirror surface while the eye is placed at approximately the centre of curvature of the mirror. The eye now sees the frame B' reflected at A'; this virtual image of the frame appears at infinity at A'' as B is in the focal plane of the mirror. The virtual image of the frame thus appears superimposed on the subject and outlines the subject field. This image does not shift even when the eye is displaced laterally from the viewing position—its view is at worst partly cut off by the inner opening C in the plate B.

The Albada finder in this form is essentially

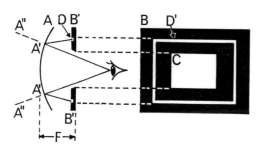

FIG. 18.10. BASIC ALBADA FINDER (AFTER J. STÜPER)

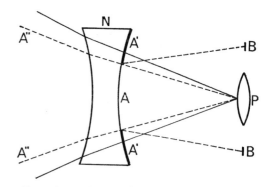

FIG. 18.12. ALBADA TYPE GALILEAN FINDER

a frame finder and suffers from three short-comings which have been eliminated in modern versions:

(*a*) The reflectivity of the semi-reflecting mirror *A* must be strong enough to show a reasonably bright image of the frame *B'* in Fig. 18.10; hence the image appears somewhat dark.

(*b*) Wide viewing angles are difficult to cover because—as with a normal frame finder—the angle of view of the eye itself is limited to around 50°.

(*c*) The brightness of the frame *D'* depends on the light falling on it through the front of the finder; under certain viewing conditions the frame may appear no brighter than the subject and thus not easily visible.

The problem of image brightness was solved by silvering the mirror surface only in the portions where the image frame had to be reflected, while the centre area remained clear. Fig. 18.11 shows an arrangement where the mirror surface *B* is the interface between two

glass blocks *A* and *C* of identical refractive index; only the portions *B'* are silvered. The frame to be reflected is contained on the interface *D* between *C* and *E*. For parallax compensation the whole finder may be tilted about an axis parallel to the side of the camera to which the finder is attached.

In many modern camera finders the Albada system is combined with a galilean type optical finder (as shown in Fig. 18.12). The frame *B* surrounds the positive eyepiece lens *P* and is reflected from the rear surface *A* of the diverging lens *N* which is partially silvered at *A'*. The eye again sees a luminous frame *A"* supported apparently in space in the subject plane.

The luminous frame may also include indications showing the displacement of the subject field at close distances for parallax correction (§ 287). In Fig. 18.13 the projections *A* and *B* inside the bright line frame show the limits of the field of view at a specific near distance—usually the near focusing limit of the camera. This applies to a finder mounted above and to one side of the lens (see also Fig. 18.6). As the parallax correcting marks also reduce the image

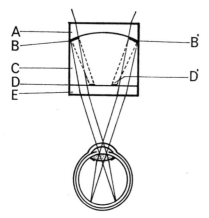

FIG. 18.11. CLEAR-VIEW ALBADA TYPE FINDER (LEITZ)

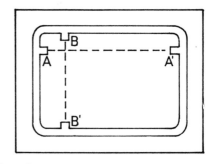

FIG. 18.13. PARALLAX CORRECTION MARKS IN ALBADA FINDER

area in the finder this provides at the same time a primitive correction for the distance framing error (§ 285).

291. The Modern Bright-line Finder. On current advanced cameras with direct vision optical finders the image frame is reflected into the finder image from a masking plate B set behind a diffusing screen C in the camera front (Fig. 18.14). A lens L forms in conjunction with the eyepiece lens P an image of the frame at infinity; reflection by a prism or mirror M_1 and a beam splitter M_2 superimposes this image on the finder view in the same way as with an Albada type finder.

This arrangement provides a more brilliant frame even in poor light since the frame in the mask is illuminated by transmitted light. Systems have even been proposed for illuminating the frame by a separate light source built into the camera.

The location of the mask plate outside the main optical axis of the finder also facilitates mask adjustments, e.g. for parallax compensation. In more elaborate systems of this kind the mask plate may have a number of transparent frames which are covered up selectively by masking slides, giving for instance a range of alternative image frames to show the field with interchangeable lenses of different focal lengths. The selection of the actual frame displayed may be controlled by a knob or lever on the camera or by an internal linkage operated by the lens itself as it is attached to the camera. The indication of multiple frames, one inside the other, becomes feasible where the masking plate is outside the main finder axis, since there is no longer any need to keep the centre of the mask clear for looking through the finder.

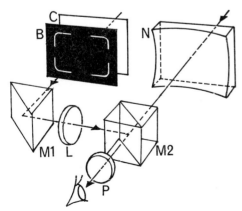

FIG. 18.14. BRIGHT-LINE FINDER SYSTEM

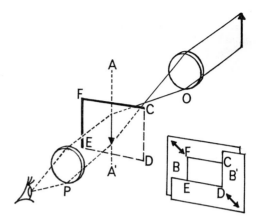

FIG. 18.15. TELESCOPIC FINDER

Other markings and symbols—for instance the settings of the focusing scale (if suitably placed)—can be reflected into the finder field in an analogous way.

Bright-line finders of this kind generally cover focal lengths from normal to medium long focus lens (e.g. 50 to 135 mm on a 35 mm miniature camera) with a finder magnification of 0·8 to 1·0. For shorter-focus lenses separate finders of reduced magnification are used to cover the wider angle of view; for long focus lenses a greater magnification is necessary to show sufficient image detail and either telescopic finders or reflex housings (§ 312) are used.

292. Telescopic and Other Direct Vision Finders. Various optical systems derived from galilean and astronomical telescopes have been used for finders giving image magnifications greater than 1·0 for use with long focus lenses. The galilean telescope, consisting of a positive front element and a powerful negative rear element gives an upright virtual image which cannot, however, be framed sharply. The magnification can be adjusted by varying the distance between the lenses, the virtual image being refocused by an additional eyepiece lens. Such an arrangement, resembling a primitive zoom lens (§ 160), can thus provide a variable focus finder to cover a range of image angles when used with lenses of different focal length.

In an astronomical telescope as in Fig. 18.15 an objective lens O produces a real image in the plane AA'; this is observed through a magnifying eyepiece P. The image is upside down, but can be reinverted by interposing a suitable prism system between the image plane AA' and the eyepiece lens P. The existence of a real

image plane also means that a mask $CDEF$ located in this plane provides a sharp frame. The mask can be made adjustable by using two L-shaped components B and B'; the different settings of the mask then correspond to the views obtained with lenses of different focal length. The mask boundary can be replaced by a transparent panel carrying one or more frame outlines to indicate the field of view of the lens or lenses, as in the Albada finder. Alternatively, a fixed mask may be used with different objective lenses O mounted on for instance a rotating turret. In this case the finder magnification varies according to the objective lens used. Both these systems have been employed as universal finders for miniature cameras with interchangeable lenses—but multi-frame brightline finders are now preferred.

An unusual finder marketed for a number of years consisted only of an illuminated mask frame (similar to B in Fig. 18.14), viewed by one eye through an eyepiece while the other eye directly observed the subject. Fusion of the frame image and the subject image in the brain of the observer provided the effect of super-imposing a bright-line image frame on the subject field.

293. Reflecting Finders. A simple finder used for many years on inexpensive cameras consisted of a small biconvex lens which projected an image via a mirror on to a plano-convex field lens or on to a small ground glass screen in an arrangement similar to the finder half of a twin-lens reflex camera (§ 207). The limits of the field were, however, badly defined—using only a mask—and mounting of the finder was often not very accurate.

294. Rangefinders. As far back as 1890 Dallmeyer proposed for this purpose two finders, one fixed and the other pivoting by the action of a cam linked with the focusing mechanism; the camera was correctly focused when the subject appeared in the centres of both finders. This arrangement has been simplified by using two optical systems, suitably separated from each other, the images of which are superimposed after one has been reflected on a mirror or prism which is turned through an angle by the focus-ing movement. In Fig. 18.16, the eye O sees directly an image of the subject aimed at, and another image of the same subject after two reflections in the mirrors M and M_1. The mirror M is pivoted on an axis A and linked to a lever L held by a spring R in constant contact with a cam C coupled in some convenient

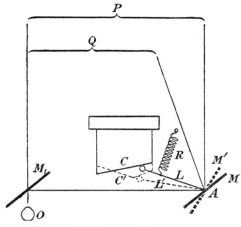

FIG. 18.16. COUPLED RANGEFINDER

manner to the lens-focusing mechanism. The mirror can therefore pass from the orientation M to the orientation M' when the lens, first focused on a very distant object P, is focused on a near object Q. The camera is correctly focused on a given subject when the two superimposed images coincide in the portion covering that subject.

A colour filter is, as a rule, inserted in one of the optical paths so that the two images are more easily differentiated.

In some cases, the two mirrors are so designed that, instead of two superimposed images, one image is seen split in half horizontally. Each half corresponds to a part of one of the images referred to above and correct focus is achieved when the two halves exactly match to produce a single picture. These split images are similar to those obtained with a biprism in a focusing screen (§ 249).

The focusing accuracy is proportional to the base length M_1 and to the magnification of the image seen through the rangefinder. A given accuracy can thus be obtained by a great base length with little image magnification, or a shorter base length with increased magnification. As rangefinders are usually combined with a viewfinder to permit simultaneous viewing and focusing with the coincident images, the mag-nification of the rangefinder is determined by that of the viewfinder. The base length is determined by the optimum compromise between accuracy and physical accommodation in the camera.

The greater the base length MM_1, the greater is the displacement between the two coincidence

or split images for a given change in subject distance. With too great a base length it may not therefore be possible to keep both images within the rangefinder field over the whole focusing range of the lens, which makes the rangefinder less convenient to use.

With a limited base length the accuracy of measurement decreases with increasing subject distance, where the difference between the angles of convergence towards P and towards Q decreases. The rangefinder, therefore, remains usefully accurate only for lenses of normal to medium long focal length whose depth of field adequately covers focusing errors in the region where the measuring accuracy of the rangefinder appreciably decreases. Rangefinder focusing is usually employed only with lenses up to about $3\times$ the normal focal length.

Different lenses—on cameras where the lens is interchangeable—can easily be covered with the same rangefinder, provided the slope of the cam C in Fig. 18.16 is such that the displacement from L to L' is always the same for a given difference in subject distance. On technical press and similar cameras (§ 237) where the lens is focused by extending the baseboard, the controlling cam is linked to the baseboard extension (Fig. 18.17). When changing the lenses, the cam is repositioned inside the baseboard to bring the appropriate cam surface A, B or C to bear against the rangefinder

coupling lever. Each cam must be precisely machined to match the exact (and not just the nominal) focal length of the lens used. The cam in Fig. 18.17 covers three lenses, but alternative cams may be mounted in the camera for additional focal lengths.

There are also various types of coincidence rangefinders, separate from the camera. In these, the orientation of the movable optical system is governed by a cam joined to an external knob bearing a distance scale. The distance of the subject being thus known, focusing is effected by means of the camera focusing scale.

295. Swing Wedges and other Rangefinder Systems. The rotating-mirror rangefinder requires high precision in manufacture; with a base length of 50 mm the entire focusing range from infinity to about 1 metre involves a mirror rotation of M in Fig. 18.16 of only 1·5°. Alternative rangefinder designs were therefore devised to utilize greater physical movements of an optical component for a given angle of deflection of the measuring rays. Most of them depend on the use of sliding, swinging or rotating wedges in place of the mirror rotation.

In the swing wedge rangefinder (Fig. 18.18) the mirror surfaces M_1 and M are fixed and may be a beam splitting and a straight reflecting face respectively in a solid glass rod R. (This simplifies precise manufacture.) The deflecting system consists of a pair of cylindrical lenses A and B

FIG. 18.17. RANGEFINDER COUPLING CAM IN TECHNICAL PRESS CAMERA

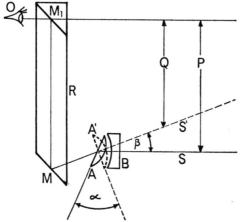

FIG. 18.18. SWING-WEDGE RANGEFINDER

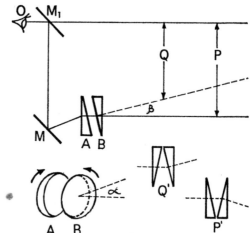

FIG. 18.20. ROTATING WEDGE RANGEFINDER

which are virtually in contact. These lenses have identical curvatures of opposite directions on their contacting faces, with plane outside surfaces. The combination thus acts as a prism of variable angle, deflecting the measuring ray of the rangefinder along BS when the swinging lens is in the position A, and along BS' when the lens swings over to A'. In practice the angle of swing α is about twice the deflection angle β, whereas with the rotating mirror the swinging angle was only half the deflection angle. The mechanical tolerance of this arrangement is therefore about 4 times as great as of the rotating mirror in Fig. 18.16. Instead of a swing wedge a sliding wedge A in Fig. 18.19 can be used.

The rotating-wedge rangefinder (Fig. 18.20)

uses two circular prism wedges A and B which are coupled to rotate to equal degrees in opposite directions. This combination again forms a prism of variable deflection with the two extreme positions being shown as P' and Q'. The rotation in opposite directions ensures that the deflection takes place in only one plane—that of the paper in Fig. 18.20.

In this system the angle of rotation α can be 10 to 20 times as great as the deflection angle β, so that the mechanical tolerances can be much greater even than with the swinging or sliding wedge rangefinder. Moreover, the rotating wedges A and B can be some way in front of the reflector M—for instance attached to the lens standard of a folding camera, provided that the lens standard itself remains stationary during focusing.

In Fig. 18.21 a sliding wedge A is located

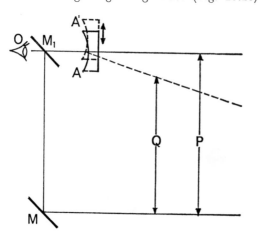

FIG. 18.19. SLIDING WEDGE RANGEFINDER

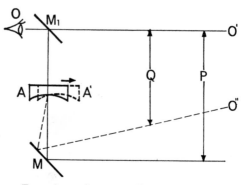

FIG. 18.21. SWINGING LENS INSIDE THE RANGEFINDER BASE

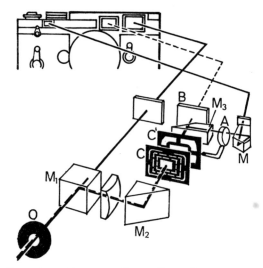

FIG. 18.22. COMBINED SWING LENS RANGEFINDER
AND MULTI-FRAME BRIGHT-LINE FINDER (LEITZ)

within the rangefinder base between the mirrors M_1 and M. Movement from A to A' changes the deflection of the measuring ray already between M_1 and M, with the same effect as before. Instead of sliding, the wedge can also swing across the light path between M_1 and M. Fig. 18.22 shows a combination of a swing lens rangefinder with a multi-frame bright-line viewfinder of the type shown in Fig. 18.14 (§ 291). The measuring ray from M to M_1 here passes through two further reflecting prisms M_2 and M_3; the swinging wedge A is mounted between M and M_3, and the finder frame mask C, together with a movable selector mask C', between M_2 and M_3. Movement of C' relative to C selects different frame openings in the mask plate C.

Most camera rangefinder layouts are unsymmetrical, i.e. the path length from M_1 to O' (e.g. in Fig. 18.21) is slightly shorter than from M_1 via M to O'', leading to slightly different scales of the two images which have to be superimposed in the rangefinder. Where the subject distance M_1O' is large compared with the rangefinder base M_1M, this difference in scale is negligible, but may become noticeable at close subject distances. Some rangefinders therefore introduce additional optical elements between M_1 and M which act as a very weak variable-focus lens to compensate for this difference in scale at different distances.

296. Lens Mounts for Interchangeable Lenses. With technical and view cameras where the

image is focused on a ground glass screen, the lens mounting is designed for convenience and reasonably rapid interchanging. The most versatile method is to have the lenses on simple panels or lens boards (Fig. 15.2, § 216). In miniature and roll film system cameras, on the other hand, lens mounts must be standardized not only for easy fitting but also for precise location of the image plane.

The earliest standard mounting for interchangeability was the screw mount: the lens simply screws into a threaded flange on the camera front. The dimensions of the lens mount and the flange are set so that when the lens is fully screwed home its focal plane at the infinity setting is identically located with the focal plane of all other lenses for that camera. Screw mounting is precise, though a little slow in operation. Any linkages between the lens and the camera (e.g. automatic aperture control —§ 283) must usually be axial couplings, such as a pin or roller in the camera bearing on a cam in the lens, or vice versa. In other words controlling movements must be transmitted in a direction parallel to the lens axis; screw-in lens mounts are less suitable for lenses with built-in diaphragm shutters which are to be tensioned by a control on the camera.

Where the lens mount has a single-start thread (the usual arrangement), fitting the lens merely involves screwing it into the camera wherever the threads engage. With a multi-start thread correct positioning of the lens before screwing in is important; signal markings may be provided which show how the camera and lens must be lined up before assembly.

The screw-over ring mount uses a captive ring on the lens. The latter is placed in position —correctly aligned—over the camera mount, and the screw ring screwed down on a corresponding socket on the camera flange to hold the two together. Since inserting the lens does not involve turning it, control elements can be coupled up between the camera and lens. Lens changing with this system is, however, even more cumbersome than with a straight screw-in mount.

The most convenient lens changing system is the bayonet mount where the lens is inserted in a keyed flange and secured in position by a quarter or half turn. This usually also engages a catch to prevent accidental removal of the lens; this catch has to be depressed or released before the lens can be taken off the camera. With a quarter or half turn it is also possible to

engage interlocking controls between the lens and the camera, including a tensioning drive for a diaphragm shutter and radial as well as axial automatic aperture linkages (§ 283).

A few cameras have used hybrid mountings with a partly screw and partly bayonet action. The screw thread of the lens and of the flange are alternately interrupted so that the two can be freely placed together. The screw threads then engage on turning the lens and firmly secure it after the quarter or one-third turn.

With all bayonet type mountings the lens must be correctly aligned before being placed on the cameras. This is usually indicated by red dots, arrows or other marks on both the camera and the lens, which have to be lined up before engagement.

The diameter of the lens mount determines the maximum diameter of the light cone between the lens and the film. With long focus lenses this may lead to vignetting when a lens is fitted into the camera flange as at A in Fig. 18.23. Some cameras therefore have an inner and an outer mount. The outer mount B is used with longer focal lengths to keep the effective opening of the lens flange as unobstructed as possible, while the inner mount serves for shorter focal lengths where the lens mounting can be kept more compact than if it had to fit over an outer mount.

297. Mount Standardization and Adapters. Lenses made for one camera type can rarely be used on another, because of lack of agreed standards on such aspects as mount dimensions and optical register (flange-film distance). Among reflex cameras a few mount types are, however, usable with a range of makes. Most prominent among them is a metric 42 × 1 mm screw mount usable on several dozen 35 mm

reflex models and several hundred lenses of various kinds and makes.

To permit interchangeability on different single-lens reflex camera mounts, some lens manufacturers have adopted standard adapter mount systems. All the lenses of one maker are produced with a standard screw mount which fits not a specific camera but a range of interchangeable adapters, and may include necessary linkages for aperture coupling, etc.

With a few exceptions, interchangeable lenses for 35 mm or roll film rangefinder or reflex cameras are fitted with their own focusing mount and iris diaphragm. A few manufacturers have developed sub-assembly mount systems where one focusing mount takes a range of alternative lenses, only the lens unit itself being interchangeable. The sub-assembly focusing mount must have a sufficient focusing movement to cover a range from infinity to a reasonably near distance with the longest focal length to be used with the mount. The main arguments for this system are reduced cost and possibly reduced bulk of the interchangeable units.

298. Decentring Mounts. Attempts have been made to provide on a limited scale camera movements (§ 220) on 35 mm roll film and reflex cameras by special lens mountings. A simple decentring mount as shown in Fig. 18.24 permits a parallel displacement of about 10 to 15 mm of the lens L from its central position L'. The lens has a sliding base A running on a track B, the two being connected light-tight. The track is fitted on a rotating section C of the main mount D (which fits on to the camera) to permit the parallel displacement to be utilized in any desired direction. The lens angle must of course be adequate to cover the image format even in

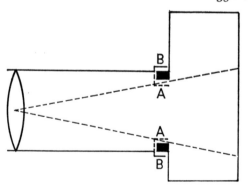

FIG. 18.23. DUAL LENS CHANGING MOUNT TO AVOID VIGNETTING

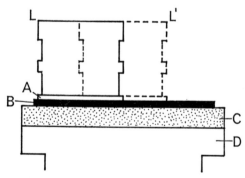

FIG. 18.24. DECENTRING MOUNT FOR PARALLEL DISPLACEMENT

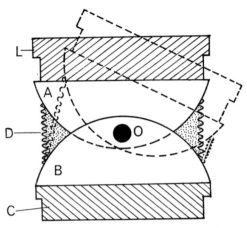

FIG. 18.25. TILTING INTERCHANGEABLE LENS MOUNT

FIG. 18.26. ROLL FILM BACKING PAPER

the decentred position (§ 136); in practice a wide angle lens (e.g. 35 mm focal length for a 24 × 36 mm format) with increased coverage is used.

More elaborate systems may include a lens tilt as in Fig. 18.25. Two frames A and B are hinged about a central pivot O and joined together by bellows or other flexible light-tight closure D. One of the frames carries the lens L and the other the camera mount C. The lens can thus be inclined (shown dotted in Fig. 18.25) relative to the camera axis to a maximum angle of around 20 to 25°. The frame B rotates relative to the lens mount C so that the tilt can be lined up in any direction. This system may in addition incorporate means for lateral displacement between B and C to provide the effect of a rear swing (§ 229).

299. Roll Film Loading. The light-tight backing paper with which a roll film is wound up on its spool permits insertion into and removal from the camera in normal lighting. The backing paper carries a series of numbers at regularly spaced intervals (Fig. 18.26), usually preceded by dots or other signals. On simple roll film cameras these numbers are observed through a red window in the camera back as the film is wound on.

For loading simpler types of roll film camera, two spools, one empty (B) and the other (B') with film wound on it (Fig. 18.27), are placed on either side of the camera proper, their end disc pieces being fitted to pivots, one of which can be turned from the outside, whilst both pairs act as axes of rotation. After taking off the

detachable cover CC, the spools are placed in position on their pivots, noting that the two spools must be placed inversely to each other, the groove in one of the discs of the spool placed in B having to fit the pin of a winding-key operated from outside the camera. Four to six inches of the backing paper wound on the spool are unwound and the taper end inserted in the slot of the empty spool at B. A few turns of the key are given to wind the paper tightly round spool B, and then the back CC is replaced. Some fifteen half-turns of the key are then given, the paper passing from B' to B, and moving without friction over the rollers rr'. As soon as the film, carried by the paper, reaches the field of the lens, a warning sign appears in the red window V, and is soon followed by the figure 1, showing that the film is in position for the first exposure. After making the exposure the key is turned until the figure 2 appears, and so on. After taking the last photograph (the spools are usually for 8, 12 or 16 exposures, according to the size of the pictures), the key is given about fifteen half-turns, and the cover is then taken off. The winding of the paper is then continued, pressing the fingers *very gently* on the spool to prevent the paper from uncoiling when it is no longer kept under tension by the springs which brake the supply spool. The spool is then removed and sealed with the gummed strip attached to the end of the backing paper.

The spools with wooden centres, on which the metal flanges were forced by pressure, are usually replaced in the current sizes by all-metal or plastic spools of more accurate manufacture.

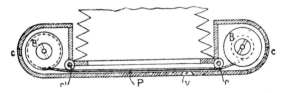

FIG. 18.27. ROLL-FILM MECHANISM

The space between the flanges must permit the rolling up of the film and its wrapping paper, but without sufficient play to admit light. The slit in which the tongue of the paper is engaged must be exactly standardized. The spool must be sufficiently rigid to resist deformation by torsion of its axis which would result in unequal tension of the film and sometimes cause scratches on the emulsion.

300. Semi-automatic Loading and Transport. With more advanced roll film cameras an exposure counter replaces the red window in the camera back for indicating the film advance. During loading the backing paper is wound on to the take-up spool—with the camera open— until a locating mark on the paper (usually a double ended arrow stretching across the paper width) is lined up with an appropriate mark inside the camera back. The locating mark is placed at a standardized distance ahead of the beginning of the film so that turning the film transport or control through a specific number of turns automatically locates the beginning of the film behind the picture aperture ready for the first exposure. The transport then locks and is released—for advancing the film to the next exposure—by a link with the shutter release (§ 284). The exposure counter makes the red window unnecessary—this window was not always safe with modern high-speed films and is in any case not suitable for No. 220 film (§ 196) which does not have a backing paper behind the full length of the film.

Before loading location marks became standardized on the roll film backing paper, some camera manufacturers evolved automatic film feeler devices to locate the beginning of the film on the roll. The backing paper A (Fig. 18.28) runs between a pair of rollers B squeezed together by spring pressure. As the beginning of the film C passes through the rollers, the increased thickness of the film (plus the adhesive strip securing it to the backing paper) pushes the rollers apart. The lever carrying the movable roller then presses against a catch D which in turn frees the movement of a lever E in the direction of the arrow. A number of further linkages transmit this movement to the film transport mechanism and film lock as soon as the film is in position behind the picture aperture.

The usual means of roll film transport is a winding knob or key acting directly or indirectly on the take-up spool. The winding knob has a built-in ratchet or other device to prevent

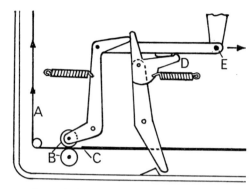

FIG. 18.28. FILM FEELER SYSTEM FOR AUTOMATIC LOADING

winding backwards and thus to avoid the film becoming slack in the camera. The winding knob may be replaced by a winding lever similar to the film transport of a 35 mm camera (§ 304), geared so that one full pull of the lever advances the film by one frame. A number of cameras, especially roll film reflexes, use a crank conveniently located in the side of the camera.

As the film winds up on the take-up spool, the core diameter of the spool grows. Where a transport lever or crank is directly geared to the take-up spool, the swing movement of such a lever or crank must be progressively decreased to compensate for the growing diameter of the film wound up on the spool. Otherwise the interval between the exposures of the film grows towards the film end and the last exposure may not be fully accommodated on the film at all. One way of avoiding this is to drive the exposure counter (and a film transport lock linked to it) from a serrated wheel pressed into contact with the edge of the film or backing paper, thus metering the film travelling through the camera.

301. Film Path and Film Flatness. In better quality roll film cameras a pressure plate in the camera back pushes the film against the frame of the picture aperture to keep it reasonably flat in the image plane. Perfect flatness is, however, practically impossible to achieve, partly because of the curl of the film supported only around the edges of the picture aperture and partly because of the presence of the backing paper. As the film is wound up with the paper on the spool, each turn of film and paper involves a slightly greater paper length than film length. This extra length of the backing paper is best absorbed if the film path between the spools

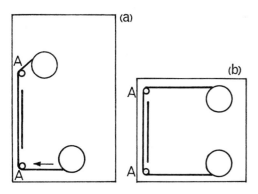

FIG. 18.29. FILM PATHS TO ABSORB LENGTH DIFFERENCE BETWEEN FILM AND BACKING PAPER

is appreciably longer than the picture aperture (often incompatible with a compact camera design) or if the film goes through one or more right angle turns between the spool and the picture aperture (Fig. 18.29). A number of twin-lens reflexes use a film path as in Fig. 18.29a; the arrangement of Fig. 18.29b used to be found in certain box cameras.

The drawback of such a film path is that the film acquires a "set" at the points A during long intervals between exposures. Unless the film is wound on by a distance exactly equal to the separation between the rollers A, this "set" may come to lie within the image area with the result that the film is there not fully flat. Interchangeable film magazines and roll film adapters (§ 240) which wind the film backwards over rollers—e.g. as in Fig. 15.42—do not favour film flatness.

Although the film slides against the backing paper when travelling from one spool to the other (and for this reason is secured only by one of its ends) it is rarely perfectly stretched in the image plane. Flatness is improved when a film without backing paper is used, such as No. 220 film or perforated 70 mm material (§ 197).

Cameras are also made with a sheet of plane-parallel glass mounted in the film plane to support the film over its whole area when pressed against the glass by the pressure plate. This improves the film flatness but needs special care to avoid scratches. The pressure plate is therefore often lifted off the film while the latter advances. Apart from meticulous cleanness of the glass plate, perfect contact between the film and the glass is essential to avoid the formation of interference fringes (Newton's rings).

302. 35 mm Miniature Film and Cartridges. Not being provided with a backing paper, perforated 35 mm film is packed in a light-tight cartridge. The beginning of the film protrudes through a light-trapped slot. For loading into the camera, the cartridge or cassette is placed into a chamber to one side of the film track and the film pulled across the track and attached to a take-up spool at the other side. The beginning of the film (film leader) is usually trimmed to a strip of reduced width to facilitate attachment to the take-up spool. In the camera the film also runs over a sprocket wheel or a pair of sprockets on a shaft, so that the film perforations engage the sprocket teeth. The sprockets are linked with the film transport and counting mechanism. Once the film is secured, the camera can be closed. The film then has to be advanced through the equivalent of at least two frames to wind up on the take-up spool the film section protruding from the cartridge during loading, which was fogged by light. Once a piece of unexposed film is in position behind the lens, the camera is ready for shooting.

When the whole film length (36 or fewer exposures) is wound up on the take-up spool, it must be rewound into the light-tight cartridge before the camera can be unloaded. A knob or crank serves for this purpose and is linked to a shaft in the camera which engages the centre spool of the film cartridge (see below). The transport mechanism is disengaged at the same time. The cartridge can be removed from the camera once the film is fully rewound.

Film changing is possible in the middle of the film by rewinding the exposed section into the cartridge, and noting the number of exposures already made. When such a partly exposed film is reloaded, it must be advanced to the previously noted exposure (taking into account the "blind" exposures at the beginning of the film) without exposing this section. Switching films is easier with interchangeable magazine backs (§ 307). Rewinding of the film may be avoided if the camera takes a second cartridge in which the film is wound up. The cartridge left empty after the exposure of a film is then switched to the take-up chamber and replaced by a new full cartridge.

The standard 35 mm film cartridge consists of an outer shell A (Fig. 18.30) which can usually be opened at one or both ends by removal of the lid B, and the inner spool or core to which the

FIG. 18.30. STANDARD 35 MM FILM CARTRIDGE

film is attached. Cartridges vary in their design and material (metal or plastics) but are standardized in their dimensions. Normally they are intended to be used once only, but some cartridge types are reloadable by a new film of the appropriate length; such films are sold as darkroom refills.

The main argument against re-use is that the velvet lining of the light-trapped slot accumulates dust and grit which may scratch the film surface. Special cassettes made for some cameras reduce this risk by using a double shell consisting of an inner part B and an outer part C (Fig. 18.31) between which the film runs in a light trapping channel as in D. On closing the camera the inner shell can be rotated to open a wide slot for unimpeded film movement (E).

303. Instant Loading Cartridges. A simplified film loading system introduced by Kodak (1965) employs a cartridge which is dropped into the camera without any need for film threading. The cartridge contains 35 mm wide

film with perforations along one edge at intervals corresponding to a single 28 × 28 mm image frame, and is wound up together with a backing paper. The film runs from a feed roll F (Fig. 18.32) to a take-up spool D past a picture opening C. In the camera the take-up spool core engages a film transport shaft. During transport, a feeler lever acting through an aperture B engages the perforations as the film is advanced and stops the transport. After an exposure this lever is lifted, ready to engage the next perforation. The cartridge also carries a code notching E, used for setting the film speed adjustment of an exposure meter (if built into the camera).

Instant loading cartridges are used mainly in inexpensive miniature cameras which have largely replaced the amateur's box camera. Precision cameras, including single-lens reflexes, for this system are available.

An alternative method of simplified film loading uses normal 35 mm perforated film wound up inside a cassette without centre spool. The cassette, with a short film length protruding, is dropped into the camera where a transport sprocket advances the film and pushes it into the slot of a similar take-up cassette. When the film is exposed, the take-up cassette is removed from the camera and the empty feed cassette takes its place. Known as the "Rapid" system, this spoolless double cassette arrangement is a development of an earlier cartridge type in the 1930s (Agfa) and permits the use of different picture formats (from 18 × 24 to 24 × 36 mm).

The appearance of the instant loading cartridge induced manufacturers of conventional 35 mm cameras to make normal 35 mm loading easier, typically with simpler methods of attaching the film to the take-up spool, sometimes with special spools which automatically grip and

FIG. 18.31. SELF-OPENING 35 MM CASSETTE

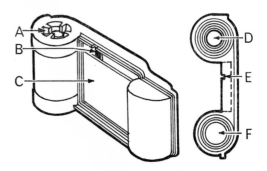

FIG. 18.32. INSTANT-LOADING PACK CARTRIDGE

wind on the film end without the need for threading the film. These cameras use standard 35 mm cartridges and the film is still rewound—in contrast to instant loading cartridges where no rewinding is involved.

304. 35 mm Film Transport. In most 35 mm cameras the film is advanced by the combined pull of a sprocket shaft or wheel, acting on the film perforations, and of the take-up spool in the camera.

The sprocket shaft A (Fig. 18.33) is geared to the transport lever B and locks the mechanism once the film has advanced through the appropriate number of perforations (8 for a full 24×36 mm frame, 6 for a 24×24 mm frame and 4 perforations for 18×24 mm). As the film winds up on the take-up spool C, the increasing core diameter of the latter would tend to pull more film through the camera than the sprocket; the spool is therefore coupled to the transport movement through a friction drive. When the transport sprocket is disengaged (usually by a button or lever on the camera body) for rewinding, the film winds off back to the cassettee against this friction drive. The usual rewind control is a knob or crank on a shaft engaging the centre spool of the film cartridge; on a few cameras the transport lever can be coupled to the rewind shaft when the sprocket is disengaged so that the transport lever action is also used for rewinding.

The transport mechanism is coupled to an indicating wheel or disc which counts the exposures made in the camera. The exposure counter may count forward from 0, indicating the number of exposures actually made, or backwards from 36 or 20 (according to the number of exposures in the film cartridge), showing the number of shots left on the film. Usually the film counter is reset to its starting position as the last stage of the film loading procedure. On a few cameras (especially the forward counting type) the counter automatically returns to 0 on opening the camera back or on removing the take-up spool. The counter here advances against the tension of a spring and opening the camera back disengages the gearing to the transport so that the spring returns the counting disc to its starting point.

The transport lever—usually on the camera top for operation by the right thumb, but sometimes at the left or in the camera base—is the most widespread film advance control on modern 35 mm cameras. It is still described as a rapid winding lever (in contrast to the

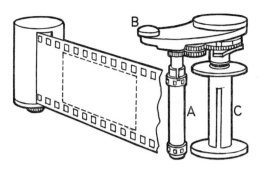

FIG. 18.33. 35 MM FILM TRANSPORT

somewhat slower knob advance). Various other systems have also been used, including swing down levers on the camera front, wheels set in the camera back, plunger actions, etc.

305. Motor Drives. The film transport may also be driven by a clockwork or electric motor. With a clockwork motor a spring, once wound up, provides sufficient power to pull a dozen or more film frames through the camera. With a battery driven electric motor the capacity is limited only by that of the batteries. The motor cuts in mechanically or electrically as soon as the shutter has closed after an exposure and immediately advances the film ready for the next shot. This permits rapid sequence shooting at rates from 1 to 4–5 exposures per second, depending on the film format and the shutter speed.

The fastest cycling rates are obtained with a sequence release coupling, i.e. the mechanism not only advances the film after every exposure, but also releases the shutter again at the end of every transport and tensioning cycle—as long as the release button is kept depressed. In contrast to individual releasing (where the button has to be pressed separately for every exposure) this also reduces the risk of camera shake in the successive shots of a sequence, for the photographer has only to concentrate on holding the camera steady without moving his fingers. The motor drive must have a reliable cut-out to stop it when the film in the camera is finished and so prevent blank exposures or tearing the film out of the cartridge. The cut-out is usually coupled to the exposure counter which must therefore be set correctly when loading the film.

Electric motor drives are also made as separate units for a number of 35 mm cameras, attaching to, or replacing, the camera base plate. The cameras themselves are often special versions

of standard 35 mm models with coupling elements to the film transport and the shutter release brought out through the base plate. Some motors may be attached to the top of the camera to link directly with the normal transport lever and release button. The shutter is usually released by an electro-magnetic device (§ 281) in the motor; this also permits remote operation of the whole exposure and transport cycle of the camera.

Remote operation is controlled by pressing a button at the end of a lead, by radio signals or by separate control units which may incorporate interval timers. This permits making exposures at preset time intervals (from a few seconds to minutes and even hours) and is used in industrial photographic applications, for instance for periodic recording of instrument dials, etc. For this purpose large capacity film magazines may be used on the camera (§ 307).

306. The 35 mm Film Track. 35 mm miniature film has a better chance of lying flat in the camera than roll film; the film format is smaller, the film thicker (usually 0·14 mm against 0·08 mm of a roll film), there is no backing paper and the perforated edges of the film provide a larger support area against the film track. On the other hand the demands on film flatness are stricter, as negatives have to be enlarged to a greater extent.

It was originally thought that a pressure plate A pushing the film edges against a track B (Fig. 18.34) should keep the film flat. 35 mm film however has a certain inherent curl as shown in F; with the arrangement of Fig. 18.34 the film edges are straightened, but the centre of the film tends to curve forward at M in the picture aperture of the camera. To counteract this, some 35 mm cameras use a film channel where the pressure plate A lies against the film track at C (Fig. 18.35). The film slides in a channel B between the pressure plate and a

FIG. 18.34. FILM CURL IN THE IMAGE PLANE

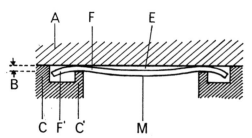

FIG. 18.35. 35 MM FILM TRACK FOR OPTIMUM FLATNESS

guide rail C' which bears on the film at the very edge of the image area, inside the perforation. The extreme edges of the film F' can now still curl forward, while the forward movement of the film in the centre at M is greatly reduced.

With a total film thickness (base plus emulsion) of 0·14 mm, H. Rühle found that a channel depth B between C' and A of 0·18 mm gave the best film flatness with a separation of about 0·04 mm at E. This varies slightly across the film, since absolute flatness is impossible to achieve without pressing the film against a glass film plane (§ 301). If the surface of the film track C' in contact with the film is taken as the image plane, the mean variation of the film position may be of the order of a few microns. This is about the same as the manufacturing tolerance in setting the distance from the lens flange to the film track in a precision camera and between 1/10 and 1/5 of the depth of focus with a large aperture lens focused on infinity.

The degree of film curl—and hence the flatness in the image plane—depends also on the type of film base, the age of the film, prevailing relative humidity and temperature. The tension between the take-up spool and the film cartridge does not, however, appear to have any noticeable effect.

307. Interchangeable Film Magazines. To permit easy switching between different film materials in the middle of a film, a few 35 mm cameras use interchangeable magazines. For convenient changing, the magazine should have its own film track. In this case the tolerance in locating alternative magazines in the camera is usually greater than the permissible tolerance in the location of the film track for optimum definition (§ 306). The only magazine changing systems which satisfy this precision requirement are those which locate the film against the film track of the camera. When fitted on the camera, the film plane must therefore protrude in front

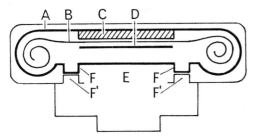

FIG. 18.36. INTERCHANGEABLE 35 MM MAGAZINE WITH OWN FILM TRACK

of the magazine body, but permit withdrawal when closing the magazine light-tight by a draw slide. This complicates the construction, and requires an involved sequence of steps and interlocks to avoid fogging the film when changing from one magazine to another. Precision constructions is more vital in a 35 mm camera than in a roll film camera with interchangeable magazines where the permissible tolerances are more generous.

Fig. 18.36 and 18.37 show the problems involved. In Fig. 18.36 the magazine A carries the film B inside an enclosed container; a pressure plate C pushes the film against a film track D. During changing, the front of the film aperture E is closed by a sliding shutter. The accuracy of location here depends on the precision of the mating surfaces of location elements

F of the magazine and F′ in the camera; wear on F or F′, or particles of grit (even of dust) between the two surfaces can seriously upset the location of the image plane.

In Fig. 18.37a the film track D is part of the camera and the film B runs in front of the pressure plate C, the picture aperture E being closed by a draw slide or similar device while changing magazines. Once the magazine is on the camera and the draw slide withdrawn, the pressure plate C pushes the film forward out of the picture aperture against D (Fig. 18.37b). This requires a more complex mechanism and the pressure plate C may have to have additional guides to pull the film back again into the position of Fig. 18.37a when the magazine is to be changed.

Bulk magazines available for some 35 mm cameras take 10 metres or 30 metres of film for 250 and 750 exposures (24 × 36 mm) respectively. These are employed mainly in industrial recording applications in conjunction with electric motor drives and systems which release the camera automatically at present intervals. They also find use in other fields where a large number of exposures have to be made before a film can be processed—including nature photography, street photography, etc.

308. Exposure Marking Devices. To permit the indication of subject and exposure data on the individual frames of a film, certain 35 mm cameras incorporate an exposure marking device similar to that shown in Fig. 18.38. It uses transparent strips A on which the necessary data are inscribed. Such a strip is pushed into a light-trapped slot in the camera base or back, so that the inscribed section comes to lie at one end of the image area in the picture aperture B. As the exposure is made, the light from the lens contact prints clear lettering against the image

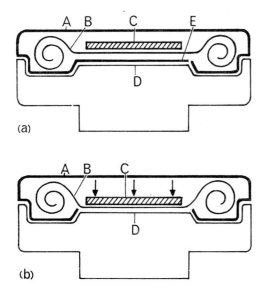

(a)

(b)

FIG. 18.37. INTERCHANGEABLE 35 MM FILM MAGAZINE USING THE CAMERA FILM TRACK

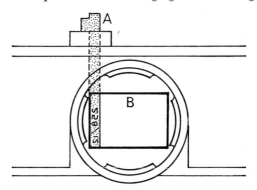

FIG. 18.38. DATA STRIP FOR EXPOSURE MARKING

background. The strip takes away about 3 mm of the frame length. Since few subjects utilize the full length of the rather long 24 × 36 mm frame, this loss in image area is rarely troublesome.

Exposure marking devices of this kind are useful in scientific, medical and similar photographic fields where numbers of similar images have to be individually identified. Industrial recording cameras sometimes incorporate supplementary optical systems which reflect the image of data panels, instrument readings, etc., into one corner of the image frame while photographing a specific subject. The optical system of such devices is similar in principle to that of an identity camera (Fig. 14.7, § 205) but the data recording area takes up only a fraction of the full film area. The data registering device can record such information as time, speed of a moving subject (for example in photographing moving vehicles by traffic police, etc.).

Amateur roll film cameras were at one time available with an autographic film marking device (H. J. Gaisman, 1913). The back of the camera carried a narrow slot, kept covered by a spring flap, in which notes concerning an exposure could be made with a metal stylus on the backing paper. The latter consisted of a not quite opaque red paper and a carbon paper. The stylus marking transferred the carbon layer to the red paper, whereupon the slight play between the two papers enabled light—diffused by the red paper—to act on the film through the inscription stencilled on the carbon paper. The special roll films required for the system are no longer manufactured.

309. Testing Cameras. Newly acquired cameras need testing and examination is also necessary at intervals with apparatus in service. Such tests and examinations might cover the following points:

(a) *Lens performance.* The tests indicated in § 177 cover most of the aspects which the photographer can test himself. Lens performance may fall with lenses which have been badly looked after (§ 179), decentred by dismantling or whose setting has been upset by mechanical damage to focusing mounts, etc.

To test focusing accuracy of a camera with a focusing scale, a test object such as a sheet of printed matter facing the camera may be placed at the various distances marked on the scale and photographed, checking whether the images obtained are sharp. If a series of such test objects is photographed, spaced in depth at intervals of a few inches and each marked

with the exact distance from the camera, the result will also show the position of the plane of sharpest focus and hence any deviation in the accuracy of the focusing scale. Such a test should be made at the largest lens aperture to reduce the depth of field tolerance. In measuring the distances, check from the camera instructions whether the focusing scale refers to distances from the film plane or from the lens in the camera.

On cameras fitted with a rangefinder or a focusing screen the above test can be compared with a visual check of the focusing accuracy of either of these devices. Generally it is more important that the image on the film is sharpest for the subject plane established as the plane of maximum sharpness by the rangefinder or focusing screen, than that the focusing scale of such a camera is accurately set. The scale can sometimes be adjusted to correct errors.

(b) *The shutter.* Although tests of shutter speeds are most easily and rapidly carried out by electronic test gear used in camera repair workshops, the camera user can employ methods described in § 277 for his own tests.

(c) *The viewfinder.* In cameras fitted with separate finders it is necessary to see that there is a reasonable agreement between the picture in the finder and that recorded on the film. A straightforward method is to set up a chart with a numbered grid, as in Fig. 18.39, in front of the camera. This is carefully centred in the finder, bringing an identical pair of numbers to the left and right hand edges and another corresponding pair to the top and bottom—as shown by the dotted outline. The boundaries of the

FIG. 18.39. TEST CHART FOR CHECKING VIEW-FINDER FIELDS

finder field are noted and the chart photographed. Examination of the image on the film will show any decentring of the finder view and lack of correspondence with the field taken in on the film (e.g. as represented by the solid rectangle). This test may be repeated at different distances to check the finder correction—if any—for loss of image field (§ 285). The numbered divisions should be at intervals of 10 cm to 6 inches for finder tests at greater distances (5 metres or 15 feet is usually a practical limit, otherwise too big a chart is required) or at intervals of 1 cm to 1 inch for nearer distances. This test is applicable to all types of finder, including the focusing screen of a reflex camera.

(*d*) *Light-tightness*. To see whether the camera is light-tight, it may be taken into a dark room and an electric lamp (e.g. torch) placed inside it—first from the opened camera back while the lens is capped (unless it has a diaphragm shutter) and then through the lens opening (if the camera lens is interchangeable) while the back is closed or a film holder is in position. The opening through which the lamp has been introduced is tightly closed with an opaque cloth. Inspection will then reveal light leak areas in the camera body.

With a reflex camera it is also worth testing whether any light escapes from or around the screen when the mirror is in its swung up position. This indicates whether light might reach the film through the screen during an exposure.

(*e*) *Tests for mechanical precision* involve trying the various camera functions (transport, release, adjustments, etc.) to see whether they work smoothly without excessive play or backlash, and whether any locks lock and unlock positively without requiring excessive force.

Technical and view cameras may need more extensive periodic tests, paying attention to the following points:

Absence of play after the various parts have been set in position; parallelism of the front and back, tested with a square; the two parts require to be perpendicular to the long sides of the base rail or baseboard; agreement in register between the focusing screen and the film holders; absence of reflections from the inside surfaces, which must be covered with a dead mat varnish; and absolute light-tightness of the camera and film holders.

In the case of small cameras the parallelism of the focusing screen and of the surface of the lens-board on which the lens flange rests may be tested directly as follows: On the points of three screws projecting from a board placed more or less horizontally, level a sheet of glass of a size closely similar to that of the focusing screen. After testing the horizontality of the glass by two cross-readings of a level, remove the glass and place the camera on the three screw-points, causing it to rest on its focusing screen. Then place the level in two cross positions on the lens flange or on the front cell of the lens, and see if the bubble indicates horizontality.

In order to check the register between the focusing screen and the film or plate holder, load the latter with a glass plate and fit it to the camera. Unscrew the lens and introduce a rod fitted with a sliding cross-piece that can be clamped. The tip of the rod is pressed against the surface of the plate, and the cross-piece is pushed against the lens flange and clamped at that point of its travel. The plate holder is then replaced by the focusing screen, and all that is necessary is to see that the tip of the rod touches the surface of the screen when the cross-piece is again placed against the flange. When the focusing screen and film or plate holder are fitted to the camera in the same manner, it suffices to see that they have the same register. To do this, use a thick wooden rule of perfectly flat surfaces, through the middle of which a screw has been placed so that it can be screwed in or out at will. The rule is placed across the front of the frame of the focusing screen and the screw is turned until its point just touches the ground surface. Films or plates are now put in the holders, and the rule is placed across the latter. If the register is correct, the point of the screw will touch the emulsion surface without pressing the film or plate back on the springs that hold it against the stops.

The light-tightness of the holders can be tested only by photographic tests, viz. by loading them with plates (or, more cheaply, with bromide paper backed by a piece of card or a glass plate) and then exposing them for a considerable time to light (preferably sunlight) in all possible positions. The holder is then placed in position on the camera, the lens capped, the shutter withdrawn, and the camera left exposed to full light. Plates or papers subjected to the above treatment should not show more general fog than material taken directly from the packet and developed at the same time, nor should they show local fog. Of course, the number of the holder will have been marked on each plate or

sheet of paper, so that the defective holder may be identified and the fault located.

These tests must always be supplemented, and may even be replaced, by practical tests with the camera under normal conditions of use. As a rule, no new and untried instrument should be used for any work which is of special difficulty or cannot be repeated. It is especially inadvisable to start on any trip, still more so on any long journey, with a camera which has not been thoroughly tested.

310. Care of the Camera. A camera treated properly can give long service without loss of performance, but careless handling as well as wrong storage can cause serious damage.

Camera manipulation should never need force, as camera parts which should move are usually designed to move smoothly. If a moving part appears blocked, check that the correct operating sequence has been followed—e.g. in working the film transport, shutter release or shutter tensioning controls—and that any catches have been released before trying to open or to replace camera parts or components. This applies especially to opening and closing the camera and to changing lenses, magazines, film holders and other items.

Camera components should never be dismantled except by skilled repair mechanics, as a specified dismantling and assembling sequence as well as tests for optical or other alignment may be required. Nor should camera functions of roll film and miniature cameras be lubricated, especially in all-metal cameras. Moving parts involving friction on wooden cameras (baseboard runners, grooves of plate holders, etc.) may be lubricated from time to time, preferably with graphite, e.g. with a carpenter's pencil. With this it is easy to apply a very thin film of graphite to reduce the risk of premature wear. The application of too much may lead to the dust being deposited on the film.

All cameras should be stored in a dry place; dampness may cause corrosion of metal parts and swelling of woodwork, the detachment of leather coverings and mould on wood, leather and other non-metallic components.

Other important hazards for a camera are:

(a) *Water.* A camera splashed by rain and particularly sea water should be wiped dry with as little delay as possible. A bellows camera should then be placed in a dry place until the bellows are quite dry. Often a plastic cover with a hole for the lens—or even an underwater housing—provides adequate protection when photographing under conditions where the camera is exposed to splashes.

A camera that has fallen into the water should be dismantled as soon as possible by a repairer to enable all components to dry out, before reassembly. Neglect of this may cause corrosion of metal parts, especially if the camera has fallen into the sea. In the latter case an immediate rinse in fresh water is advisable.

(b) *Sand, dust and grit.* Particles of foreign matter entering the camera mechanism may cause damage to moving parts, upset the accuracy of focusing and rangefinder systems and settle on the emulsion surface, causing light spots in the negative. When photographing in dusty or sandy locations the camera should be kept wrapped up as far as possible and never left lying on a sandy beach, etc.

(c) *Tropical conditions.* The main risks here are dampness and sand or dust. When not in use the camera is best kept in a sealed box or a special moisture-proof case together with a dehydrating cartridge. In the tropics, bacteria and other micro-organisms may attack leather, woodwork and even the lens. Excessive damp and heat seriously impair the keeping qualities of exposed and unexposed films.

(d) *Knocks and vibration.* A leather case (§ 318) offers some protection against damage if the camera is dropped or knocked. Equally important is the avoidance of constant vibration which in time may cause the loss of screws holding parts together or may upset precise optical or mechanical adjustment. Cameras should not therefore be carried on the floor or in the glove box of a car; a padded camera case, preferably placed on the seat, is safer.

When storing a camera for longer periods, metal parts may be rubbed with a rag very slightly greased with petroleum jelly. Wooden cameras may be rubbed over with a polish composed of wax and turpentine, but bellows of varnished leather must never be greased. They may be dusted from time to time (only from the outside) with talc and the excess wiped off. This prevents the folds from sticking together.

All the interior parts should be cleaned fairly frequently with a brush and dry rag.

Special precautions must be taken with metal plate or film holders and steel sheaths. They must never be left in a dark-room, where it is always somewhat damp. When in process of loading and unloading they should be placed on a perfectly dry table, secure from risk of

splashings of liquid. Blackened steel rusts very easily, and the rust comes off in flakes and is likely to adhere to the sensitive surfaces and cause spots, for which there is no remedy. When holders and sheaths are likely to remain unused for a long period it is well to grease them very slightly with petroleum jelly, but they must be freed from the grease with a dry rag before using them again. These accessories are easy to damage if clumsily handled, and a holder or draw slide that has been bent is usually not light-tight, while a bent sheath is likely to scratch the emulsion surface of the plate behind it.

A camera should never be left in a cupboard except in its case. The lens should be cleaned (§ 179) from time to time, but not to an undue extent, the surfaces being liable to injury as the result of improper cleaning. Finally, it should be remembered that the shutter must never be oiled, and that it must not be taken to pieces except by an expert.

311. Close-up Accessories. To cover near subjects, cameras without the large bellows extension of technical and view camera types employ various special accessories. The simplest are supplementary lenses (§ 181), often used with special focusing aids to ensure accurate distance setting.

The latter include close-up rangefinders, similar to a separate rangefinder (§ 295) but calibrated in specific settings of the camera focusing scale and adjusted for near distances when used with specified close-up lenses. In use the rangefinder is mounted on the camera, its adjustment set to the supplementary lens and focusing scale setting used, and the subject approached with the camera until the rangefinder images coincide, when the exposure can be made. Such rangefinders often fit into the accessory shoe on the camera and may tilt to serve as parallax compensated close-up viewfinders.

Distance gauges permit accurate location of the subject plane for maximum sharpness in close-up work. They consist of a four-legged stand, or a rod with a frame, attached to the front of the camera. The tips of the four legs or the frame outline the subject field taken in and indicate the plane within which objects are reproduced sharply. Such gauges are used for close-up shots with hand-held miniature cameras, and often alternative legs or frames are available to cover different near fields with various supplementary lenses. No such viewing

and focusing aids are required with a single-lens reflex camera where the image sharpness and field can be observed on a focusing screen.

Where the camera lens is interchangeable tubes of various lengths mounted between the lens and the camera body provide the necessary extra extension for large close-up and macro-photography. The front and rear fittings of the tubes must match the lens changing mounts and flanges of the camera system, and sometimes incorporate internal linkages to connect the automatic aperture selection mechanism of the lens with the controls on the camera (§ 283). While extension tubes cover specific near distance ranges (depending on the focusing range of the lens), extension bellows provide a continuous adjustment range which with certain focal lengths can extend from subjects at infinity to close-ups on a 1:1 scale. The shorter the focal length of the lens used on the bellows, the larger the scale of reproduction obtainable.

The bellows unit is usually a scaled-down version of a monorail or twin rail technical camera, with the rear standard equipped for mounting the camera body and the front standard with a fitting to take various alternative lenses. A few bellows attachments include lateral swings of the front and rear standards (§ 223) but usually the standards permit only axial displacement for focusing. The extension range with bellows for miniature cameras is usually around 10 to 15 cm (4 to 6 inches); extension bellows for roll film reflexes may cover total extensions up to 20 cm or more. Where the aperture control of the lens and the camera cannot be coupled through the bellows, a twin cable release A (Fig. 18.40) may

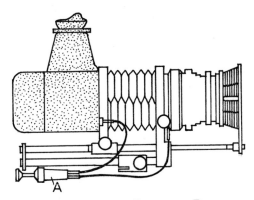

FIG. 18.40. CLOSE-UP EXTENSION BELLOWS ON A REFLEX CAMERA

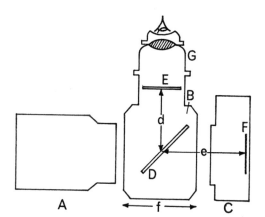

FIG. 18.41. REFLEX HOUSING FOR RANGEFINDER CAMERA

The near range is further extended by interposing extension tubes or bellows.

For focusing long focus lenses on infinity, the lens itself must be set in a mount shortened by the distance f. Some telephoto lenses are produced in mounts for exclusive use with such a reflex housing. Medium long-focus lenses can sometimes also focus to infinity if the lens unit (without its normal mount) is fitted to the housing via a short adapter ring or special short mount.

313. Micro Adapters. For photographing through a microscope the camera only has to be mounted—without lens—above the microscope eyepiece, so that the latter directly projects the microscope image on to the film. The micro adapter A in Fig. 18.42 provides a light-tight connection between the microscope and the lens flange of the camera. The adapter usually incorporates a beam splitter B which diverts about 25 per cent of the light into an eyepiece D for viewing and focusing. This is essential only with rangefinder cameras, as in a reflex the screen can be used for focusing the image. For freedom from vibration it is, however, preferable to move the mirror out of the way before making

be used for synchronized operation of the lens diaphragm and the camera shutter.

312. Reflex Housings. As focusing on a ground glass screen is the only satisfactory way of assessing the field of view and image sharpness in extreme close-up work as well as with the longer focus telephoto lenses, reflex housings or attachments are available for most advanced rangefinder cameras taking interchangeable lenses. The housing B (Fig. 18.41) fits between the lens A and the camera body C and incorporates a mirror D and a focusing screen E in a layout similar to that of single-lens reflex camera. The dimensions of the housing are determined by the fact that the distance d between D and E must be the same as e between D and F. There is, however, often sufficient space above D for the mirror to slide vertically upwards instead of swinging about an axis O. The reflex housing usually takes a magnifying eyepiece in a hood G for focusing on the screen E; this is often interchangeable against an eye-level pentaprism finder. The coupling between the mirror D and the camera shutter may be a lever bearing on the shutter release button; depressing the lever raises the mirror just before the camera shutter is released. The mirror action may be spring-loaded to cut down the dark interval on the screen before the exposure. With some reflex housings the mirror is operated by a twin cable release in synchronism with the camera shutter.

Owing to its depth f, the reflex housing acts as an extension tube and the forcusing movement of the lens A covers a near distance range—the shorter the focal length, the closer the distances.

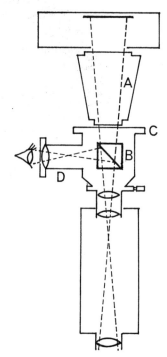

FIG. 18.42. MICRO ADAPTER FOR USE WITHOUT CAMERA LENS

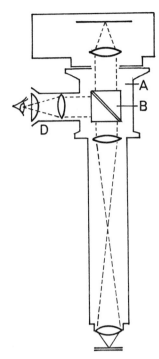

FIG. 18.43. MICRO ADAPTER FOR USE WITH
CAMERA LENS

lowered. The arrangement is very stable and is still used for certain branches of commercial photography. But for portraiture it has largely been replaced by an arrangement giving a larger range of movement. In this there is a table or top, carrying the baseboard of the camera, which top can be tilted on a horizontal axis. The table moves up or down between two or four pillars fixed to a base. Pinions fixed beneath the table engage with racks on the insides of the pillars which sometimes contain counterweights. The top can thus be lowered to within a few inches of the floor, and can be raised to a height limited only by the height of the pillars. Metal bipost stands of this type are widely used.

In either case the stand must be mounted on castors, allowing it to be moved easily and rapidly. It is preferable, especially when the stand is to move on carpets, that the castors be replaced by wheels of larger diameter with rubber tyres. Once the stand has been brought

the exposure and to observe the image through the viewing eyepiece of the adapter. Often the latter incorporates a diaphragm shutter to eliminate the risk of vibration from the focal plane shutter of the camera

Where the camera lens is not interchangeable, the camera is mounted on the adapter with its own lens focused on infinity. The microscope must also be adjusted for infinity viewing; the camera lens then projects a sharp image on the film (Fig. 18.43). A focusing eyepiece in the adapter again provides a check on the image. For maximum light transmission, the beam splitter of the focusing eyepiece may move out of the optical path during the exposure.

314. **Camera Stands.** In the studio the camera must be capable of being fixed at various heights and at various angles. The studio stand has long been in the form of a small table, or platform supported on pillars sliding within the framework. Racks and pinions enable the front and the back of the top to be raised or lowered either simultaneously or separately. On this system the maximum height to which the top can be raised is only about 33 per cent more than the minimum height to which it can be

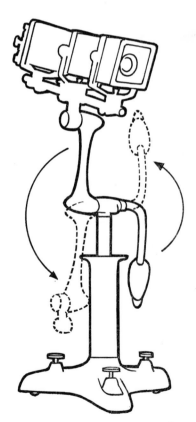

FIG. 18.44. BOOM TYPE STUDIO STAND

into position it can be fixed there by means of four movable rods which project a little under the stand and lift it slightly, usually by operation of a pedal.

Modern heavy studio stands may use a counter-weighted boom pivoting about a horizontal axis. The camera is mounted on one end of the boom and can swing from about 10 to 20 cm above floor level up to a height of 3 metres or more. The pillar carrying the boom may also be extendable within a supporting column, and the whole stand movable on castors.

315. Semi-portable and Portable Tripods.
Away from the studio, technical and view cameras have to be set up on a tripod stand, consisting of three legs linked to a central platform on which the camera is supported. The legs are usually adjustable in length, and the platform may be raised or lowered on a centre column. Heavy duty tripods of this kind are adequately rigid for most requirements, yet fold up for convenience of transport. With smaller cameras such a tripod would be heavier and more bulky than the camera itself. Nearly always telescopic metal tripods are used, in which the legs are divided into sections sliding or folding one in another. The rigidity of an extended leg leaves more to be desired, as the diameter of the tubes is smaller and the number of sections is increased with the object of reducing the length for carrying. Weight for weight, it is preferable to use tripods with aluminium tubes of large diameter fitted with brass slide-sleeves rather than tripods with slender brass tubes. Tubes of triangular section can be quite sturdy without the total section of the tripod being too large, as the legs fit closely against each other. The length of the legs is regulated by drawing out a greater or less number of sections. As a rule, the sections lock automatically as each is fully extended (some tripods with cylindrical legs have a bayonet catch), and for closing all that usually needs to be done is to press one catch on each leg, the whole leg then collapsing on applying a fairly sharp push.

Some tripods have a screw ring around the head by means of which the degree of opening of the legs can be regulated and the tripod can thus be prevented from slipping.

Lightweight tripods are not recommended for heavy cameras. While the tripod might be able to support the camera, the vibration of mirror or shutter mechanisms can lead to greater unsharpness through camera shake than if the camera is held in the hand. Special care is also needed when working with a cable release (§ 280) to avoid jerking the camera on its tripod.

The camera is mounted on the tripod by means of a screw which screws into a bush fixed to the camera body. The better types have fairly large platform heads.

While manufacturers have apparently accepted the decisions of International Congresses as regards the standard of the thread of the tripod-screw, it is still sometimes found that a tripod-screw by one maker fails to fit the bush of a camera by another. The International Photographic Congress of 1889 (the decisions of which have not been accepted by English-speaking countries) adopted the screw known as "$\frac{3}{8}$ in. Whitworth". Most British and American cameras are fitted with "$\frac{1}{4}$ in. Whitworth" bushes.

Whatever the bellows extension used, the camera must be well balanced on the tripod. For this the camera should be fitted with several bushes arranged so that the one affording the greatest stability may be chosen.

The steel points with which tripod legs are shod tend to slip on pavings and polished parquet floors, and may damage carpets on which they are used. Slipping may be prevented by placing on the ground, in the shape of a three-pointed star, three chains joined to a ring in the centre; the points of the tripod are placed in the links at a suitable distance from the centre. The points may even be tied to each other with a piece of string. When working on a carpet, a three-pointed star made of thin lengths of wood is of great service. Each length is connected to the others at one end (this being the centre of the star), notches being provided near the free ends to receive the points of the tripod legs. This fitment is also exceedingly useful on pavings or polished floors, as it allows of the camera and stand being moved as a whole without disturbing any adjustment of the camera, as regards level, which has been made in composing the subject. The tripod points are sometimes fitted with rubber shoes hollowed in the form of suckers.

It is often advantageous and sometimes necessary to be able to tilt the camera without moving the tripod. This can be done by means of a tilting-head fixed to the tripod-top and to which the camera is secured. *Ball-and-socket heads* are suitable for light cameras, provided they are of robust design.

When photographing extended panoramas at

successive exposures, the prints from which are subsequently to be joined up, it is of service to be able to rotate the camera on a vertical axis through an equal angle each time. For this work a panoramic top is used; there are several commercial patterns intended particularly for light cameras.

To permit rapid mounting and removal of the camera from the tripod, various quick coupling systems are available. They consist of two halves —one being permanently screwed to the tripod head and the other to the camera—which can be pushed together in a dovetail or similar fitting and locked in position in an instant. Removal of the camera from the tripod involves only releasing the coupling and sliding the two components apart.

316. Table Stands and Compact Supports. Where a tripod is too cumbersome to carry, a monopod with a single (usually collapsible) leg provides useful vertical support by taking the weight of the camera so that the latter has to be steadied only against swaying. When collapsed, the monopod can even be supported against the chest of the cameraman. To steady a hand-held camera, a long chain can also be used and held anchored under the operator's foot while he pulls upwards against the chain tension.

Table stands and table tripods are, as a result of their greater compactness, more rigid than telescopic tripods and are thus useful camera supports where a firm platform (table, etc.) is already available at nearly the right height. Table stands are also convenient camera supports for close-up photography of objects arranged on a table or other platform.

The pocket supports have their uses. They usually comprise a base, with screw, for the camera, and a ball-and-socket uniting the base to a kind of joiner's clamp. The latter enables the fitment to be fixed to the back of a chair, handlebar of a cycle, fence, or door frame. In some cases the support can be fixed to a tree-trunk or mast by a steel ribbon or chain which can be drawn tight by an eccentric fastening.

317. Levels and Plumbs. It is desirable to be able to level the camera when holding it in the hand and sighting the subject, in order both to avoid the distortion which is produced if the sensitive surface is tilted and the reduction in the size resulting from the trimming which becomes necessary.

When the camera is held at waist-height, its level can be indicated by a circular spirit level or by two tubular air-bubble levels placed at right angles to each other; the levels must be placed near the finder or over it. The spirit in the air-bubble levels tends to evaporate by the join between the concave glass that forms the cover and the metal body of the level. Levels have been made in which a steel ball rolls on a concave surface, but the ball is too mobile unless immersed in a viscous fluid such as a mixture of water and glycerine.

For sighting at eye-level, various plumbs or levels visible in the viewfinder, or plumbs on the outside of the camera, have been suggested. These are now rarely fitted and it is usually found in practice that the camera can, with care, be held sufficiently nearly level. Modern photographic practice tends to minimize the importance of the strict observance of verticals except with subject-matter which would normally be photographed with a stand camera.

318. Camera Cases. For carrying larger cameras and their accessories, use is generally made of waterproof cases of canvas or leather or even metal lined with soft baize. Canvas cases intended for almost daily use should have the edges, folds and seams bound with leather. Strips of wood or metal studs must be fixed so as to project considerably from the bottom, in order to protect the latter when the case is put down on wet ground. Straps, particularly those for carrying the case on the back or slung across the shoulder, should be of strong leather, and their width must be the greater as the weight is heavier.

In camera sizes up to 13 × 18 cm or 5 × 7 inches, the camera, film holders, and accessories, such as focusing cloth, are often all packed in one case. It is then advisable to have a long narrow case in which the camera and the holders are arranged side by side. For larger sizes it is best to have two cases, one for the camera and the other for the holders and accessories. In the case for the tripod, space should be provided for accessories such as the fitment for preventing the tripod points from slipping. Every camera case which is likely to be left in the care of others should be fitted with lock and key.

Cases for amateur cameras used to be little more than a leather or canvas container for protecting the camera but evolved into the so-called every-ready case in which one side of the case swings down to uncover the front and the controls of the camera. The latter can then be used (though not reloaded) while still in

the case. Such ever-ready cases are widely used for miniature and miniature reflex models and offer good protection not only against dust and the weather but also against knocks. The camera is normally carried in the case more or less ready for shooting, but many professional press and other photographers consider the ever-ready case too bulky for convenience and prefer to carry the camera only on a strap when shooting.

For miniature camera outfits hold-all cases have become popular. These contain the camera, interchangeable lenses and other accessories in compartments for easy removal and replacement while the case is being carried.

Special dust and waterproof metal cases have been made to protect cameras in tropical and other hazardous conditions. Some of these cases open fully while still attached to the camera, somewhat in the manner of an ever-ready case, but can be closed hermetically.

319. Underwater Housings. Special waterproof and pressureproof containers take specific cameras for underwater photography. The camera photographs through a glass or plastic window in the front of the case. In more elaborate versions some of the camera controls are linked through pressurized glands with corresponding controls outside the case to permit focusing and adjustment of exposure and aperture in addition to releasing and film transport. Usually underwater housings are pressureproof down to a water depth of 100 metres and may be part of a complete underwater vehicle with a built-in motor, lamps, etc.

While underwater housings are bulky compared with the camera they contain, special underwater cameras with a waterproof body exist which are no larger than a normal miniature camera. The use of underwater housings and cameras is not confined to photography in the water; they also offer useful protection against splashes while photographing from small boats and against grit and sand in very dusty environments.

Index

The numbers refer always to the paragraph numbers in the text, and *not to the page numbers.*

The numbers refer always to the paragraph numbers in the text, and *not to the page numbers.*

The numbers refer always to the paragraph numbers in the text, and *not to the page numbers.*